ABANDONED WORLD WAR II
AIRCRAFT, TANKS & WARSHIPS

CHRIS McNAB

amber
BOOKS

Published by Amber Books Ltd
United House
North Road
London N7 9DP
United Kingdom
www.amberbooks.co.uk
Instagram: amberbooksltd
Facebook: amberbooks
Twitter: @amberbooks
Pinterest: amberbooksltd

ISBN: 978-1-83886-087-5

Project Editor: Michael Spilling
Designer: Keren Harragan
Picture Research: Terry Forshaw

Printed in China

Contents

Introduction

For six unprecedented years in human history, almost the entire globe thundered to the sounds of war, lit by strobe-like flashes of gunfire and explosions. By the time the guns, aircraft, tanks, artillery, warships and myriad other weapon systems fell silent in September 1945, more than 50 million of the planet's population, civilian and military, were dead, and millions more wounded or displaced. Despite the passage of more than seven decades of time since

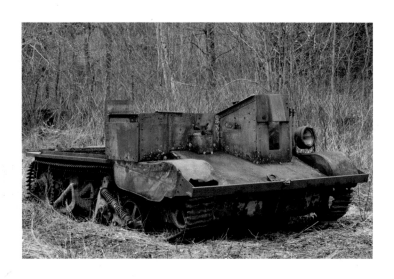

the end of the war, the physical evidence of that conflict remains prolific and poignant. Some of it is small in scale – a rifle rusting in a ditch or a pile of shells stacked in a wood. Some of it is open and defiant – many wartime fortresses still sit powerfully above coasts or atop mountains, their strength undiminished by time. Beneath the waves are numerous wartime ships and aircraft, muted in deep-blue, silt-grey or coal-black waters. All these objects speak of the hands and minds that operated them, so deserve our respect. But given their original purpose of delivering or fuelling violence, we should ultimately be glad that they and the world around them are now silent.

ABOVE:
Universal Carrier, Pleasant Valley, Canada
The Universal Carrier was an awkward-looking but useful vehicle, used for troop carrying, scouting and mobile communications.

OPPOSITE:
Nakajima B6N bomber, Truk Lagoon, Micronesia
A Japanese torpedo bomber disintegrates on the seabed. Truk Lagoon is the site of more than 60 ship and aircraft wrecks.

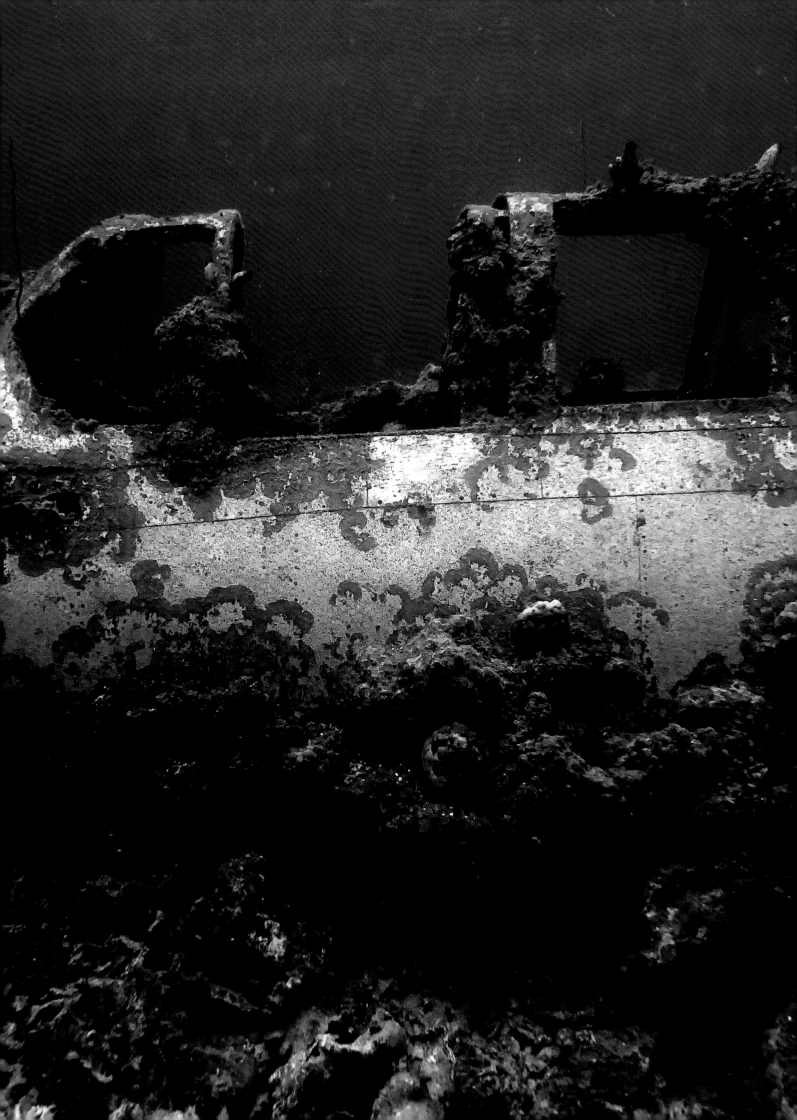

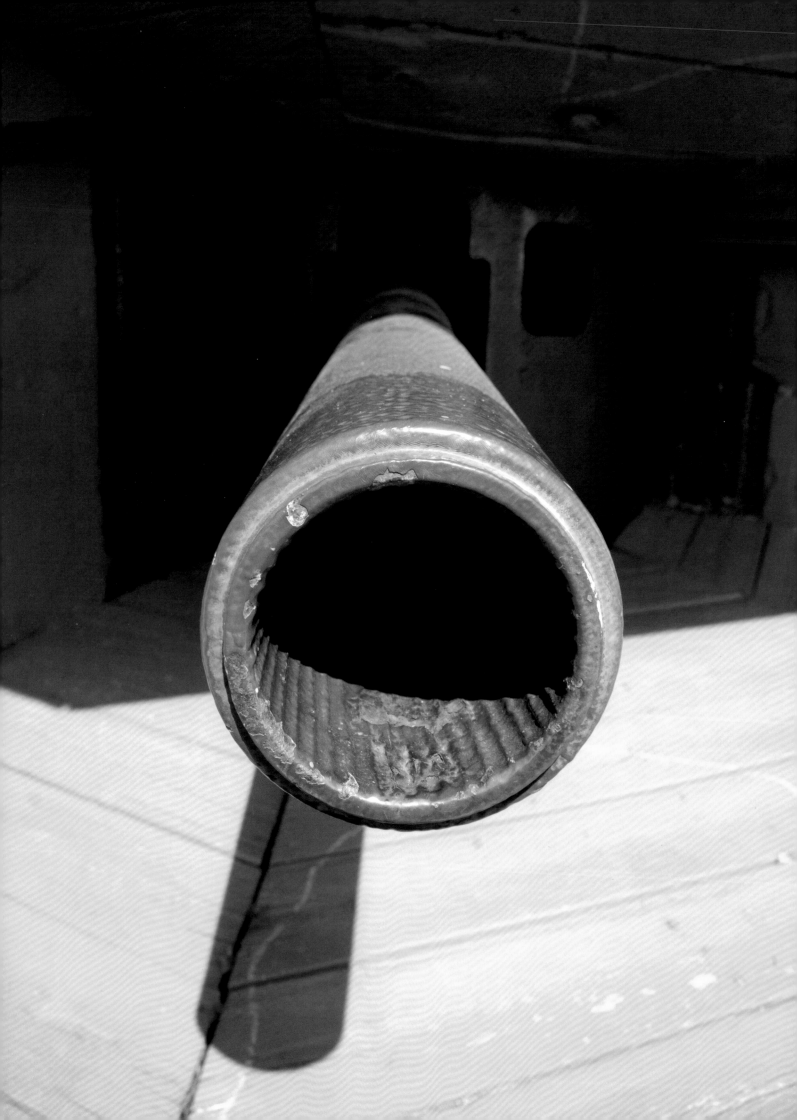

Western Europe and Scandinavia

Despite the passage of more than 75 years since the end of World War II, Western Europe remains a region that wears the open scars of that convulsive conflict. Much of the permanent visible legacy is expressed in concrete and steel, in the networks of static defences that many European nations constructed on the approach to war during the 1930s, or during the conflict itself. The French Maginot Line or the German *Atlantikwall* are among the mightiest examples, but every European nation has its ghostly and rusting bastions, ranging from major coastal gun emplacements – many still formidable in appearance – through to isolated and damp pillboxes maintaining a lonely vigil in remote woodland. But the scale of the fighting in Western Europe, conducted on land, sea and in the air, left countless smaller but equally evocative physical memories, including the weapons of both strategic and tactical warfare. Some of these still have lethal potential – in Germany, for example, more than 2000 tonnes (1970 tons) of unexploded World War II munitions are discovered every year, and defusing them has come at the cost of 11 bomb technicians since 2000 alone.

Military archaeologists and metal-detecting enthusiasts find the full spectrum of military materiel in the earth around key engagements such as the Ardennes forest in Belgium or the Seelow Heights east of Berlin; almost every combatant nation has equivalent battlegrounds. The monuments of World War II in Europe can therefore be as great as a fortress or as humble as a common soldier's firearm.

OPPOSITE:
**10.5cm Coastal Gun,
Fort Hommet, Guernsey**
Fort Hommet has military origins dating back to the seventeenth century, but this gun and casemate were emplaced by the Germans following their occupation of Guernsey in June 1940. The *Stützpunkt Rotenstein* (Strongpoint Rotenstein) featured two 10.5cm K331(f) guns.

**SS *Richard Montgomery*,
Thames Estuary, Kent, UK**
The US Liberty Ship SS *Richard
Montgomery*, carrying 7000
tonnes (6890 tons) of munitions,
was grounded on a sandbank in
the Thames Estuary on 20 August
1944, and subsequently sank.
Today there are still approximately
1422 tonnes (1400 tons) of
explosives contained in her
forward holds.

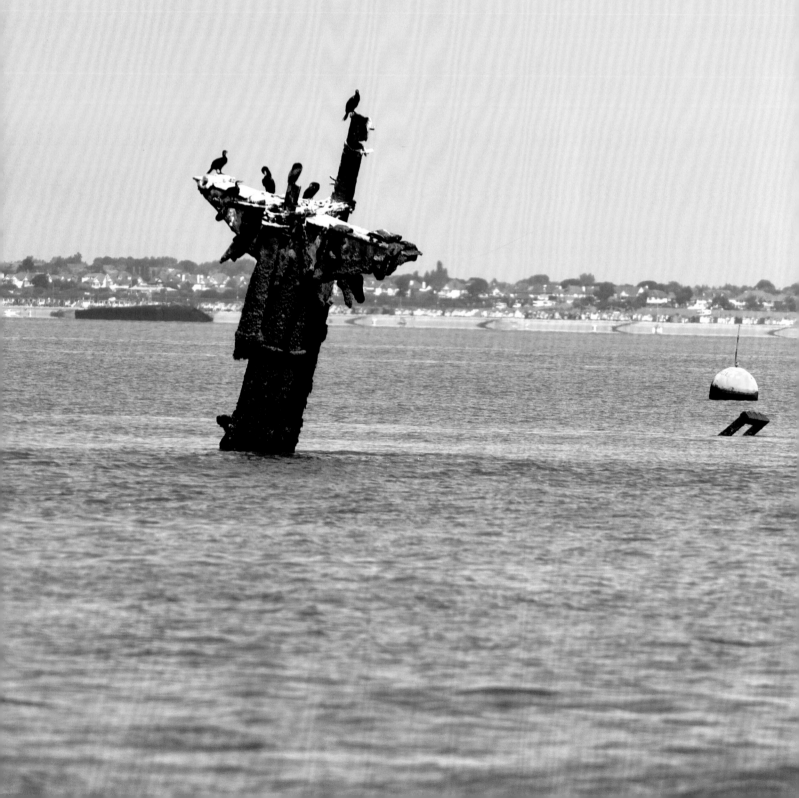

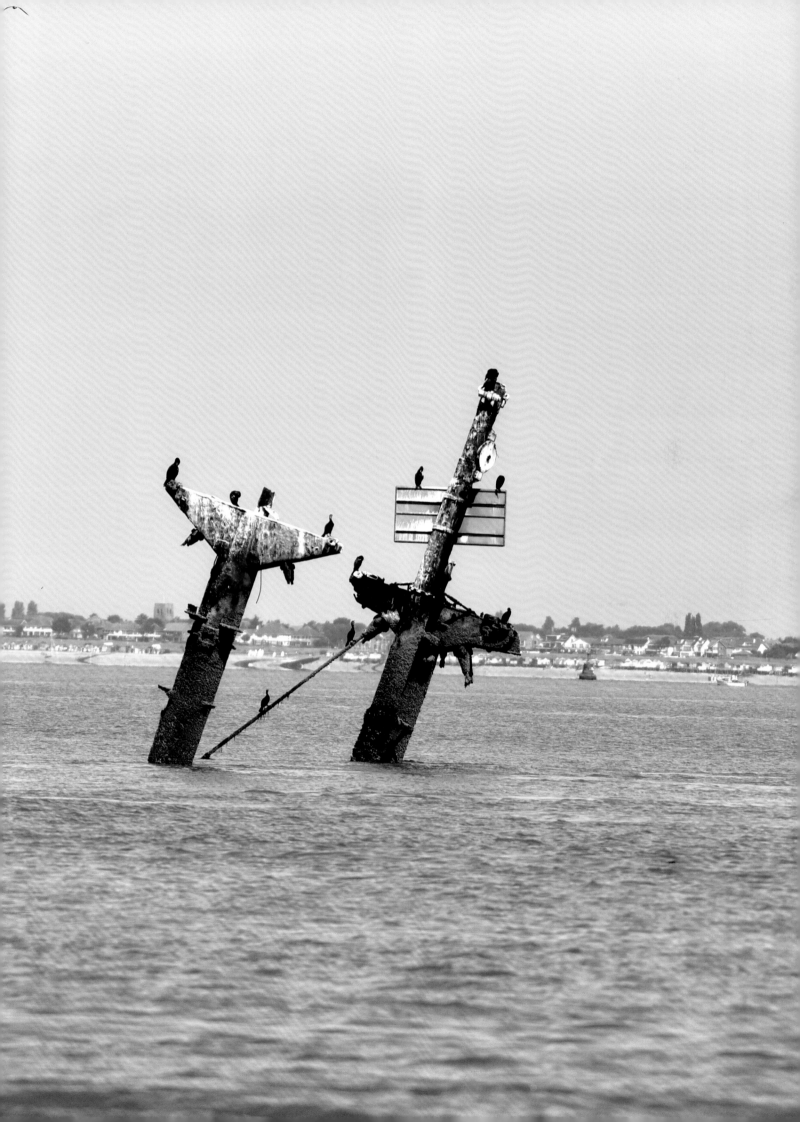

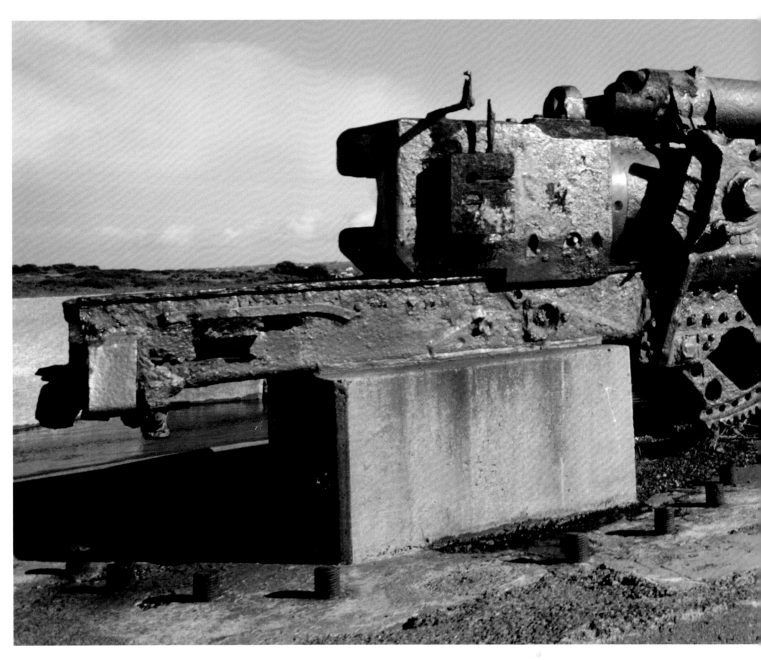

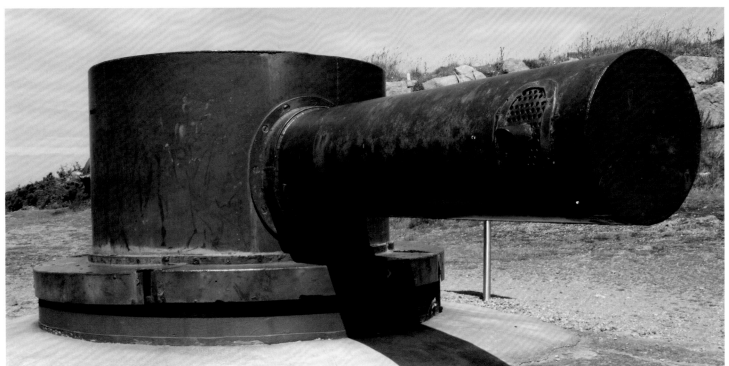

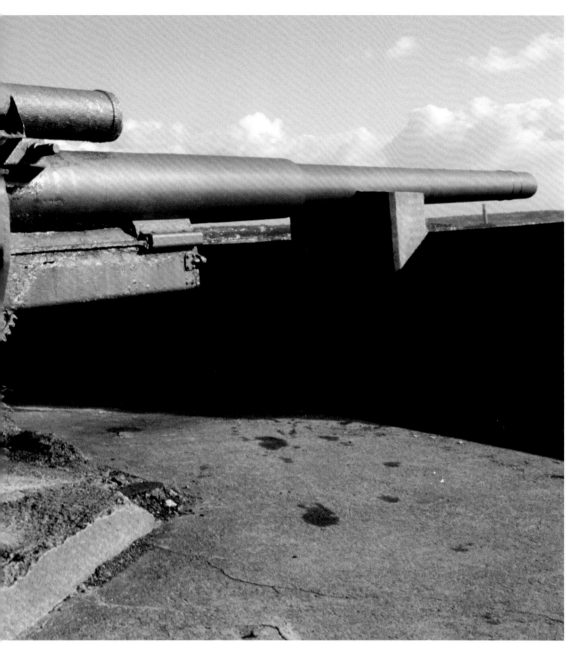

LEFT:

8.8cm Flak 36, Jersey
Following the occupation of Jersey in 1940, German forces constructed major coastal fortifications on the island as a cross-Channel extension of their Atlantic Wall. This gun was part of the anti-aircraft (AA) defences, and by late 1944 there were 37 8.8cm (3.46in) AA guns emplaced.

BOTTOM LEFT:

Rangefinder, Battery Lothringen, Jersey
Battery Lothringen was a German coastal gun emplacement on the southwestern edge of Jersey. Here we see an armoured naval rangefinder, which provided gunlaying information to the nearby command bunker.

BOTTOM RIGHT:

Battery Lothringen, Jersey
In the foreground are two steel observation cupolas at Battery Lothringen, while in the background we can see the top of the Marine Peilstand 1 (MP1) observation tower, each of its four floors serving a specific gun emplacement.

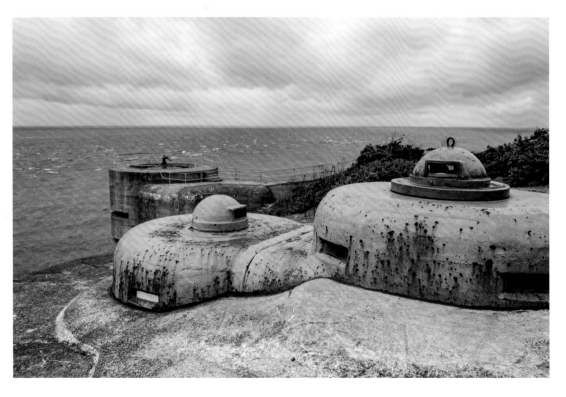

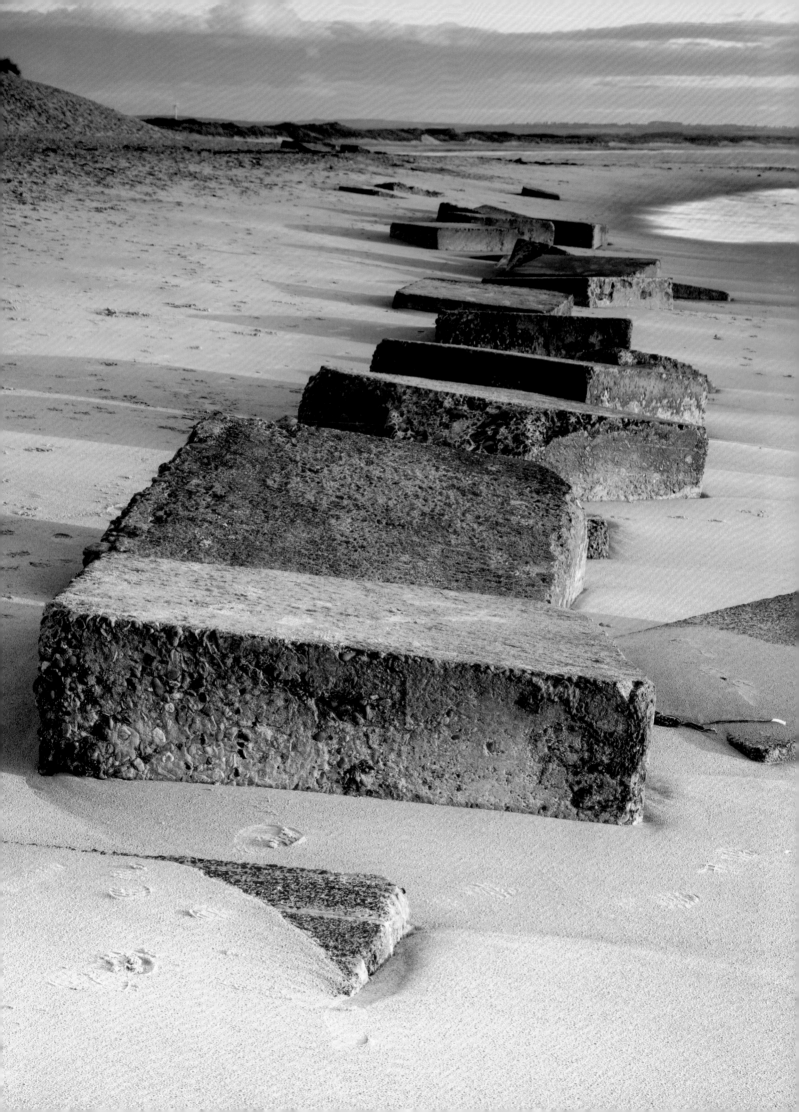

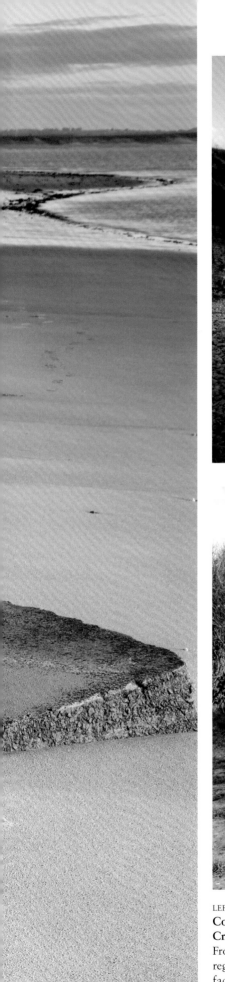

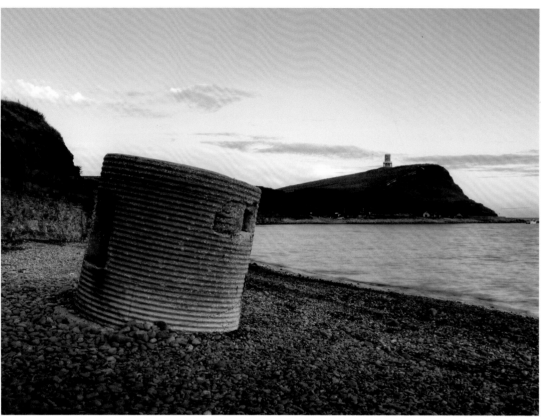

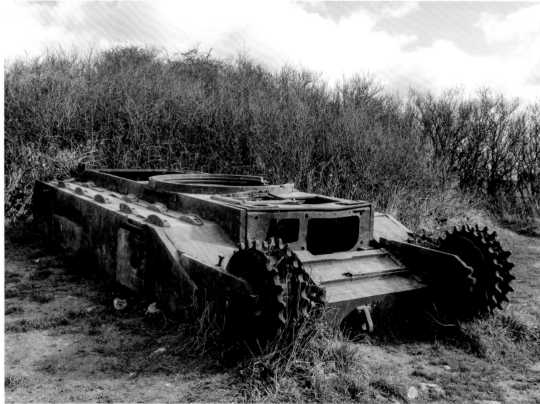

LEFT:

**Coastal defences,
Cresswell Beach, England**
From 1940, Britain's coastal
regions were preparing to
face an imminent German
invasion. Here we see beach
obstacles on Cresswell Beach in
Northumberland, concrete blocks
designed to prevent the movement
of landing craft and armour.

ABOVE TOP:

**Pillbox, Kimmeridge Bay,
Isle of Purbeck, Dorset, England**
This abandoned pillbox, tilted
crazily by time, was one of
thousands emplaced around the
British coastline in 1940. It is a
circular Type 25 pillbox, which
featured an entrance at the back
(visible here) and three embrasures
for rifles or light machine guns.

ABOVE BOTTOM:

**Churchill Mk II Tank,
South Downs, England**
The South Downs was designated
as a training area during World
War II. This particular tank, a
Churchill Mk II, was used by the
Canadian 14th Tank Battalion
when preparing for the ill-fated
Dieppe Raid of 1942. It was later
used for target practice.

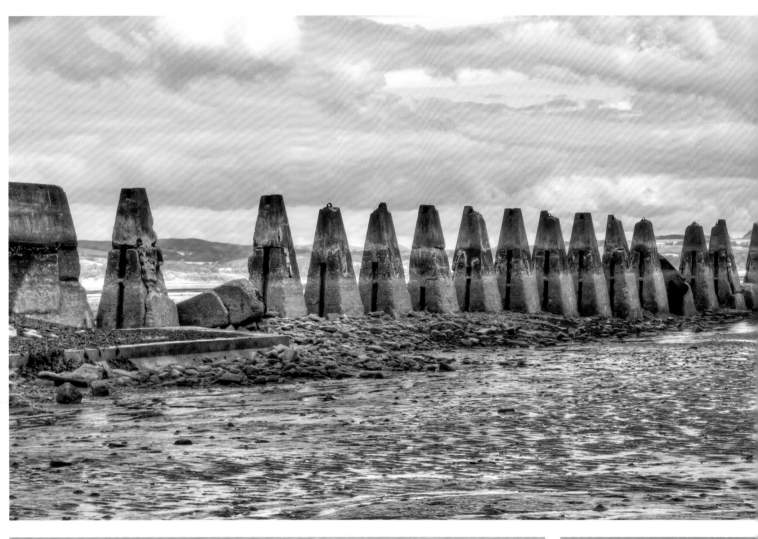

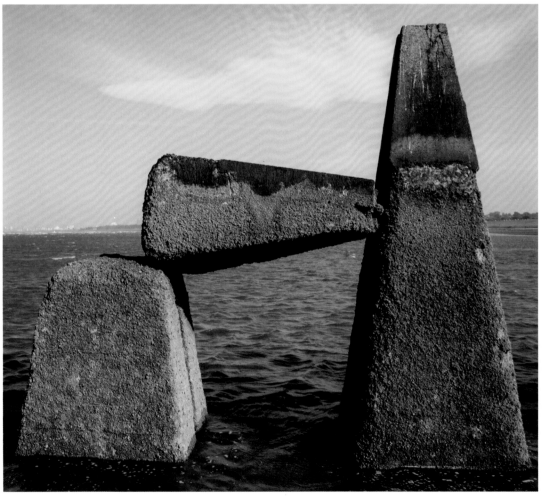

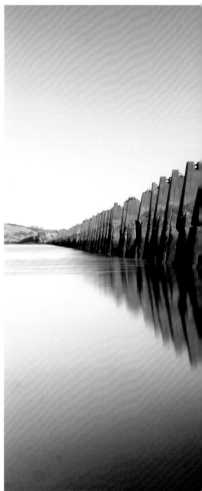

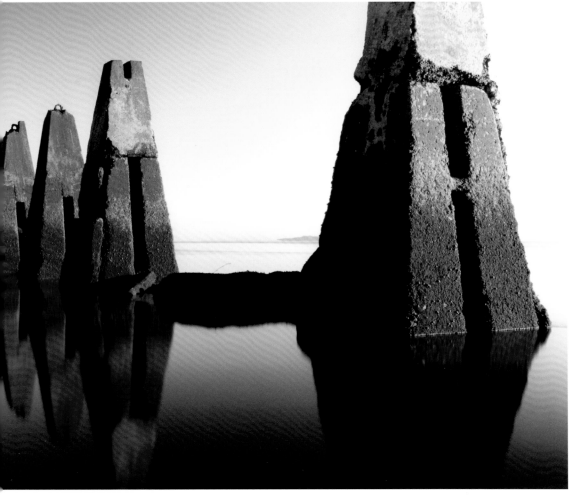

ALL PHOTOGRAPHS:
**Crammond Island,
Firth of Forth, Scotland**
Sentinels against a threat that never came, the concrete pillars that stretch between Crammond Island and the shoreline were once a formidable anti-boat barrier, constructed to prevent German torpedo vessels and other surface craft from attacking shipping anchored further up the Firth of Forth, particularly at Rossyth dockyard.

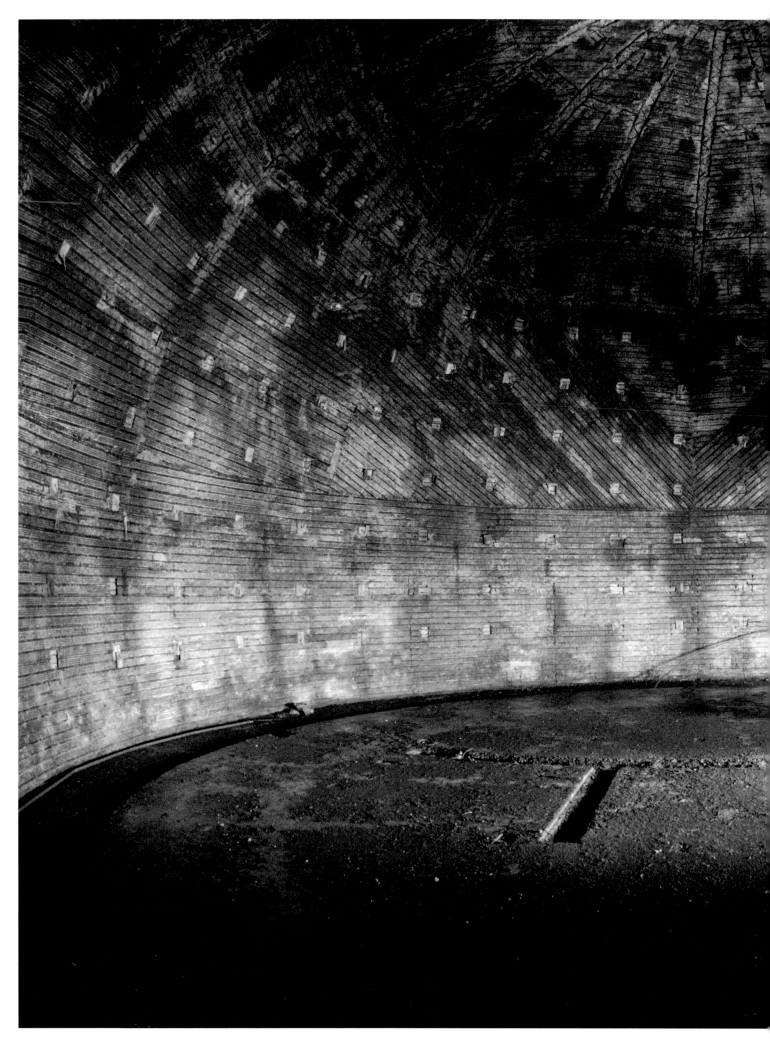

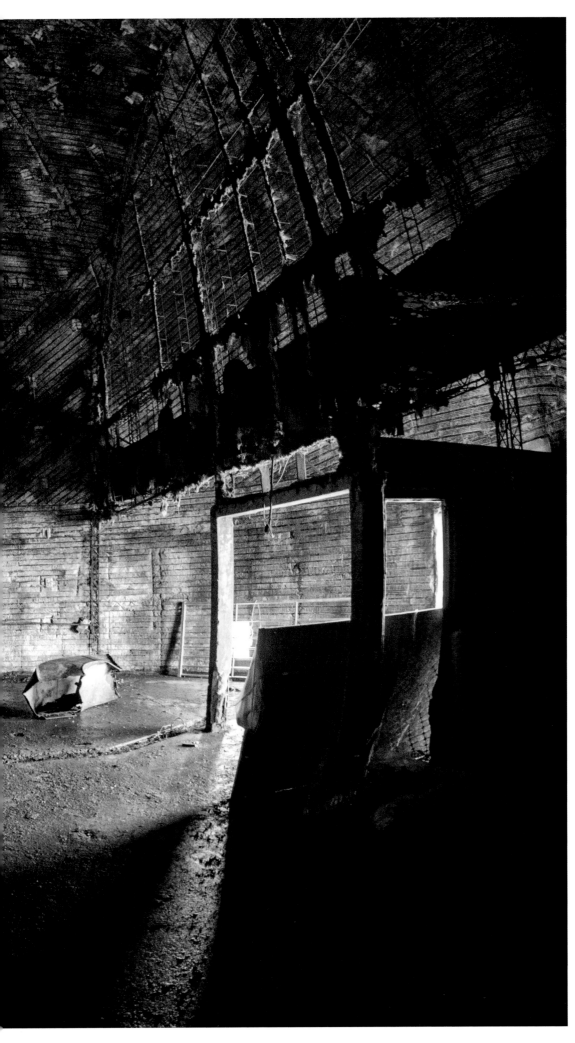

Gunnery training dome, RAF Pembrey, Carmarthenshire, Wales
RAF Pembrey was home to the No 1 Air Gunnery School, which trained a total of 3000 anti-aircraft gunners during the war. Standing 7.6m (25ft) tall and some 12m (40ft) wide, the dome was used to project images of enemy aircraft onto the interior walls, which the gun teams used to calculate their ground-to-air fire.

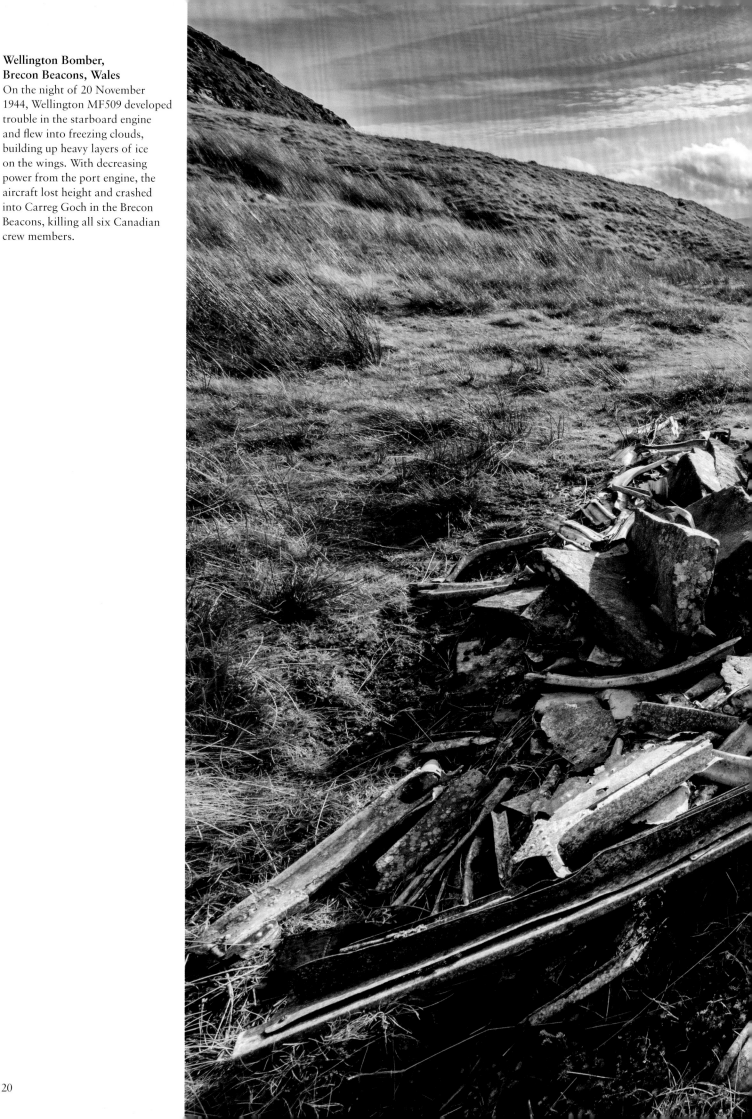

**Wellington Bomber,
Brecon Beacons, Wales**
On the night of 20 November 1944, Wellington MF509 developed trouble in the starboard engine and flew into freezing clouds, building up heavy layers of ice on the wings. With decreasing power from the port engine, the aircraft lost height and crashed into Carreg Goch in the Brecon Beacons, killing all six Canadian crew members.

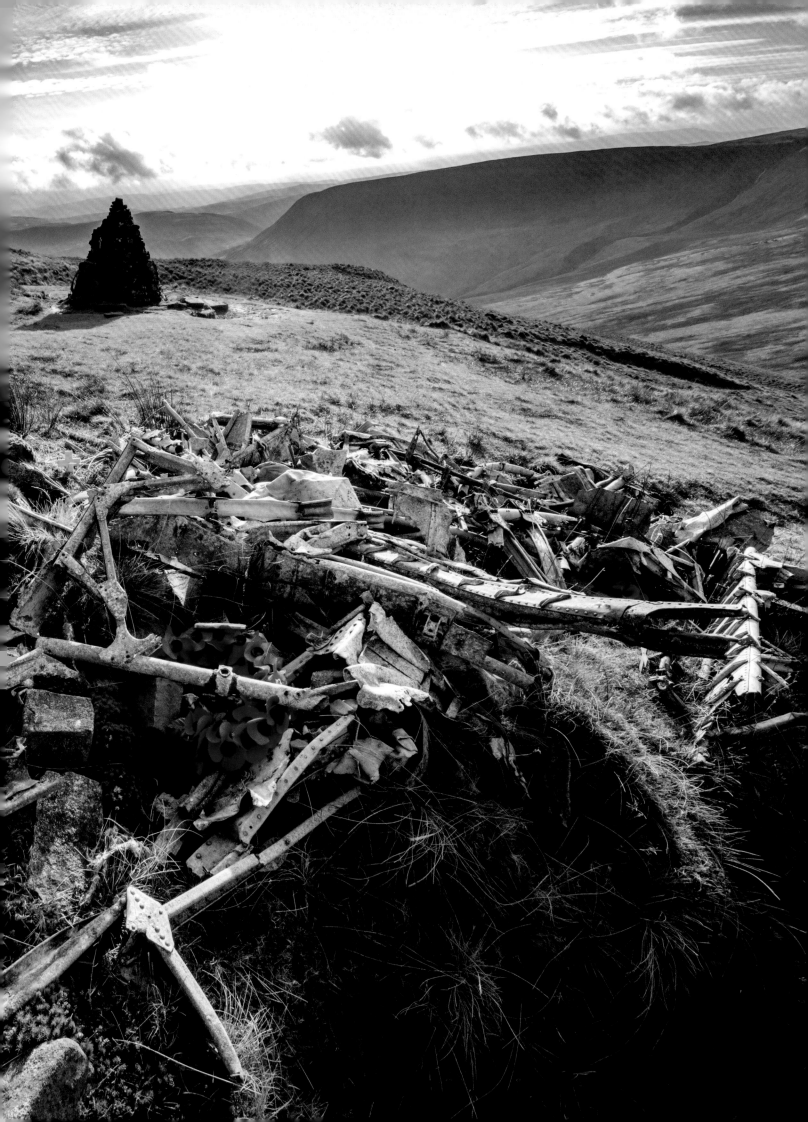

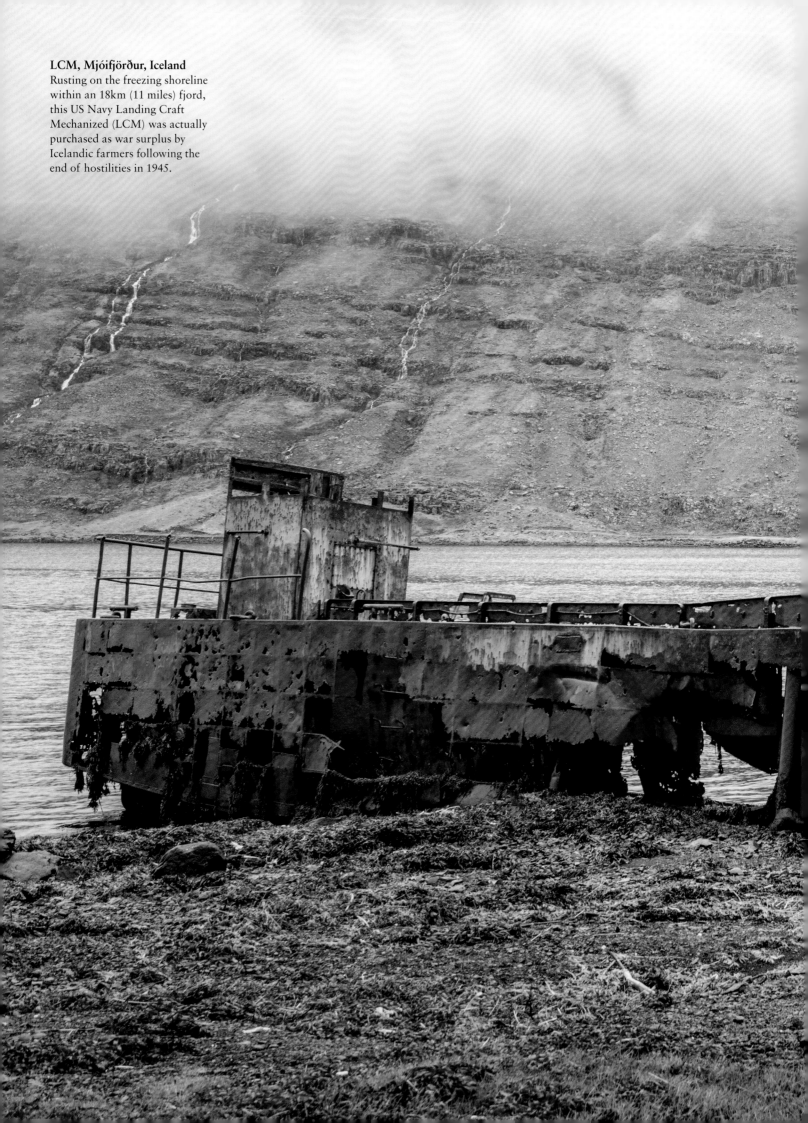

LCM, Mjóifjörður, Iceland
Rusting on the freezing shoreline within an 18km (11 miles) fjord, this US Navy Landing Craft Mechanized (LCM) was actually purchased as war surplus by Icelandic farmers following the end of hostilities in 1945.

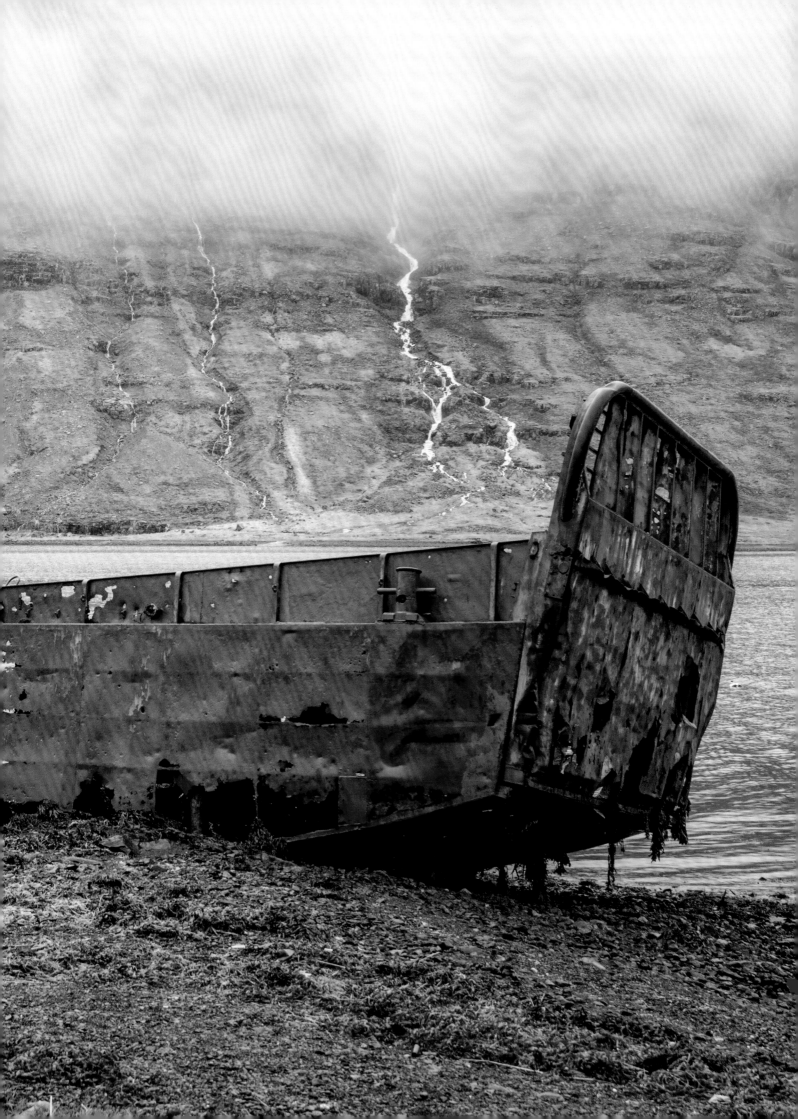

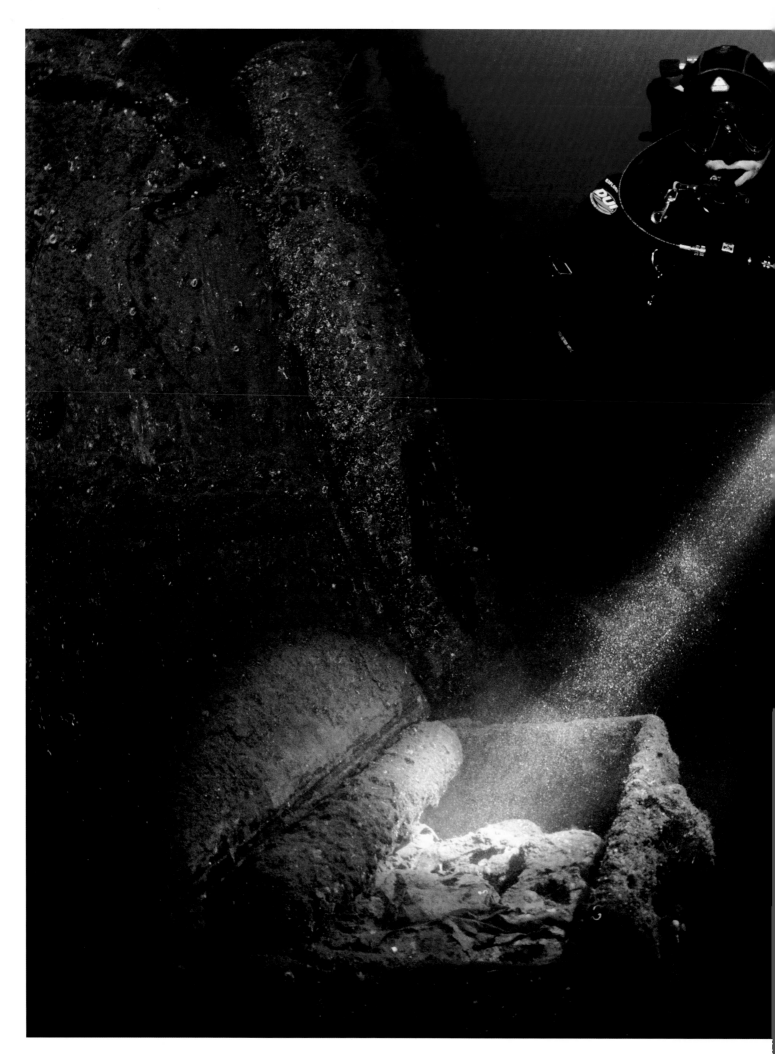

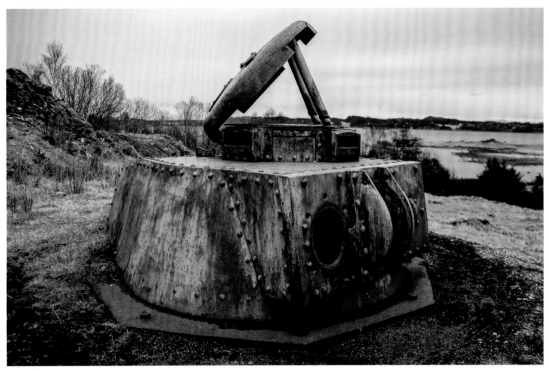

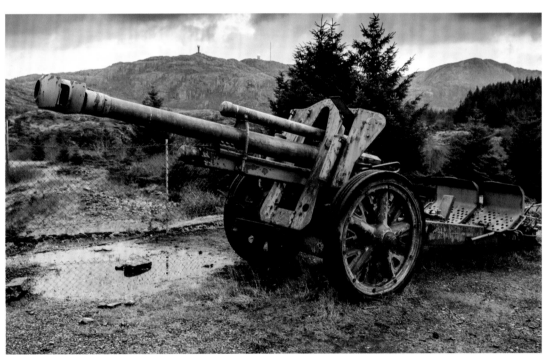

LEFT:

**V 1605 *Mosel*,
southern Norway**

The V 1605 *Mosel* was a German minesweeper, first built as a trawler in 1937 but converted to the minesweeper role in 1939. On 15 October 1944, while escorting a German tanker off the coast of Norway, the ship was sunk in a concentrated attack by British Beaufighter and Mosquito aircraft. Here a modern diver explores a box of ammunition on the wreck.

ABOVE TOP:

German bunker, Norway

Although the *Wehrmacht* constructed many sophisticated concrete bunker emplacements, others were far less advanced. The bunker here is simply a ground-mounted armoured vehicle turret, used as both a gun position and and observation post.

ABOVE BOTTOM:

**German howitzer,
Trondheim, Norway**

This German artillery piece is a 10.5cm leFH 18M light howitzer, one of the most prolific pieces of artillery in the German arsenal, with more than 22,000 examples produced. It was the standard German divisional field howitzer.

Coastal gun, Hamningberg Fort, Varanger Peninsula, Norway
German coastal fortifications stretched from southern France to northern Norway. Hamningberg is a quiet and remote Norwegian village, but also a potentially perfect landing zone, so occupying German forces built defences on the high ground behind the settlement. Here we see the derelict remains of one of the gun positions.

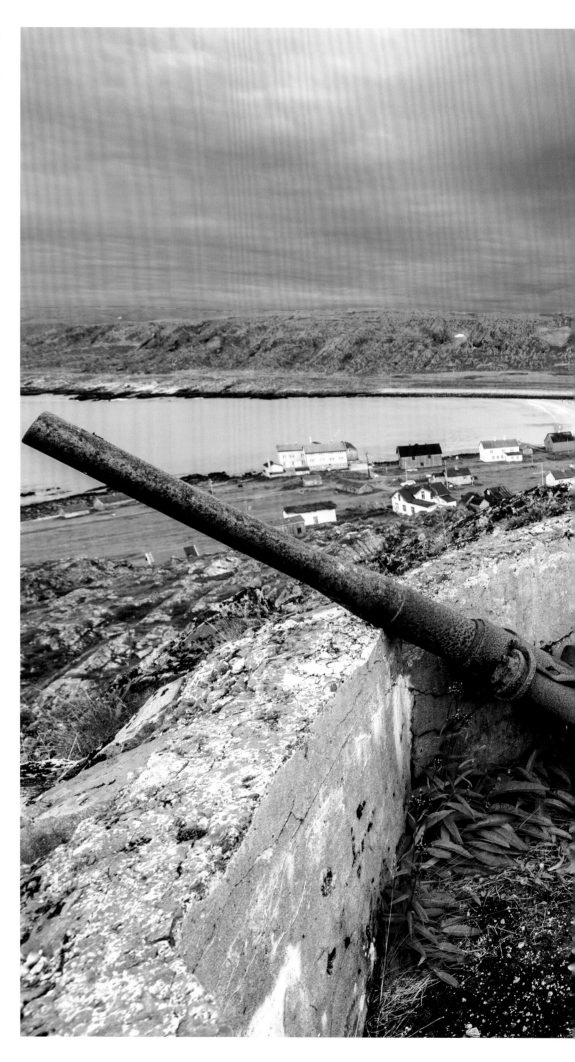

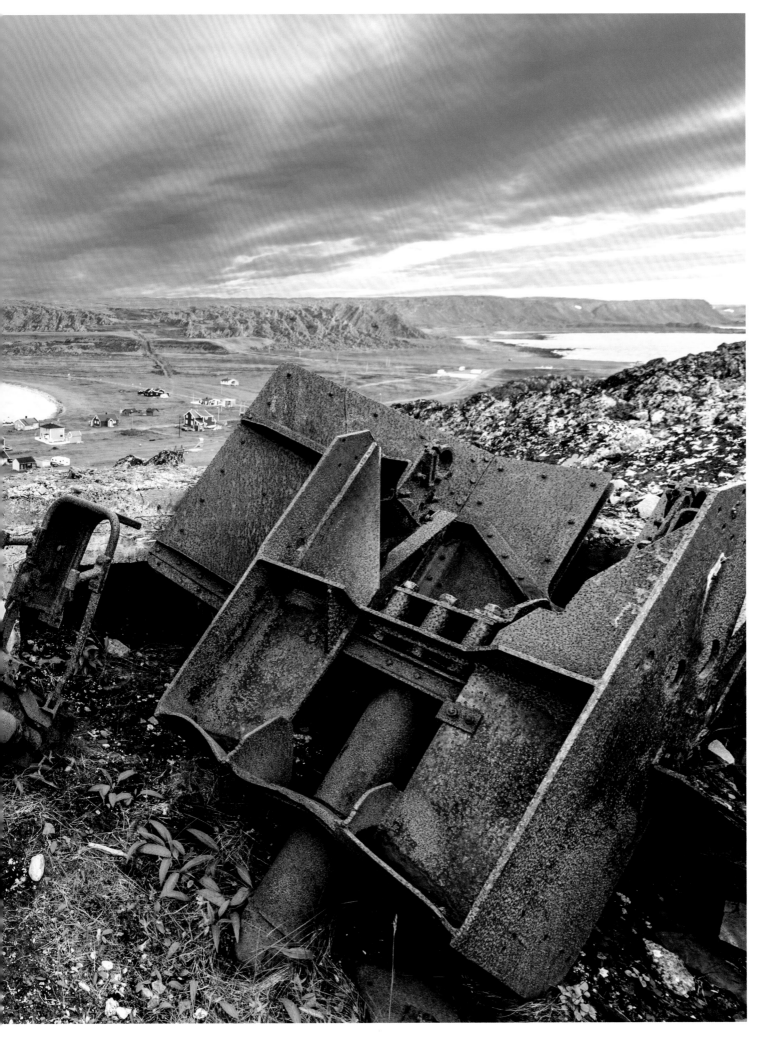

**SS *Frankenwald*,
Norwegian west coast**
The SS *Frankenwald* succumbed
not to combat, but to nature and
poor navigation. On 6 June 1960,
while transporting 8099 tonnes
(7,971 tons) of magnetic iron
ore from the mines in Kiruna,
the 122m (400ft) long German
freighter was caught in
a treacherous current, struck
rocks, and sank.

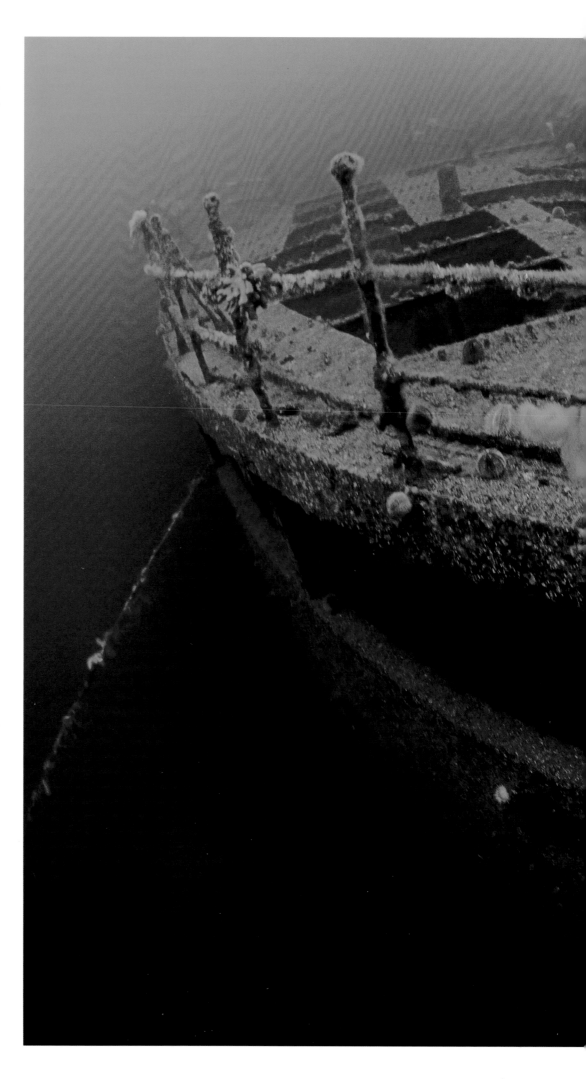

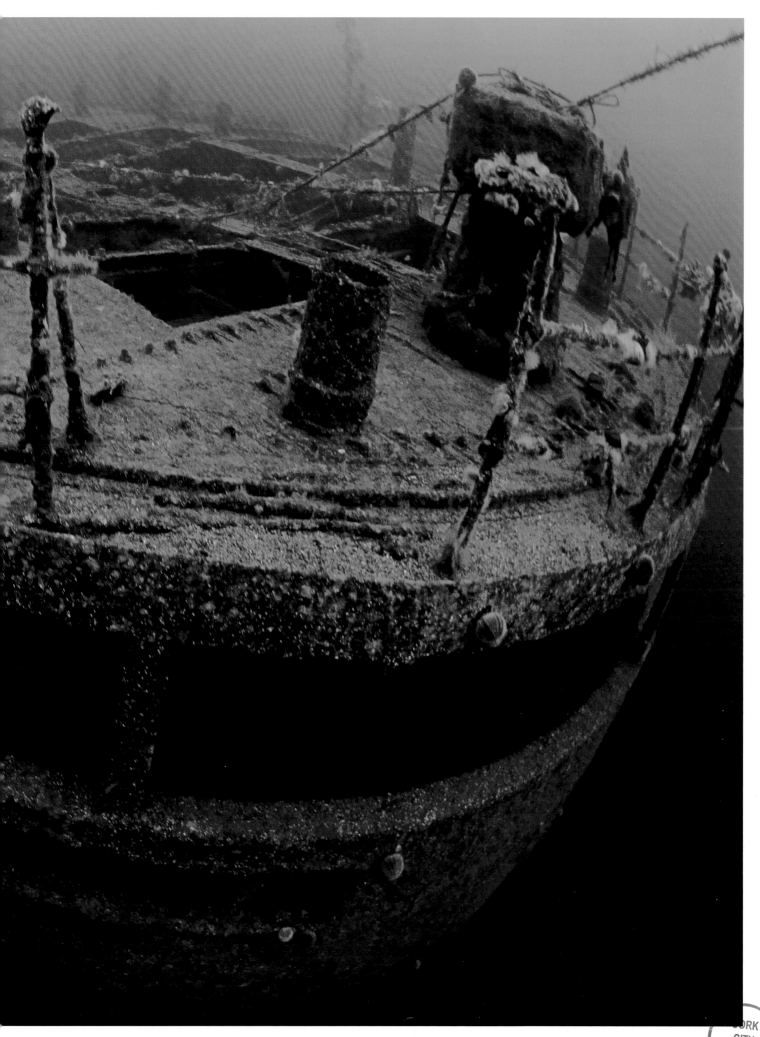

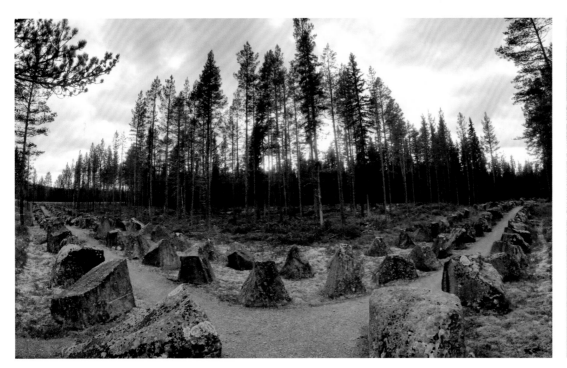

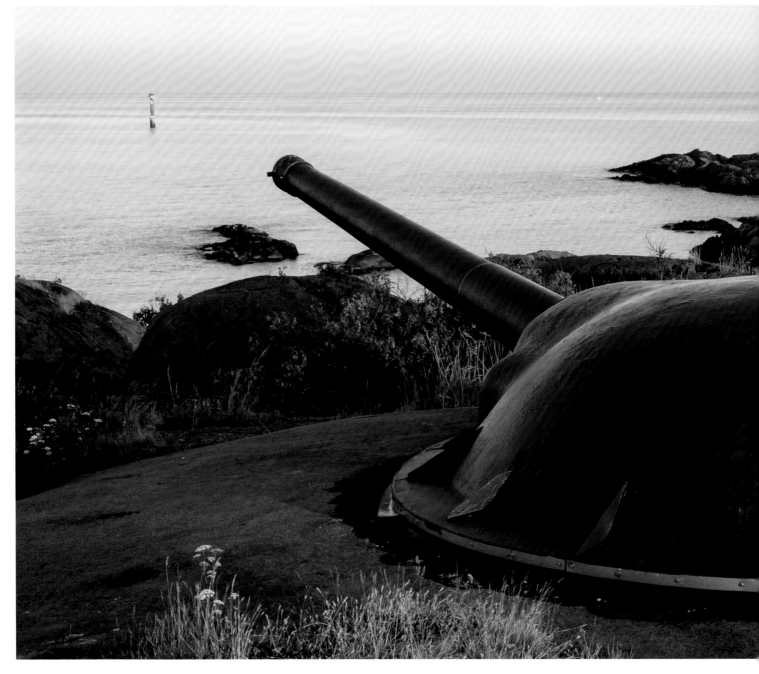

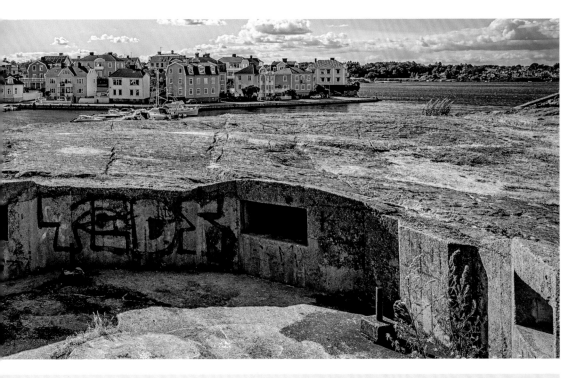

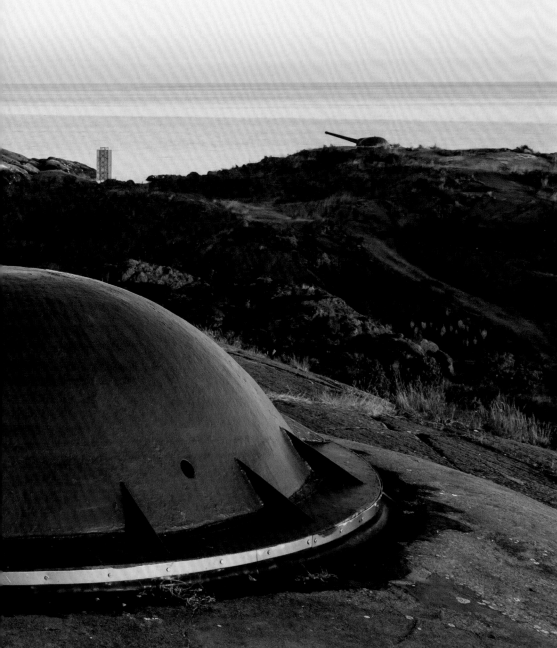

**Anti-tank barriers,
Saerna, Sweden**
Sat like rows of giant teeth, these
rocks were part of the outer
defences of the Swedish Skans
211 fortification system, built
in 1940–45 when the Germans
occupied neighbouring Norway.
The rocks were emplaced to
prevent free movement of tanks.

Bunker, Stackholmen, Sweden
An abandoned World War
II bunker on the island of
Stackholmen, looking towards
Ekholmen, its concrete faces
now an attractant surface for
modern graffiti.

**Landsort Coastal Artillery
Battery, Öja, Sweden**
Although Sweden was a neutral
country in World War II, the
European tensions of the 1930s
and the onset of war in 1939
meant that it took its defence
seriously. Here we see 152mm
caemated guns on the island of
Öja, emplaced during the late
1930s. Öja was the home of
coastal batteries until 2007.

BL 5.5in Mk I naval gun, Skansin Fortress, Tórshavn, Faroe Islands
This solitary piece of British naval firepower was removed from British aircraft carrier HMS *Furious*. The ship was originally launched in 1915 as a Courageous-class battlecruiser, but was heavily modified and repurposed as an aircraft carrier in the mid-1920s. Eleven of these guns were carried aboard the ship.

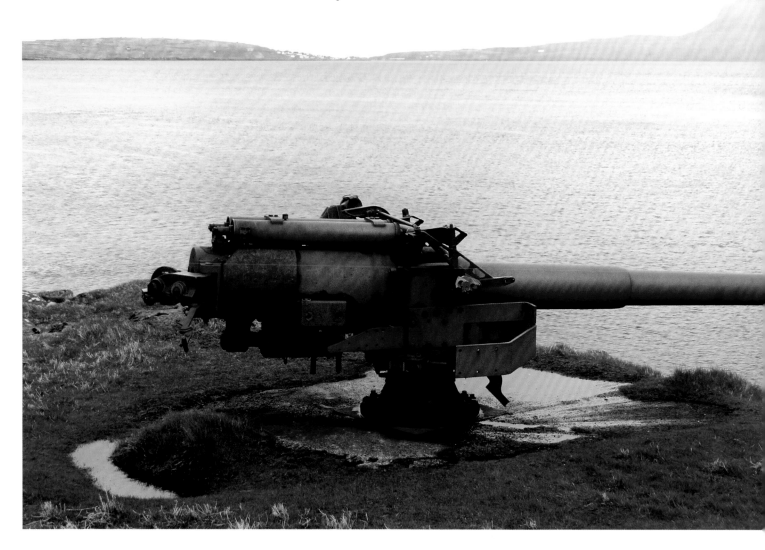

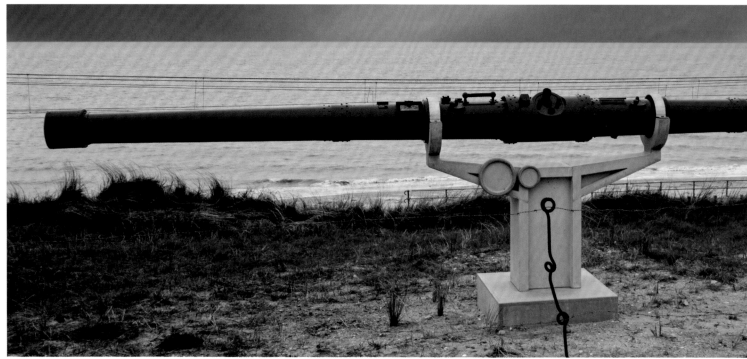

BOTTOM LEFT:

Raversyde *Atlantikwall*, Oostende, Belgium

The picturesque coast at Raversyde, Belgium, features one of the best-preserved sections of Hitler's Atlantic Wall. Here is a German coincidence rangefinder, which used a stereoscopic image and simple triangulation to provide range information for the coastal gun batteries.

BELOW TOP:

Dutch bunker, Grebbeberg, Rhenen, Netherlands

During the 1930s, the Dutch military constructed dozens of defensive positions close to the German border. Illogically, many surrounding trees were left in place, meaning that the positions had reduced fields of fire. The outposts fell quickly to German attack in May 1940.

BELOW BOTTOM:

M26 Pershing, Belgian–German border

The M26 Pershing was amongst the most potent American tanks, although the fact that it did not enter production until November 1944 meant that it was a latecomer in the war. This specimen is the victim of one of countless armour battles as Allied forces pushed into Germany.

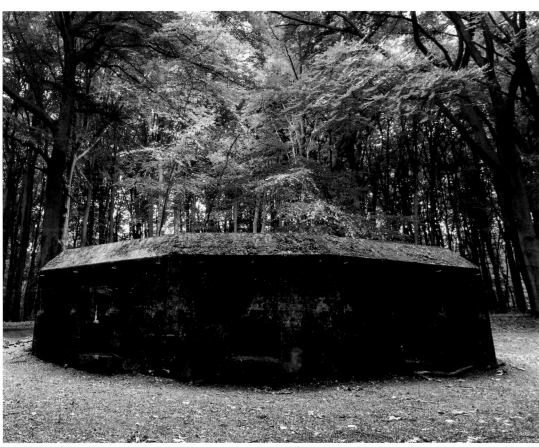

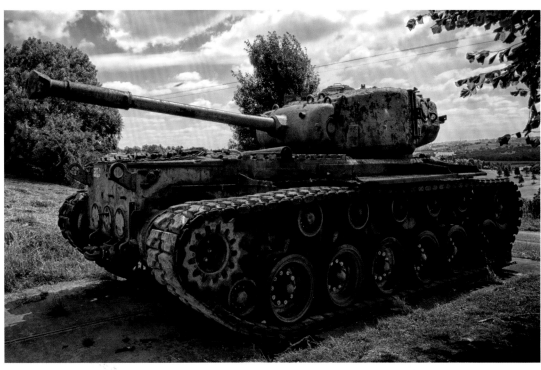

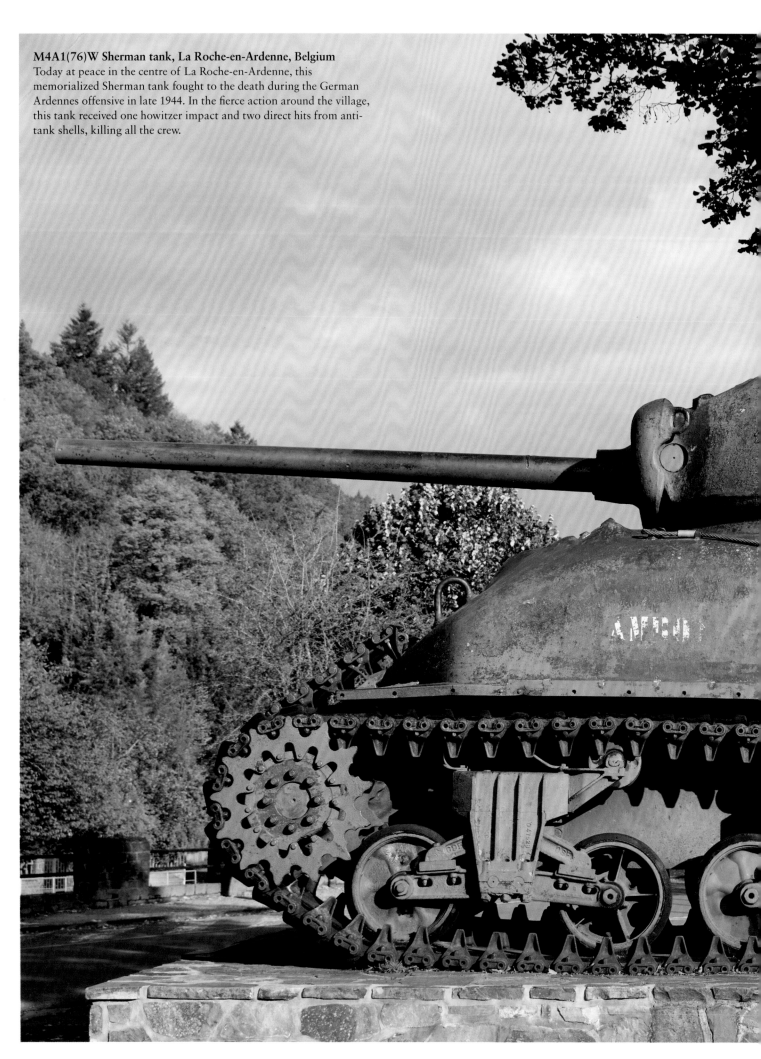

M4A1(76)W Sherman tank, La Roche-en-Ardenne, Belgium
Today at peace in the centre of La Roche-en-Ardenne, this memorialized Sherman tank fought to the death during the German Ardennes offensive in late 1944. In the fierce action around the village, this tank received one howitzer impact and two direct hits from anti-tank shells, killing all the crew.

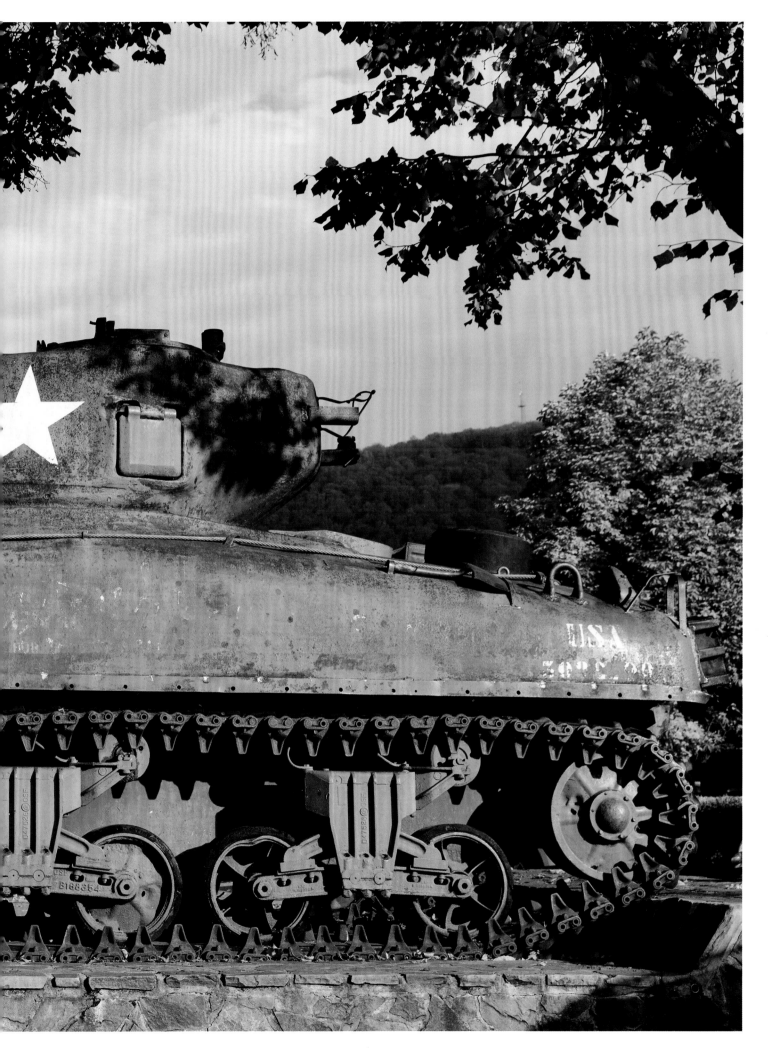

GMC CCKW, Corsica
Known by the nicknames 'Jimmy' or 'Deuce and a Half', the General Motors Company (GMC) CCKW was a 2½-ton 6×6 cargo truck, and the logistical backbone of many US military campaigns in World War II. It was predominantly manufactured in a long-wheelbase format, although there was also a short-wheelbase model. In total, and including all its numerous variants, more than half a million of this vehicle were produced.

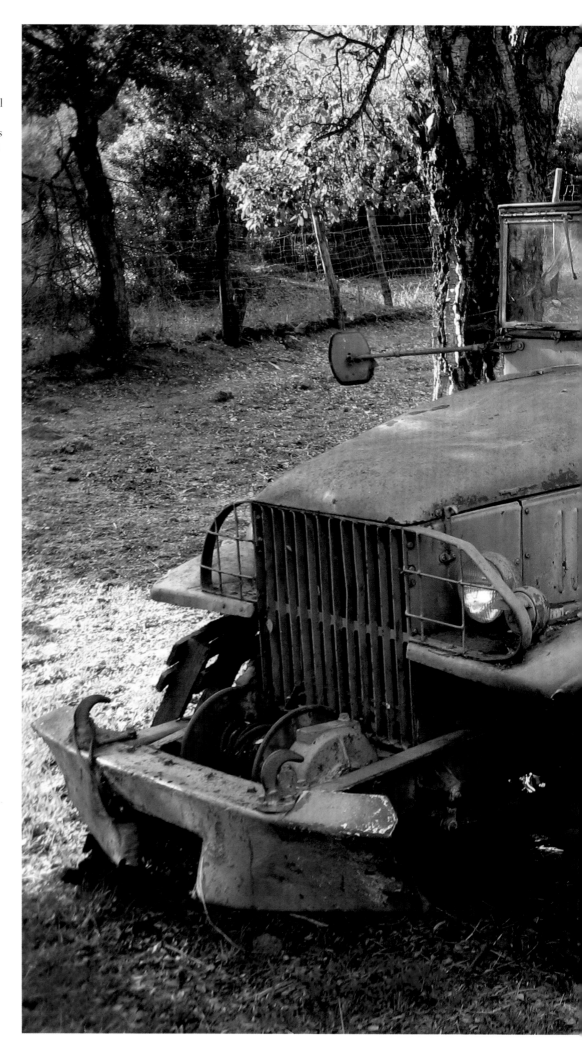

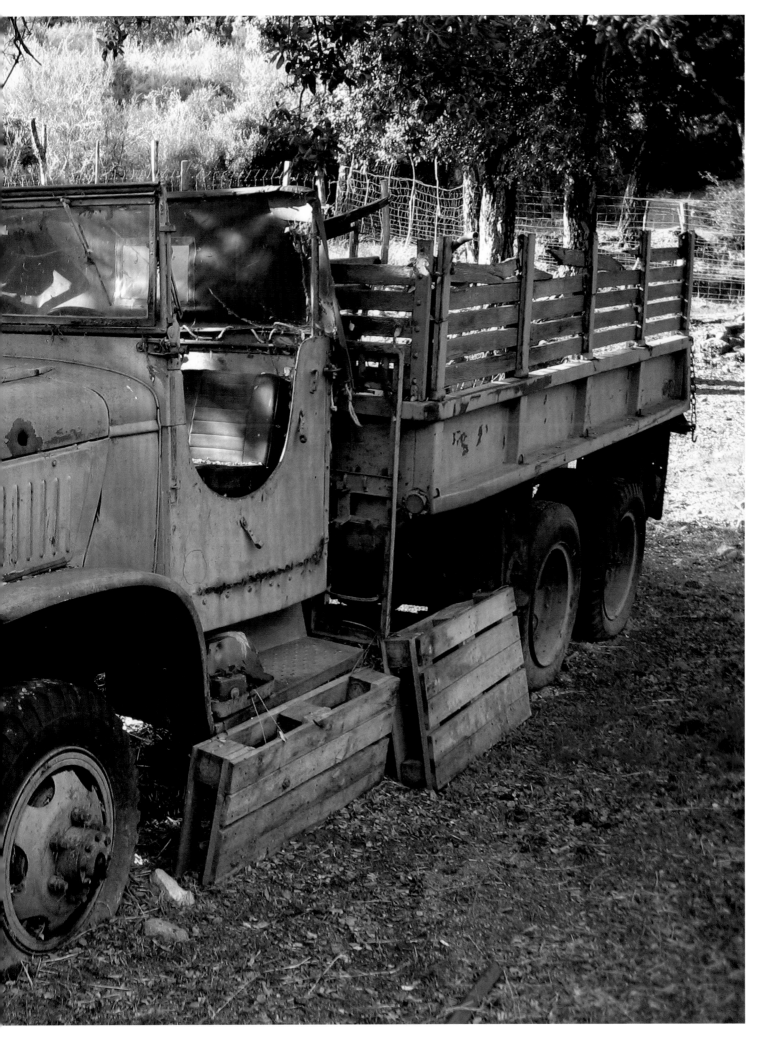

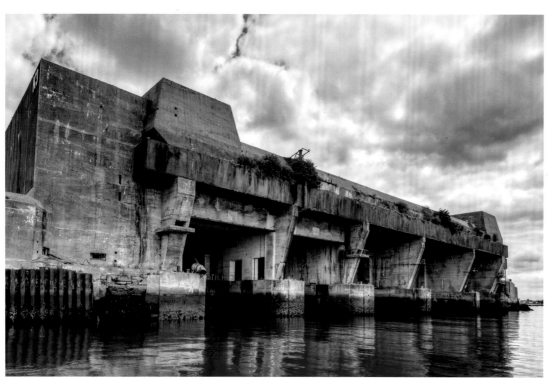

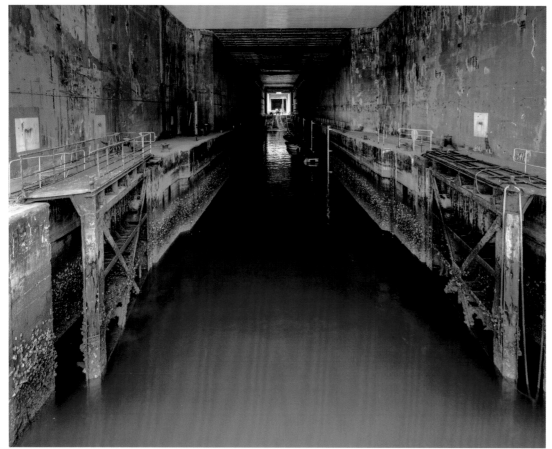

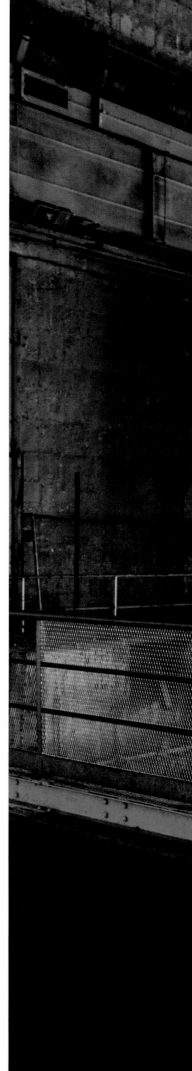

ALL PHOTOGRAPHS:

Lorient Submarine Base, Lorient, France

With the fall of France to the Germans in mid-1940, the *Kriegsmarine* set about establishing protected Atlantic bases for its U-boat fleet. Here we see the formidable Keroman 3 (K3) U-boat pen at Lorient. With wet cells for housing seven U-boats, the K3 pen was virtually impregnable to conventional bombing, courtesy of a roof 7.6m (25ft) thick, including a 1m (3ft) air gap in the middle to disperse explosive force. On 6 August 1944, an RAF bombing raid hit the bunker with a 5454kg (12,000lb) 'Tallboy' bomb, but the structure was not penetrated. Even today the complex of storage cells evoke a sense of physical defiance.

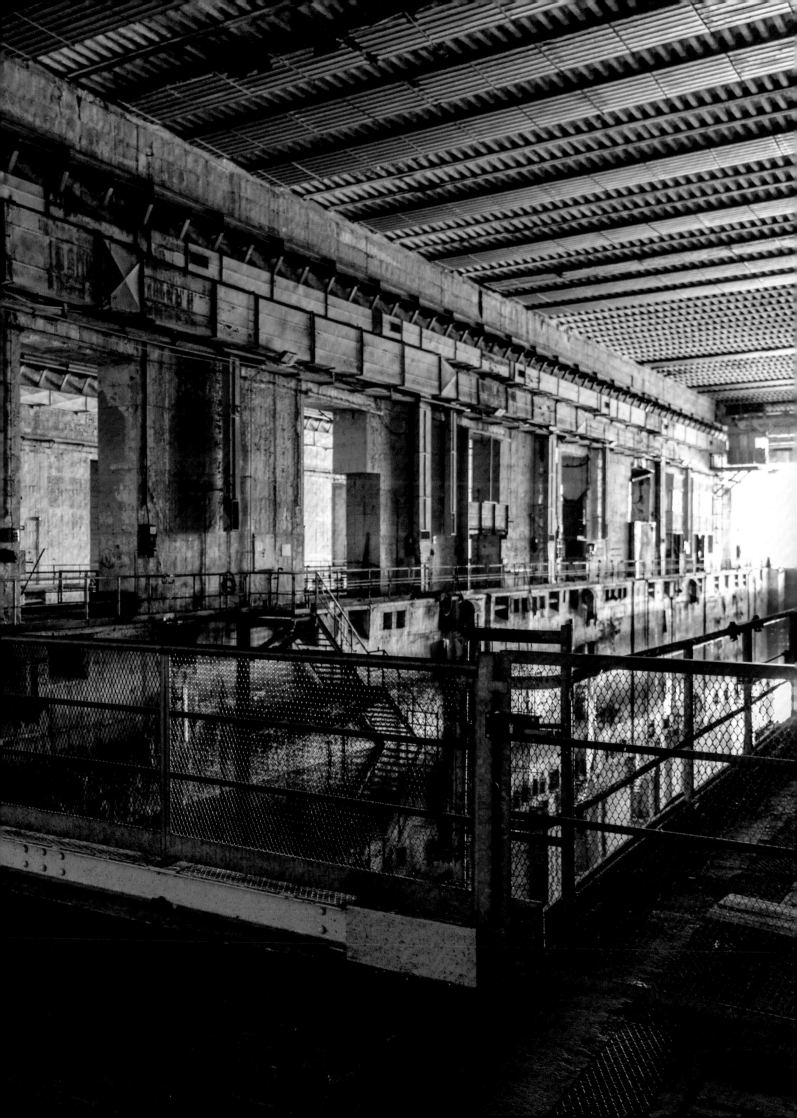

**Messerschmitt Bf 109 fighter,
Île du Planier, France**
Now resting in the beautiful
waters off the Mediterranean coast
of France, this Bf 109 fighter has
become a popular draw for divers.
The aircraft was shot down by an
American P-38 Lightning twin-
engined fighter in March 1944.

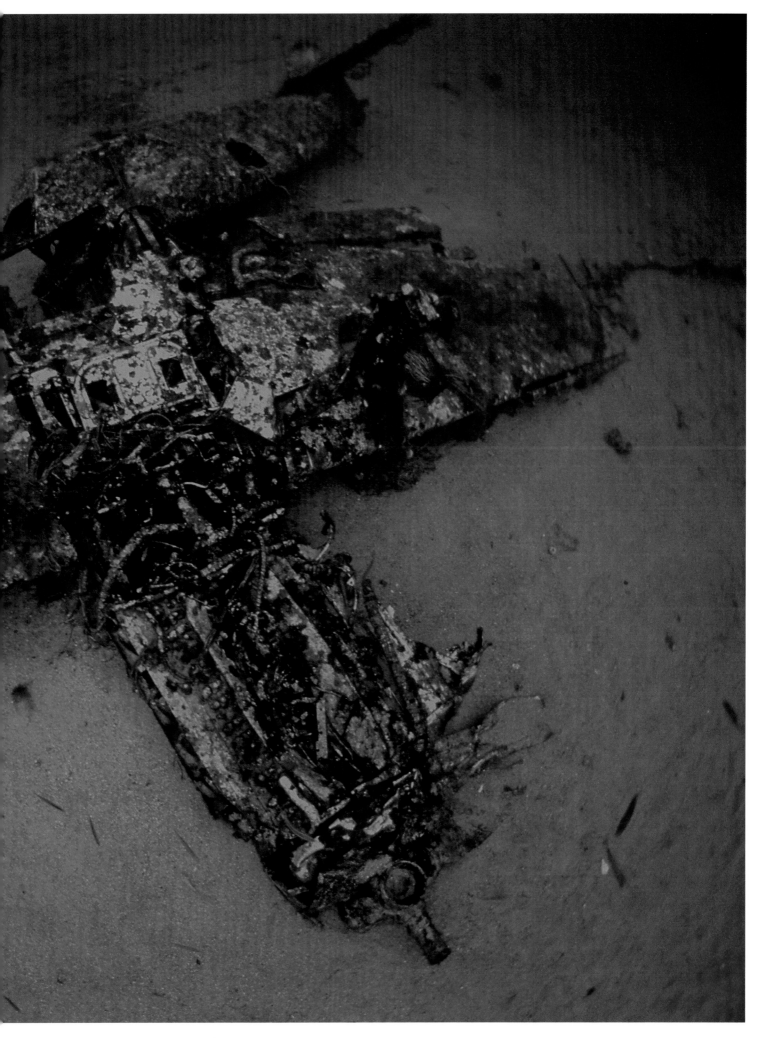

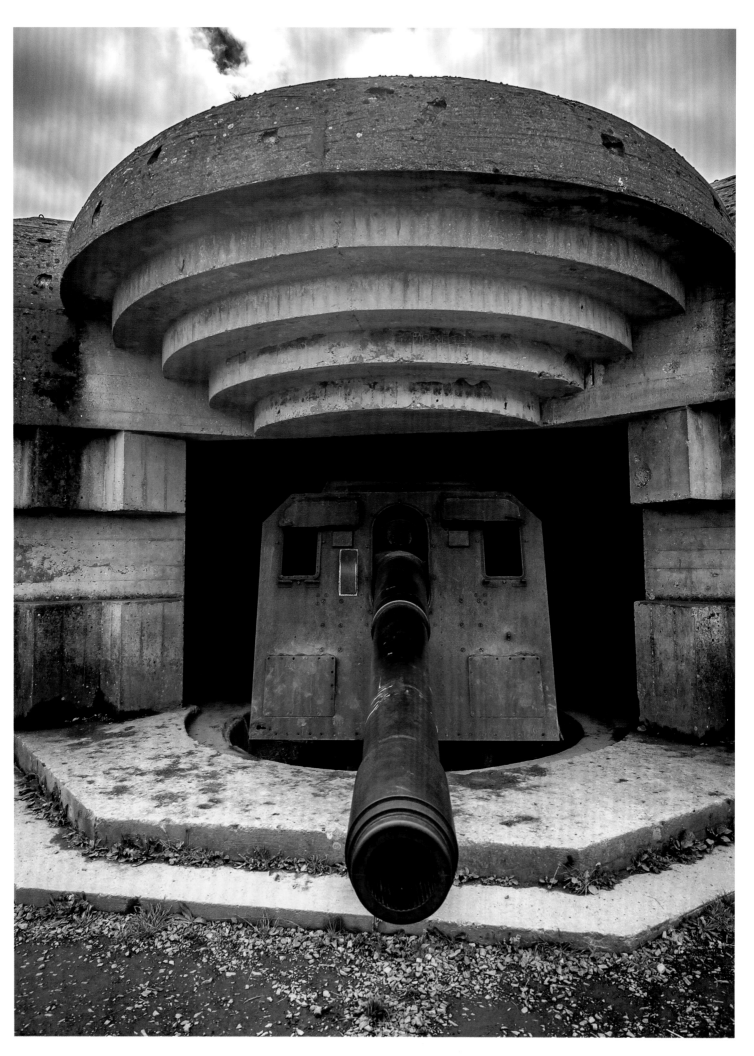

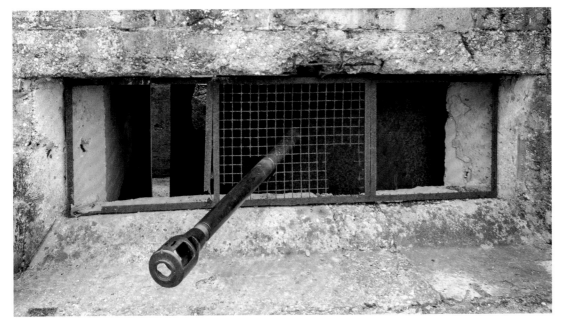

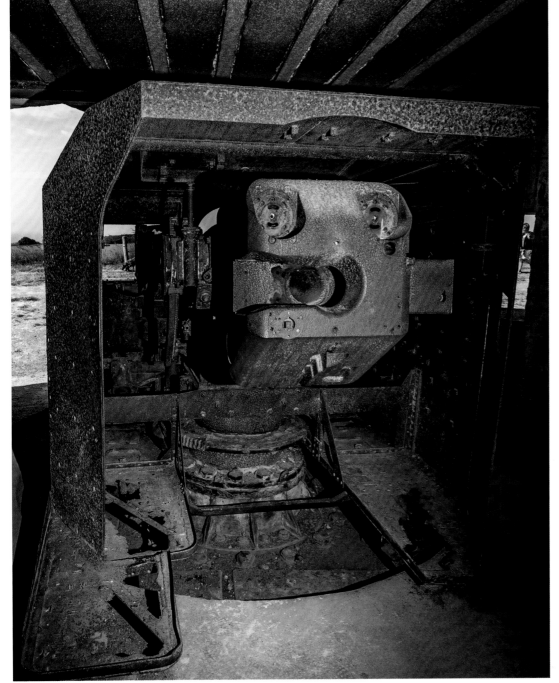

OPPOSITE:

German artillery, Longues-sur-Mer, Normandy, France
Set atop 60m (200ft) cliffs, the German batteries at Longues-sur-Mer were able to deliver exacting fire on both Omaha and Gold beaches during D-Day. Here is one of four 15cm TK C/36 marine guns, set in a type M272 casemate.

LEFT TOP:

5cm PaK, Omaha Beach, Normandy, France
Widerstand (Strongpoint) 665, a Type 667 bunker, still keeps watch over Omaha Beach at Normandy. The barrel visible in the mouth of the casemate is that of a 5cm KwK 39 anti-tank gun, used to engage enemy armour on the beach.

LEFT BOTTOM:

German artillery, Longues-sur-Mer, Normandy, France
The breech end of a 15cm TK C/36 marine gun at Longues-sur-Mer. In the hands of a skilled crew, this weapon could send out shells at a rate of eight per minute, to a range of more than 21km (13 miles).

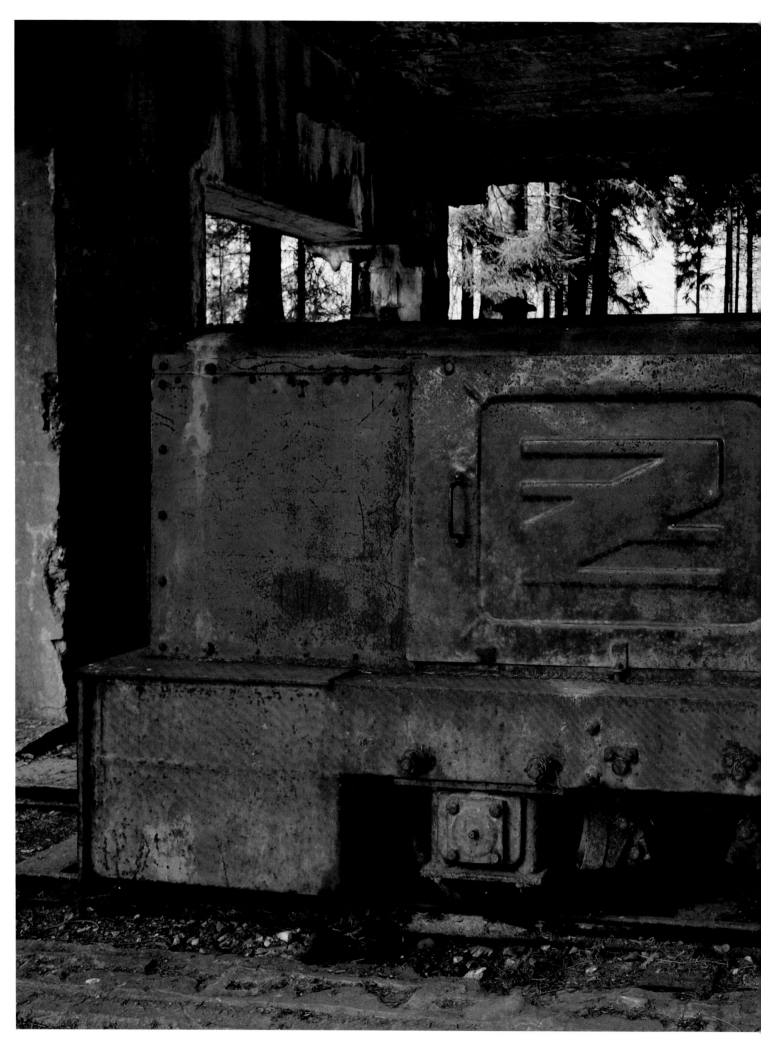

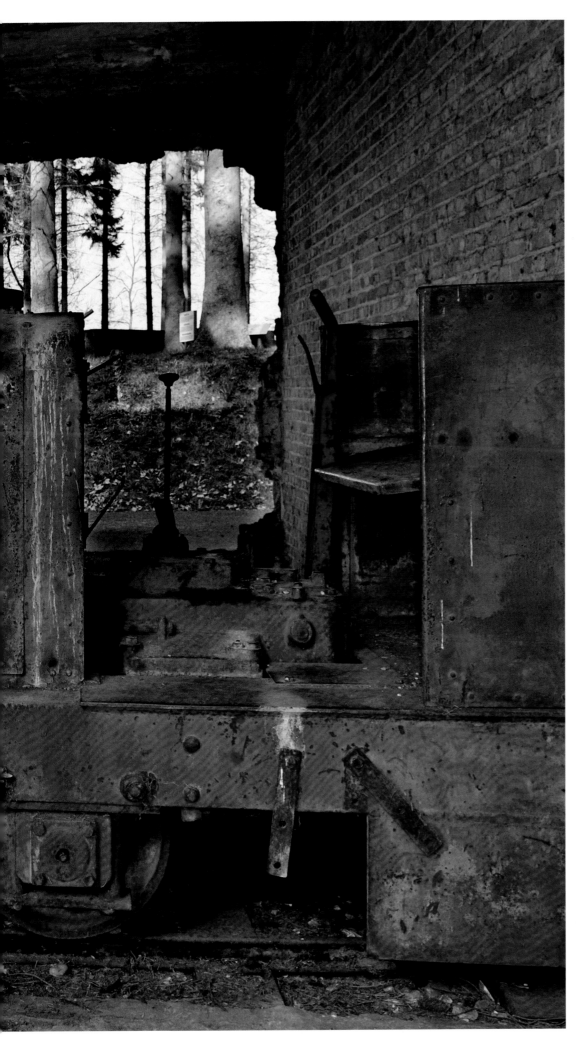

PREVIOUS PAGES:

**Gotha Go 242 glider,
Vercors, France**
Now just a fuselage frame, the
remnants of this German glider are
testimony to a largely overlooked
German airborne action,
conducted in July–August 1944.
Some 200 glider-borne troops, part
of a *c.* 8000-strong German force,
assaulted a major concentration of
French resistance forces around the
Vercors Massif in France, in the
largest anti-partisan operation in
Western Europe.

LEFT:

**V-1 launch site, Val Ygot
d'Ardouval, Normandy, France**
Val Ygot d'Ardouval was amongst
dozens of V-1 flying bomb launch
sites constructed in Western France
in 1943–44. Here we see one of
the transport locomotives, which
pulled the V-1s from storage to
launch pad atop a handling trolley.

OVERLEAF (BOTH PHOTOGRAPHS):

**Fort Sainte-Agnès, Alpes-
Maritimes department, France**
Here we have interior views of
the beautifully preserved Ouvrage
Sainte-Agnès, an elevated defensive
position constructed in south-
eastern France between November
1931 and October 1934. Above
ground there were multiple
reinforced concrete machine-gun
and artillery strongpoints,
while below ground there was
more than 2000 square metres
(22,000 sq ft) of operating space
for the garrison.

**Pontoon, Arromanches,
Normandy, France**
Beached and rusting, this unusual
structure is actually one of the
huge pontoons that supported
roadways running to shore
from the Allied 'Mulberry'
harbour, which was constructed
as temporary port facilities to
support the D-Day invasion.

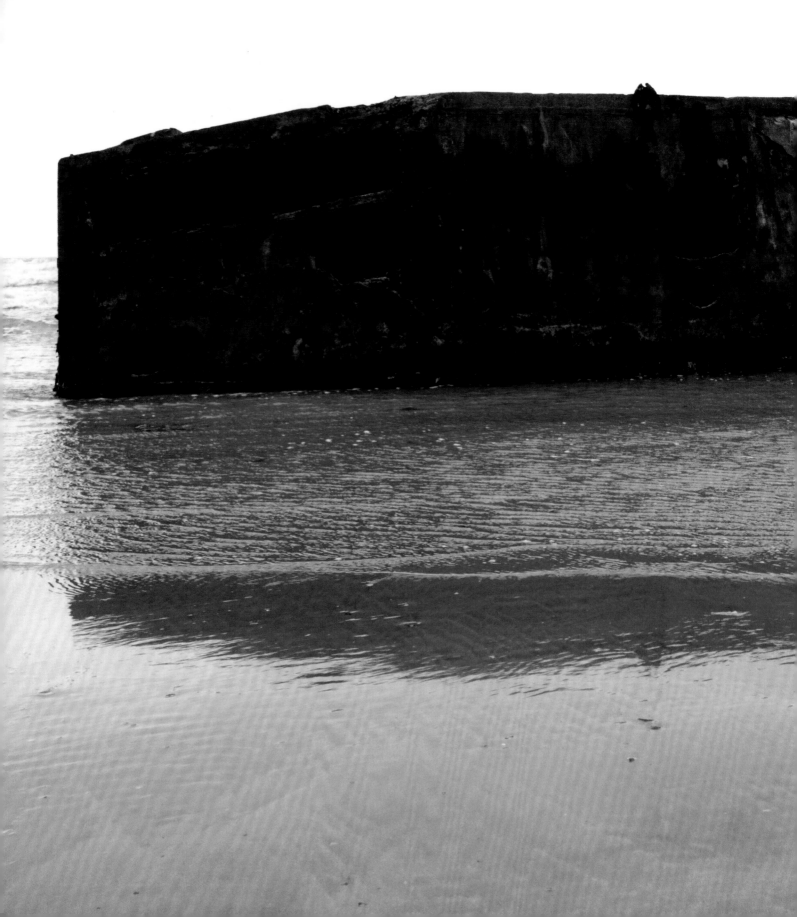

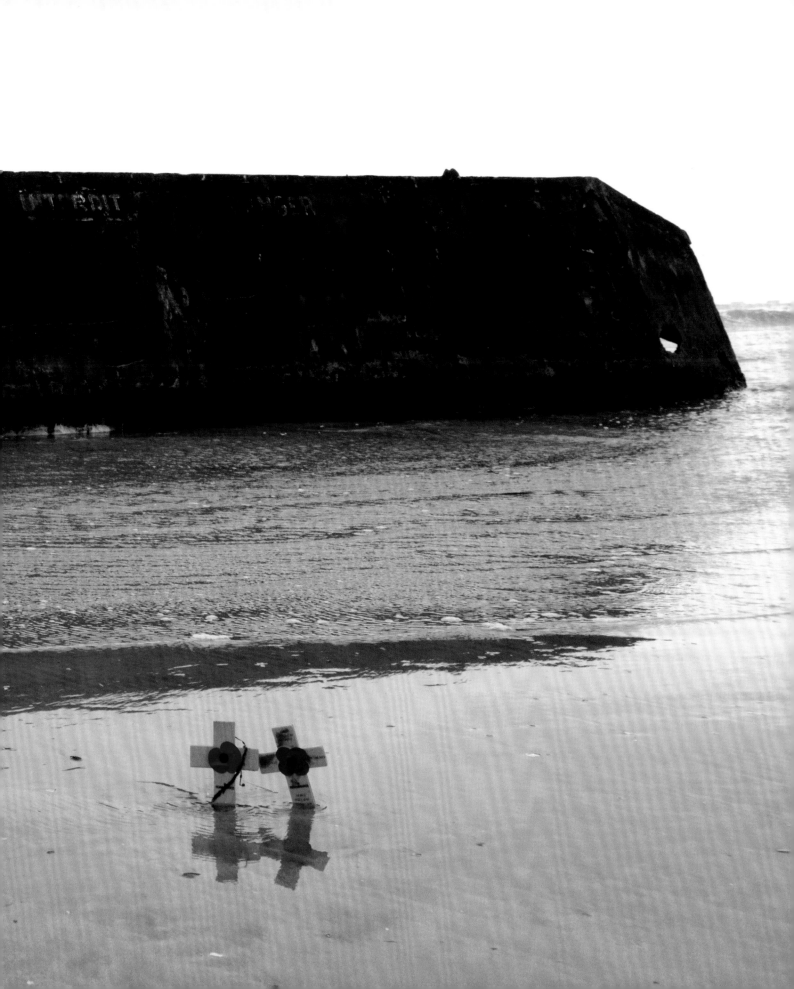

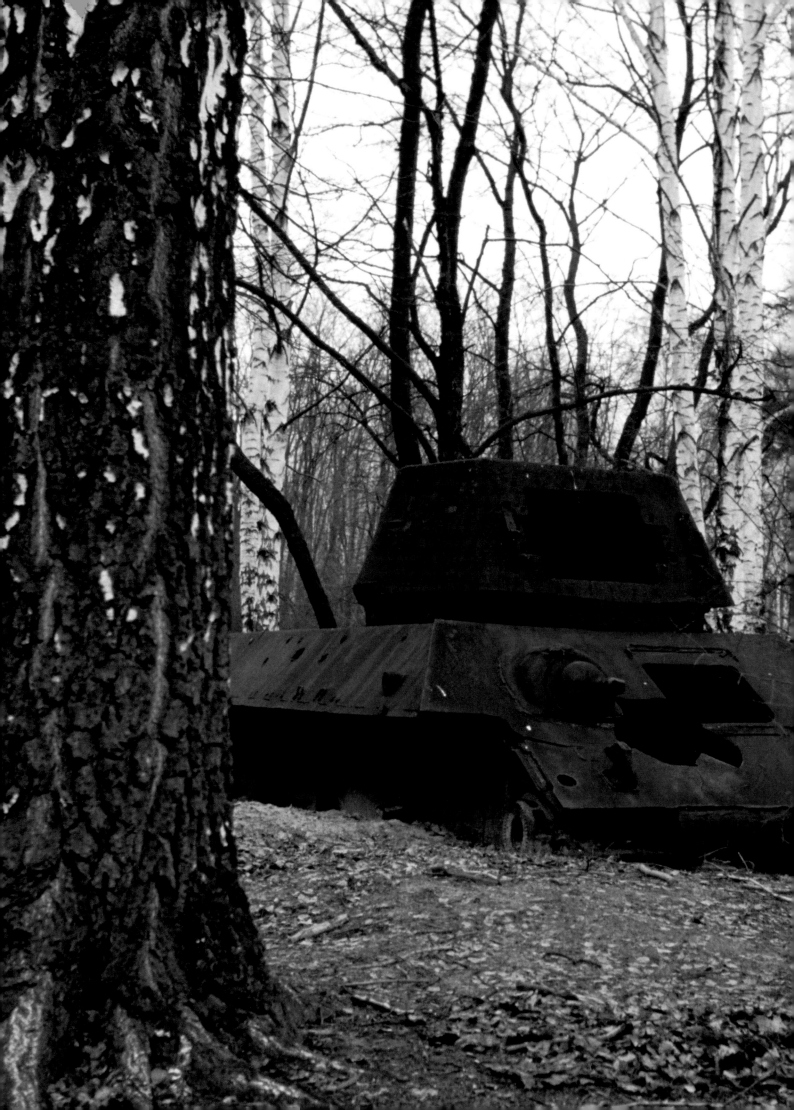

T-34, Ruhleben, Berlin, Germany
Ghostly amid autumnal trees, the remains of a Soviet T-34 is found at Ruhleben, on the western side of Berlin. The Soviet army lost up to 2000 armoured vehicles in the battle for the city in 1945.

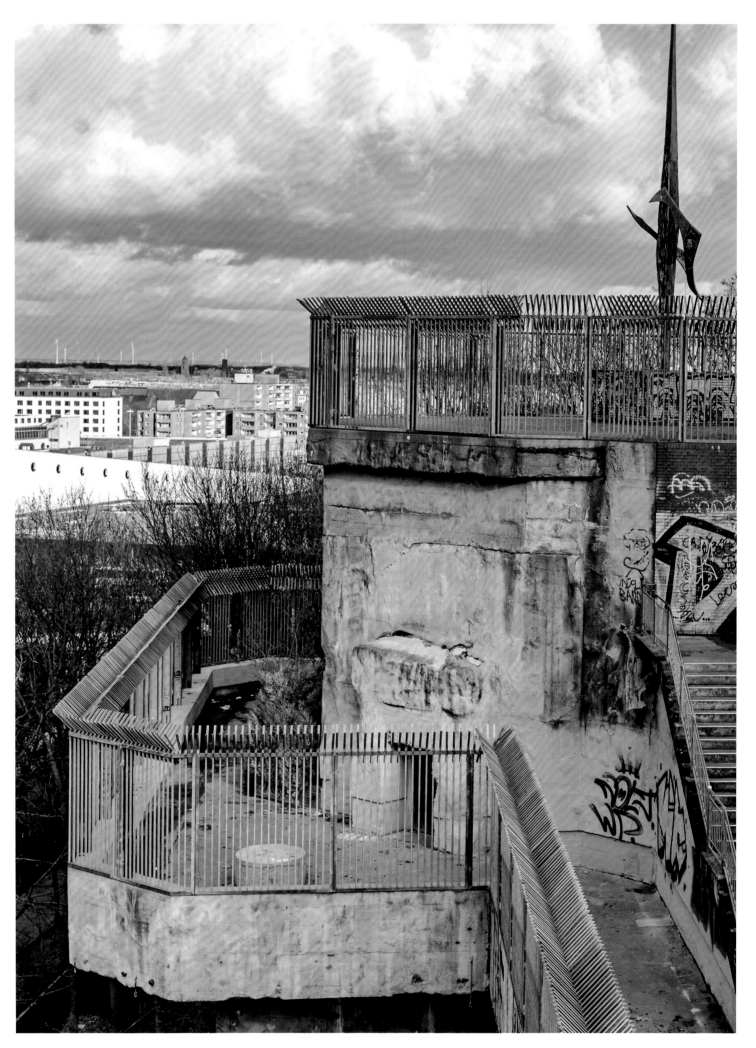

OPPOSITE:
Flak tower, Berlin, Germany
Flak towers were enormous elevated reinforced concrete platforms for anti-aircraft guns, constructed from 1942 in several of Germany's major cities. Berlin received eight such towers, in which thousands of civilians spent shivering, terrified nights suffering Allied strategic bombing.

BELOW:
Anti-aircraft gun position, Wadden Sea National Park, Lower Saxony, Germany
Many of the remains of World War II are scarcely recognizable. This section of suspended concrete is all that is left of an anti-aircraft gun position that fired out over the North Sea, defending the ports and cities of Lower Saxony against Allied air raids.

BOTTOM LEFT:
Mortar shells, Lebus, Brandenburg, Germany
To this day, Germany is littered with the rusting detritus of a world war, often unearthed in forgotten patches of earth, once the sites of extraordinary personal battles for survival. Here are three mortar bombs, still dangerous ordnance after more than seven decades in the ground.

BOTTOM RIGHT:
Cartridges, Stockstadt, Germany
These machine gun cartridges were actually recovered from the wreck of a US combat aircraft, downed over Stockstadt in Bavaria during the later years of the war.

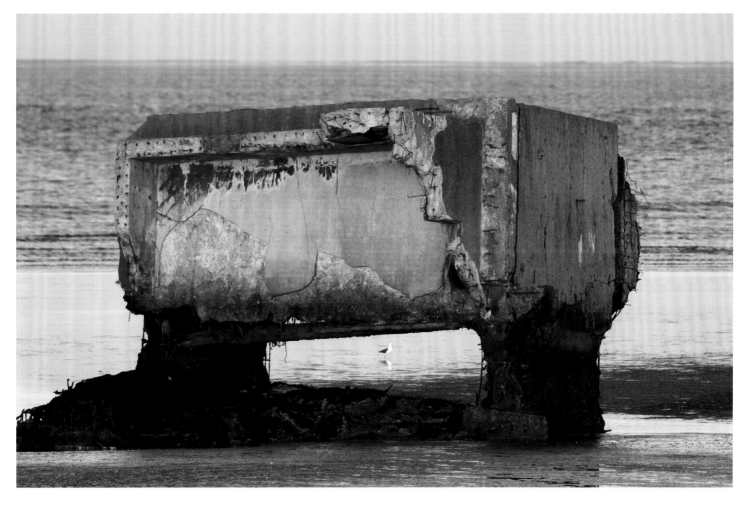

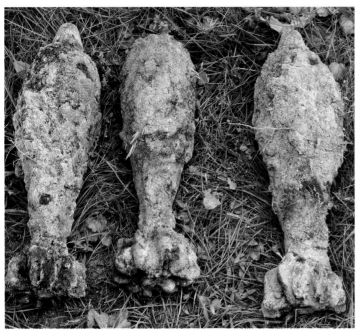

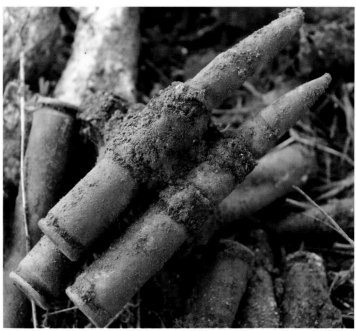

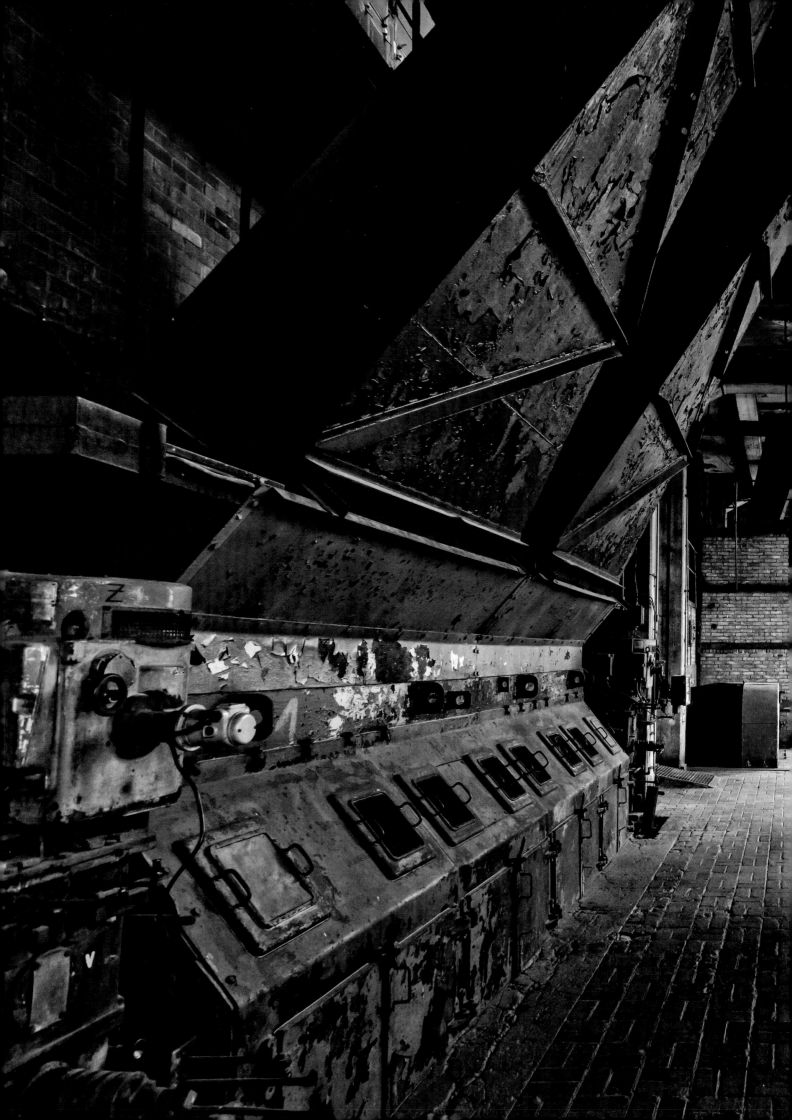

Rocket production workshop, Peenemünde, Germany
World War II transformed the village and seaport at Peenemünde on the Baltic coast into a hub for research into advanced weaponry, specifically the V-2 ballistic missile. Peenemünde was originally intended as the manufacturing facility for the V-2, but the Allied Operation Hydra bombing raid in 1943 prompted the Germans to move production to the underground *Mittelwerk* (Central Works) in the Kohnstein, Thuringia.

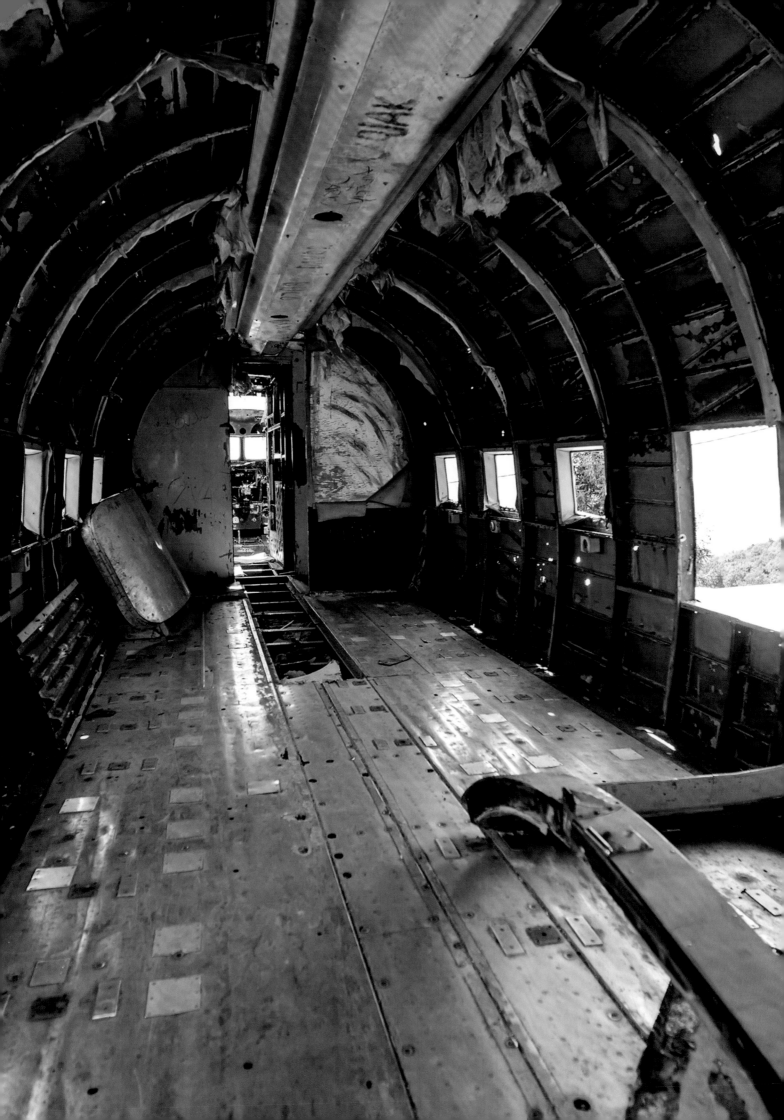

Eastern Europe

The scale of fighting on the Eastern Front still beggars belief. In terms of military casualties alone, the Soviets suffered 8–10 million combat deaths, while the Germans lost 4.3 million dead in the theatre (as opposed to about 830,000 deaths in Western Europe); to the German casualties we can add upwards of 1 million POWs dying in Soviet POW camps following the end of the war. Compounding the tragedy exponentially is the civilian cost to the Soviet Union – estimated civilian deaths range from about 14 to 17 million. But the grinding mill of war in Eastern Europe was not just confined to the Soviet Union. The former Yugoslavia, for example, took *c*. 1 million war dead, largely through four years of the most internecine partisan warfare, and Poland lost 6 million citizens, about one in five of its pre-war population.

Such a regional apocalypse has left its scars on both the psyche and the landscape of Eastern Europe. Derelict tanks are to be found everywhere, whether pristine and polished in city centres or rusting and lost in marshes and woods. The ubiquity of such relics is unsurprising given that the Soviet Union lost 120,000 armoured vehicles during the war. The major battlefields also yield thousands of smaller items of weaponry and equipment, often alongside the bodies of the men who used them. A group of Soviet battlefield diggers working near the town of Lyuban, 80km (50 miles) south of St Petersburg, have found more than 2000 Soviet and German bodies in an area of just 10 square kilometres (3.8 sq miles). Indeed, across Russia, volunteer groups have found and reburied 500,000 war dead, reminding us that the artefacts speak of unmeasurable human suffering.

OPPOSITE:
Dakota DC-3,
Otocac, Croatia
The DC-3 was the workhorse of Allied aerial logistics, and served in almost every theatre. The aircraft was used to perform airbridge and supply missions to partisan forces in the former Yugoslavia.

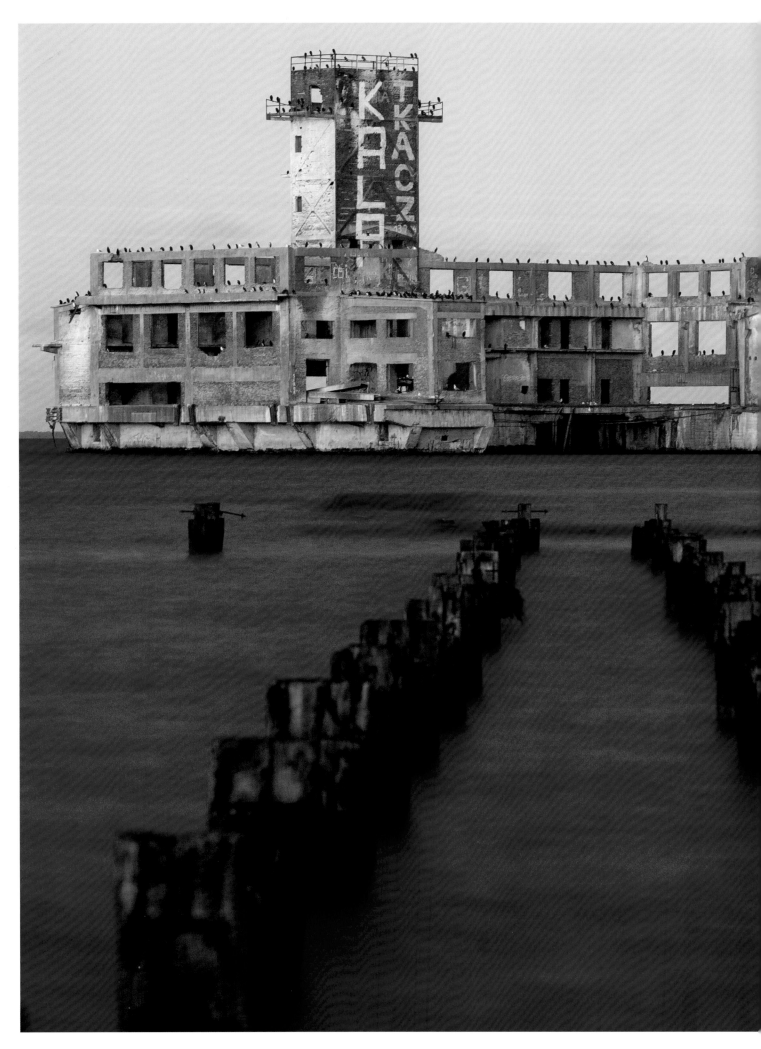

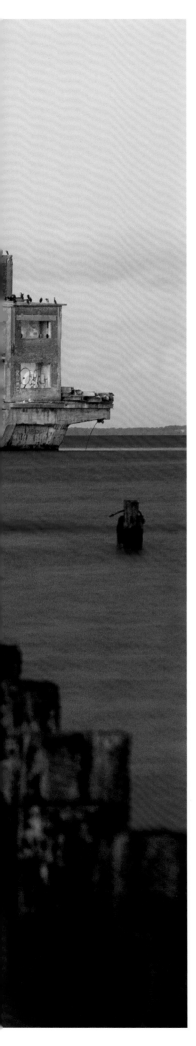

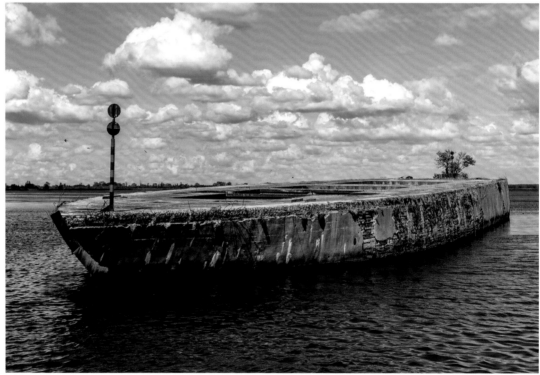

LEFT AND ABOVE TOP:

Torpedowaffenplatz Gotenhafen – Hexengrund, Poland

This unusual structure in the Gulf of Danzig is a German torpedo test facility, constructed in 1942. Dominated by its central observation tower, the building featured two torpedo launch shafts; the torpedoes tested were inert, and caught in nets following their launch.

ABOVE BOTTOM:

Concrete ship, Lake Dabie, Poland

From June 1942, a special German committee began to explore the possibility of constructing supply ships from concrete to save dwindling supplies of steel. This one is the tanker *Ulrich Finsterwalder*, wrecked by Soviet bombing in March 1945 but subsequently raised.

OVERLEAF:

T-34/85, Kłodzko, Poland

Many historians see the T-34/85 as one of the finest all-round tanks of World War II. Responding to the superior firepower of much German armour, Soviet engineers in 1943 upgraded the T-34's 76mm gun to a high-velocity 85mm weapon, without compromising the tank's overall mobility.

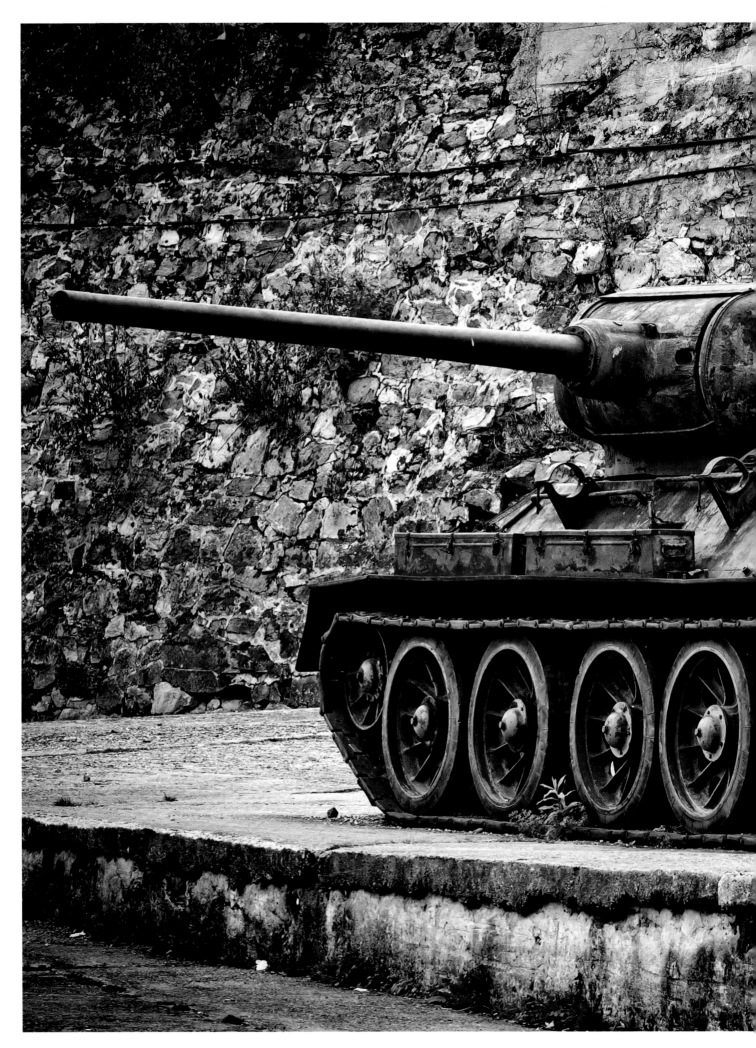

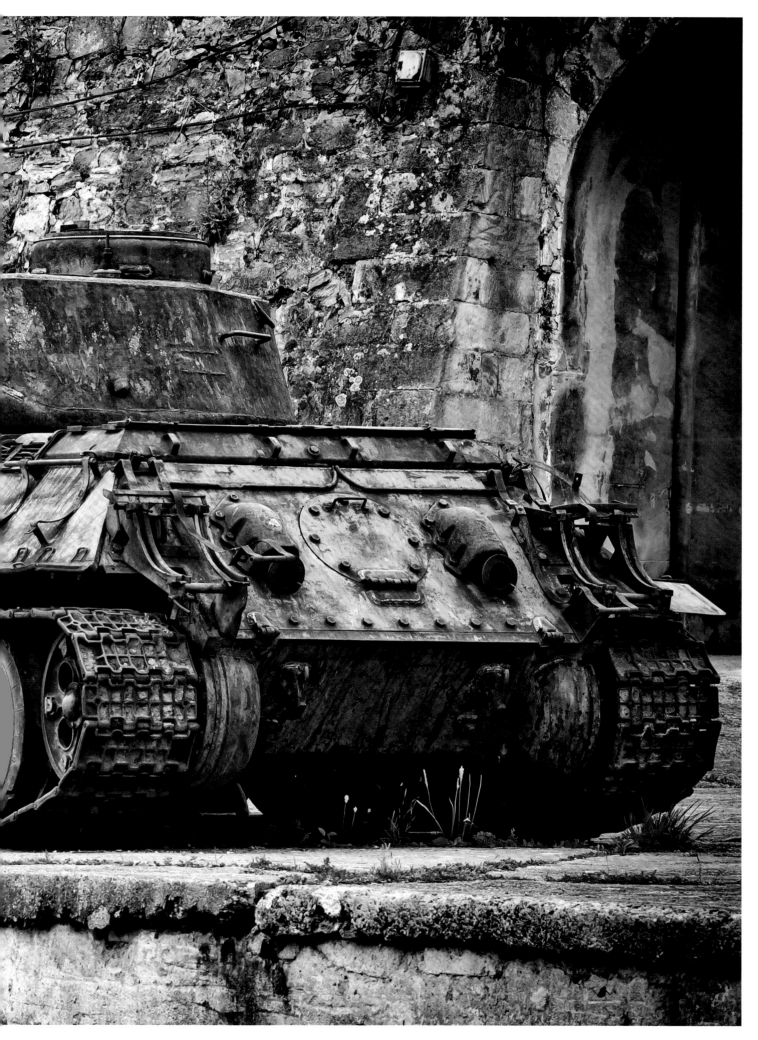

130mm (5.11in) cannon, Gdynia, Poland
The Poles constructed some formidable stretches of defensive positions around the coast and borders of Poland during the 1930s. Although these did not prevent the country falling to the Germans in 1939, some positions did hold out with exceptional tenacity. The weapon here is a 130mm/50 B13 Pattern 1936, a Soviet-made naval weapon.

Lavochkin La-7, Klimkovice, Czech Republic
Military archaeologists unearth the remains of a Lavochkin La-7, a single-seat Soviet fighter. Although the aircraft served principally with the Soviet Air Force, limited numbers were also exported to the Czechoslovak Air Force in 1945.

V-2, Blizna, Poland
Blizna, a remote village in south-eastern Poland, was the location for an SS rocket-testing base from November 1943 to July 1944. During this period, the SS conducted no fewer than 139 V-2 test launches, and here we see the remains of one such missile. The launch site was established as a safer location following the Allied bombing of the facility at Peenemünde, Germany.

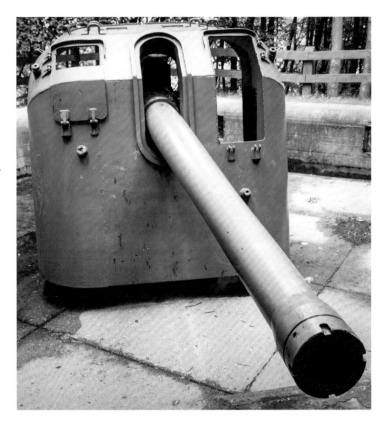

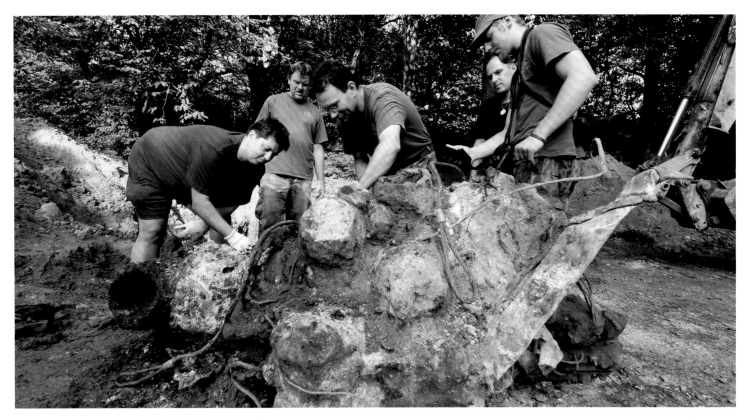

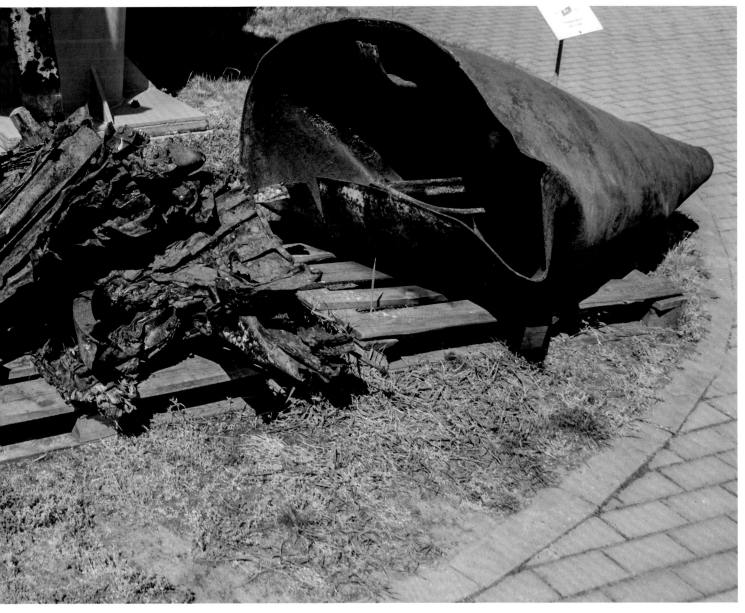

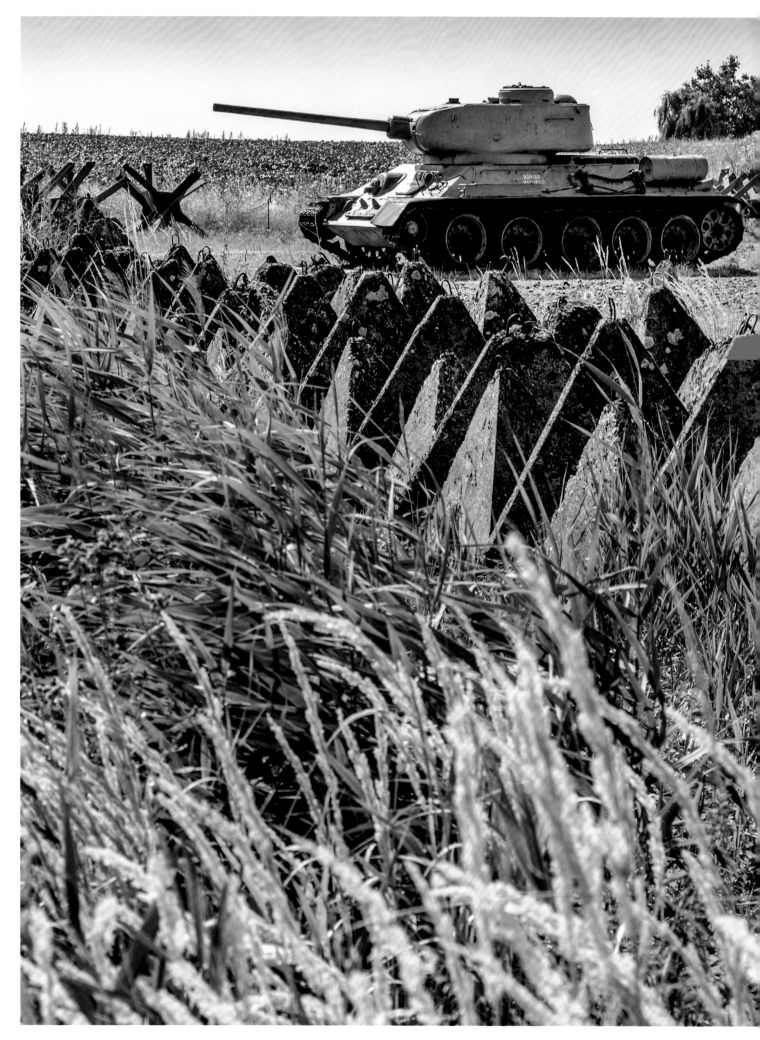

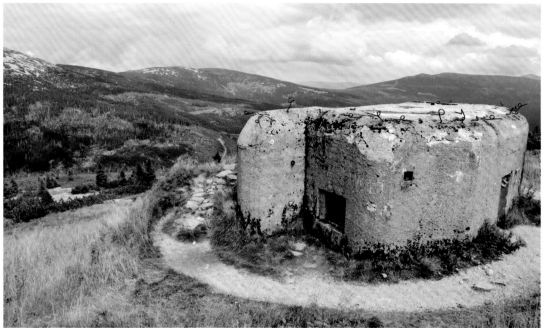

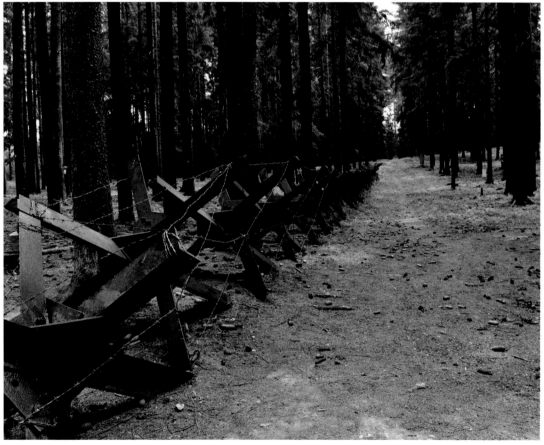

LEFT:

Fortifications, Hlucín, Czech Republic

The fortifications at Hlucín in the Czech Republic are yet another example of European defensive thinking in the 1930s, these being constructed between 1935 and 1938. Framing a T-34 tank, here we see a blockhouse (top right) and a series of tank traps.

ABOVE TOP:

Bunker, Bush-Krkonoše, Czech Republic

The mountainous borderlands between Czechoslovakia and Poland offered good terrain for elevated defensive positions. This Czech Army hilltop bunker was likely built during the 1930s, in what is today the Krkonoše Mountains National Park.

ABOVE BOTTOM:

Anti-tank barricades, Slavonice, Czech Republic

These anti-tank traps, made from welded steel girders, were universally known as 'Czech hedgehogs', on account of the fact that they were first used on the Czech–German border during the fortification of that region by the Czechs in 1935–38.

IS-2 tank, Lesany, Czech Republic

The IS-2 was one of the few Soviet tanks that could go toe-to-toe with high-end German armour such as the Tiger or Panther. Wrapped in thick armour that took its weight up to 46 tonnes (46 tons), it was armed with a potent 122mm D-25T gun. Its main limitation was its ponderous speed and also a slow rate of loading on the main gun.

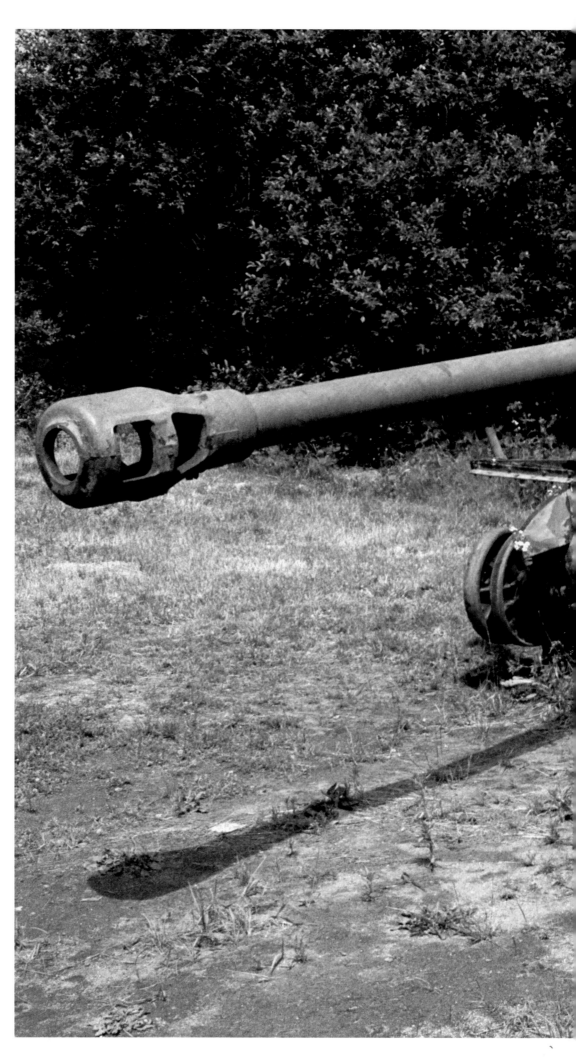

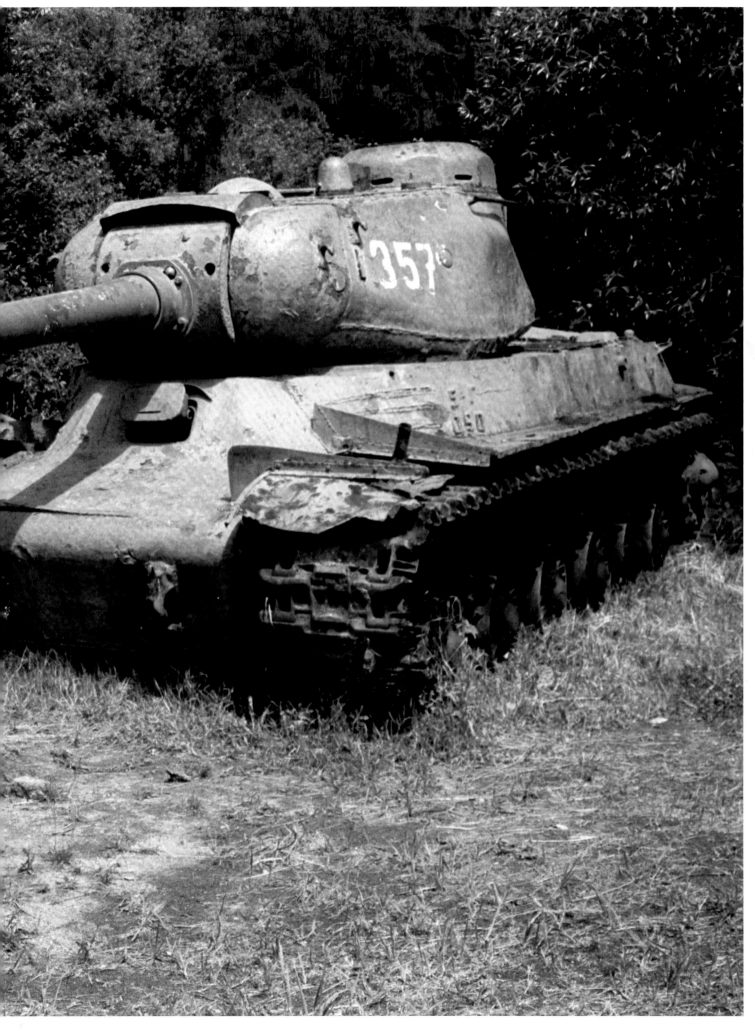

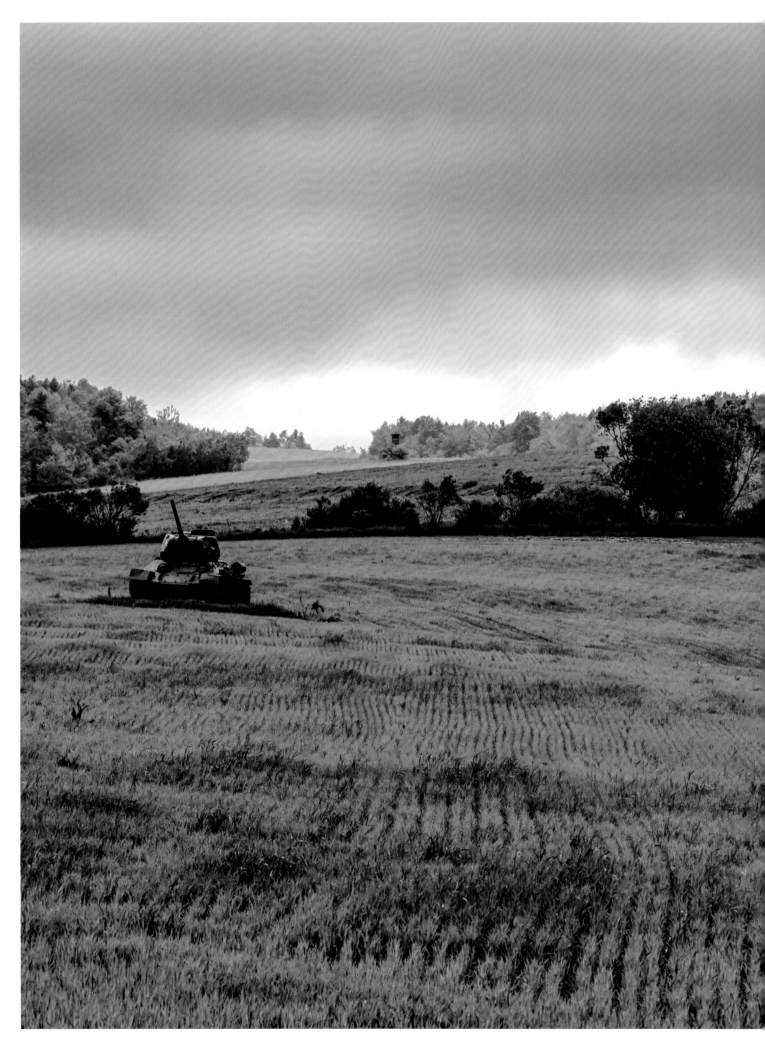

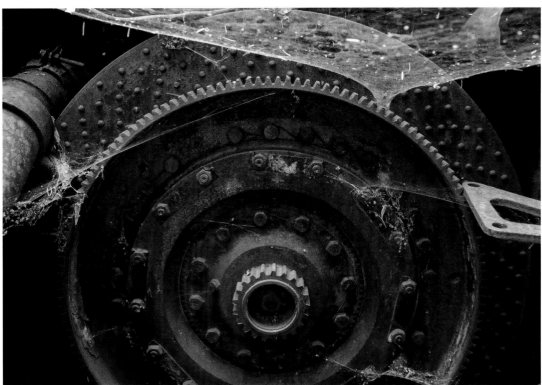

LEFT:

T-34, Dukla Pass, Slovakia
The Dukla Pass on the Polish–
Czech border was the site of a
major battle between German
defenders and advancing Soviet
forces from 8 September–28
October 1944. This lonely T-34
is a memorial to an oft-forgotten
clash that cost 70,000 casualties.

ABOVE (BOTH PHOTOGRAPHS):

T-34 parts, Dargov, Slovakia
In the aftermath of World War II,
military vehicle parts often ended
up rusting in farm outbuildings on
the edges of fields and farmland.
These innocuous-looking pieces of
hardware are actually the flywheel
(top) and headlamp casings of a
Soviet T-34 tank.

OVERLEAF:

Coastal gun, Vis, Croatia
A derelict coastal gun position
looks out over the shimmering
waters of the Adriatic Sea. During
the war, the island was used as
a base by Yugoslavian partisans,
the British No.2 Special Service
Brigade and even some US Army
Rangers.

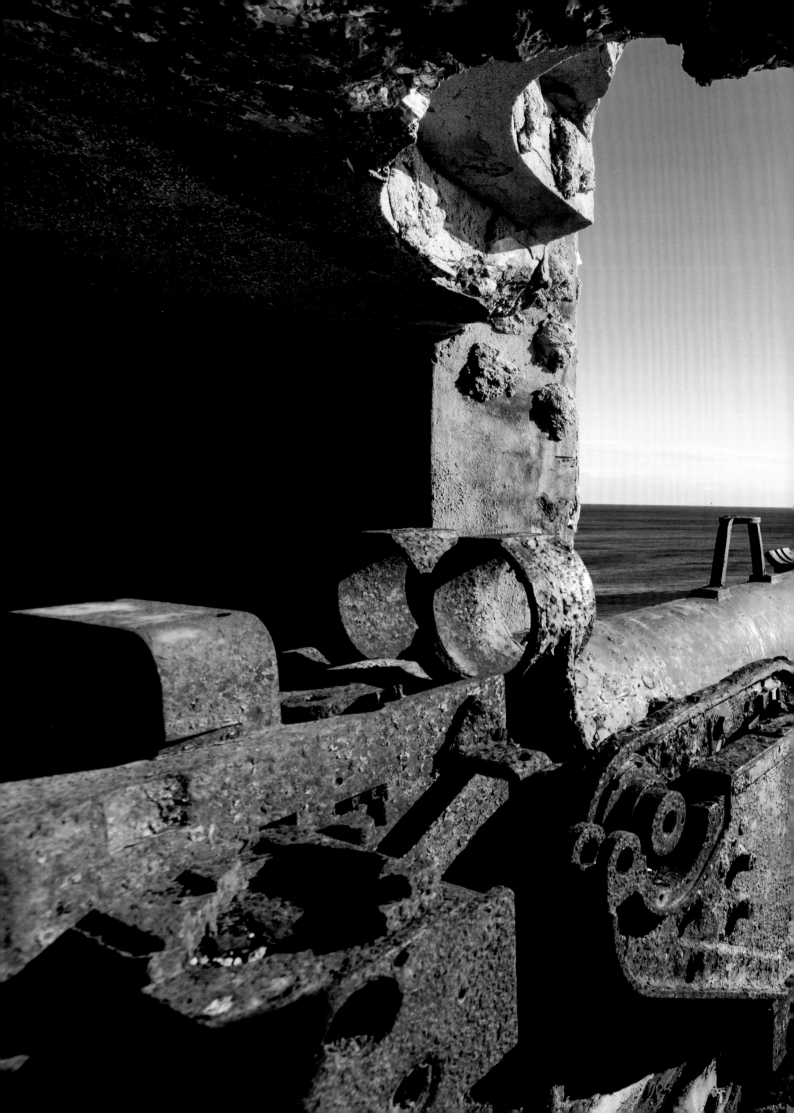

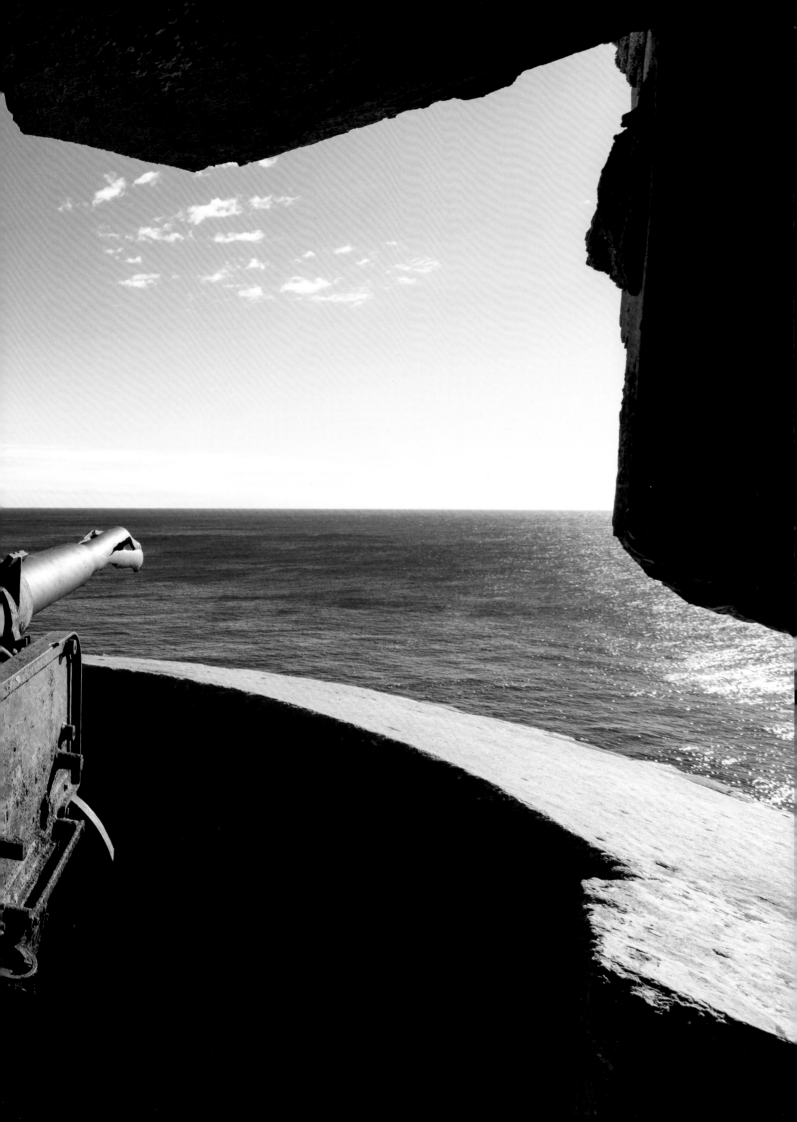

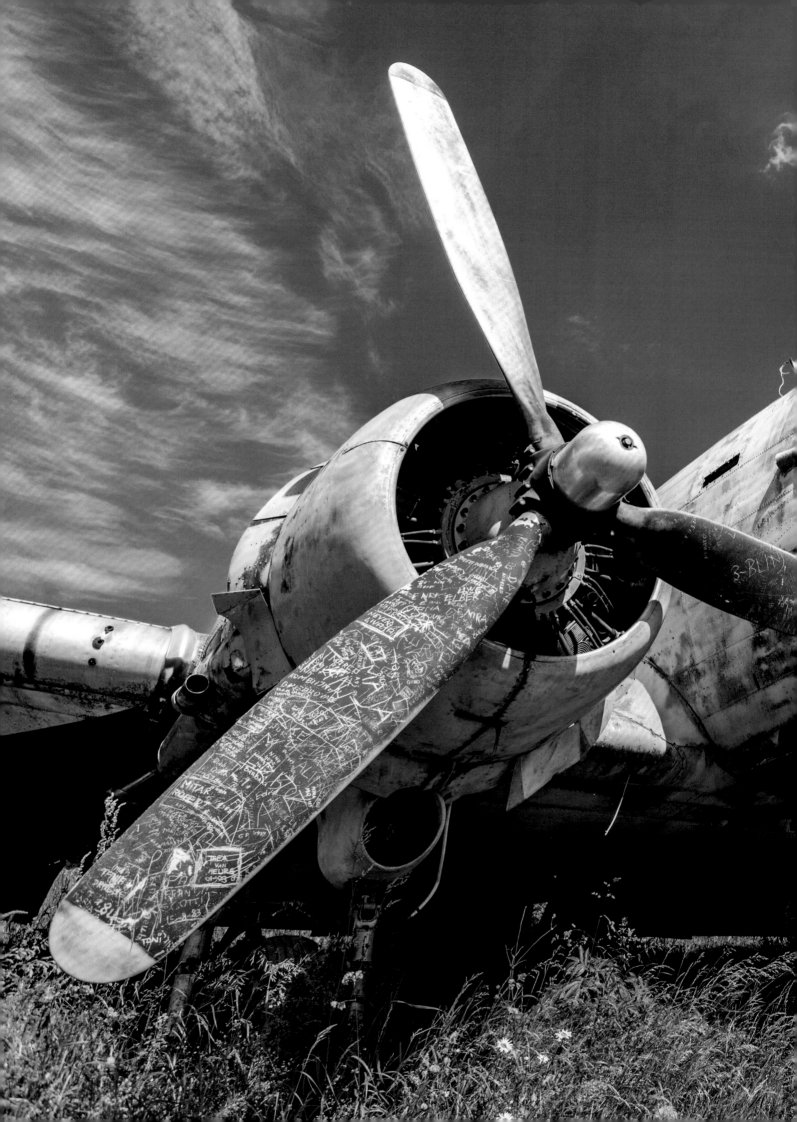

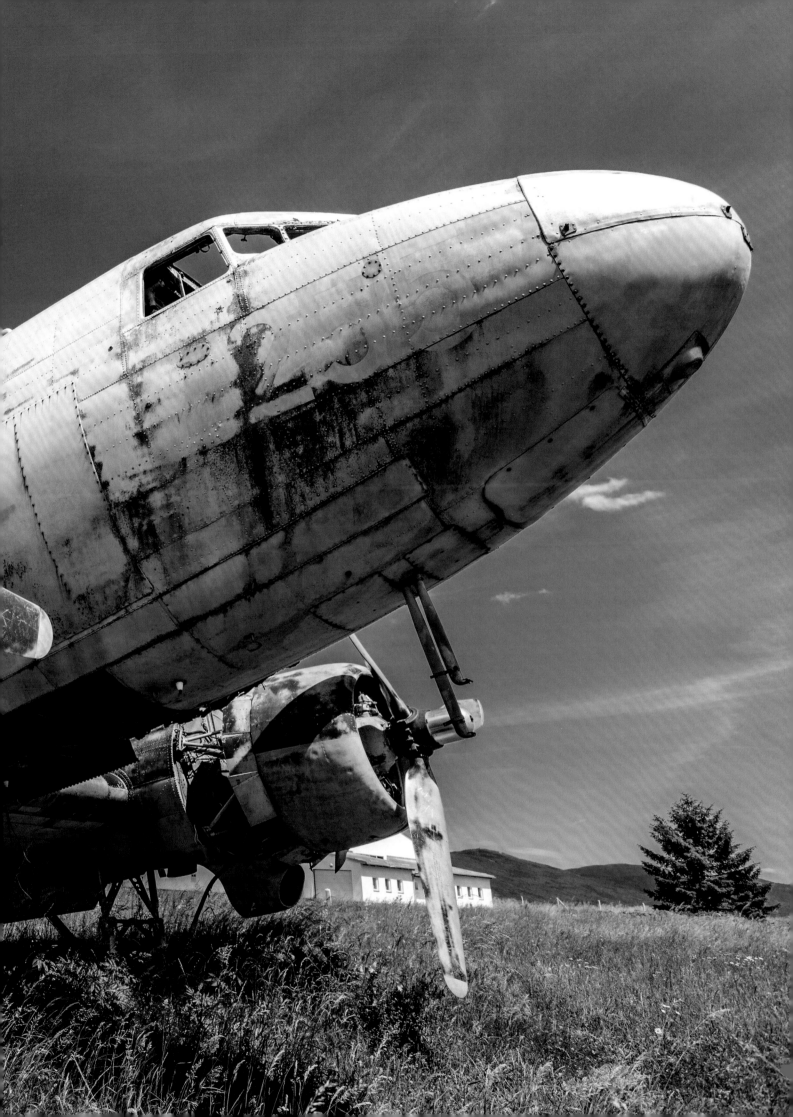

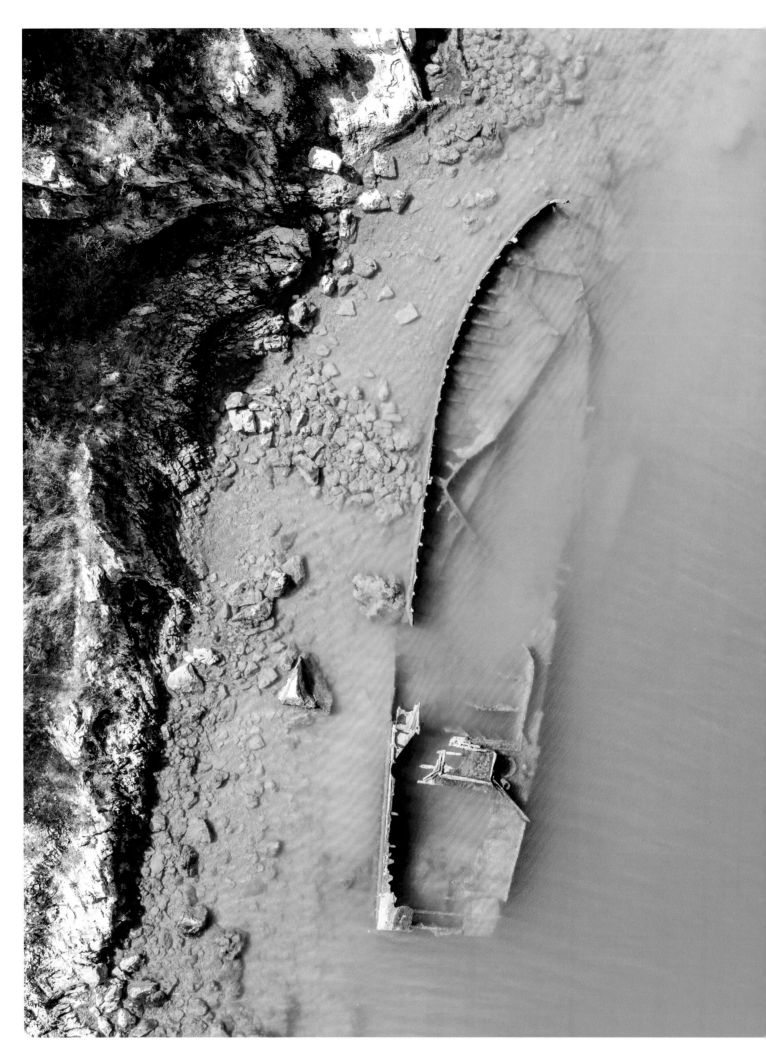

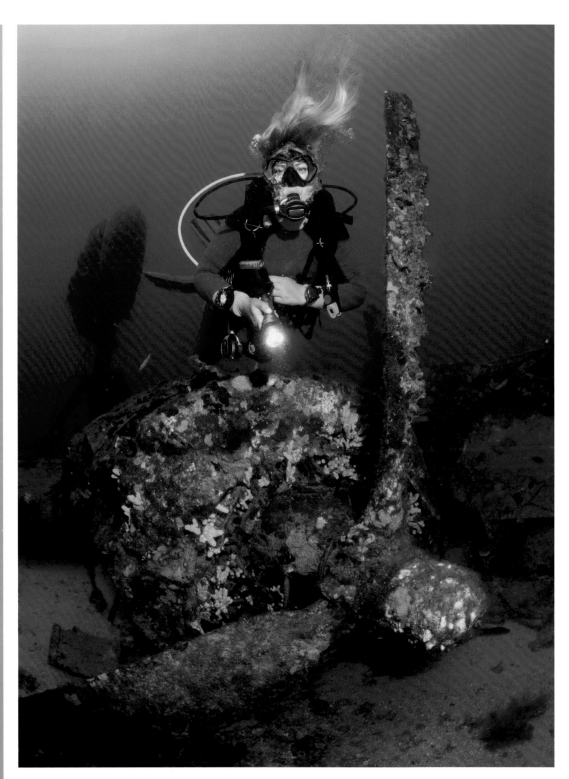

**Douglas DC-3 Dakota,
near Otocac, Croatia**
The Douglas DC-3 Dakota, or
C-47 Skytrain (in US military
service), had a capacity of 21 to
32 passengers or 2700kg (5950lb)
of cargo. Wartime aircraft
often went on to have long
post-war careers. This aircraft,
manufactured in 1944, was still
in civilian service in the 1970s
in Croatia.

LEFT:
**Sunken German ship,
Salamustica, Rasa Bay, Istria**
The outer hull is all that remains
of this German ship, sunk in Rasa
Bay, Istria. From 1943 in particular,
German surface vessels were
increasingly vulnerable to Allied
anti-ship aircraft patrols and also
to the menacing presence of Allied
submarines.

ABOVE:
**Consolidated B-24 Liberator,
off Vis Island, Croatia**
The B-24 Liberator to which this
engine belonged was severely
damaged by German fire over
Croatia during an outgoing flight
to raid targets on the Poland–
German border. The aircraft
made a heavy crash landing in the
sea; three crew members did not
survive the impact, but the other
seven were rescued.

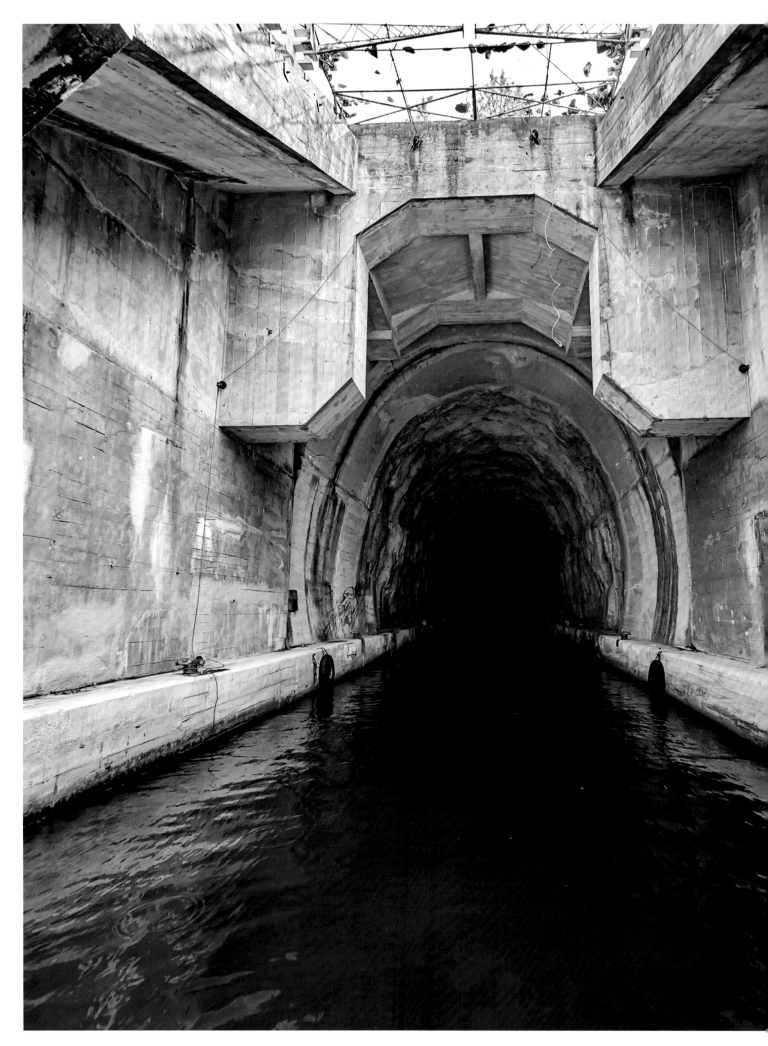

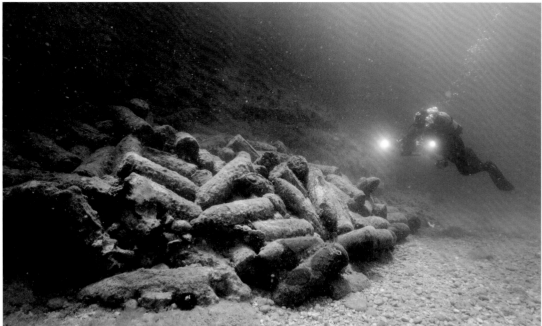

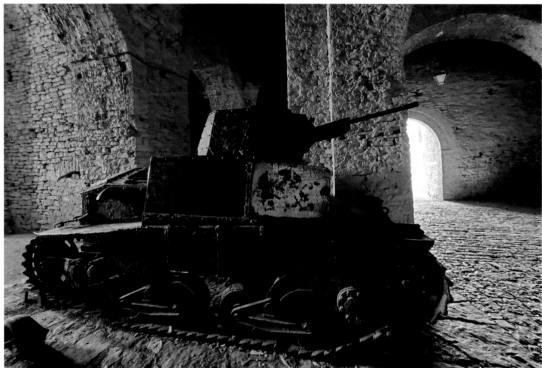

LEFT:
Submarine tunnel, Šibenik, Croatia
During their long and bloody occupation of Yugoslavia, German forces built several impressive tunnel systems into the coastal rock to house U-boats operating in the Adriatic and Mediterranean seas. This particular one is 250m (820ft) long and is often swum by tourists and thrill-seekers.

ABOVE TOP:
Artillery shells, coastal Albania
This pile of underwater artillery shells appears to have been dumped. Such was the fate of millions of tons of ammunition during the war, as a way of preventing it falling into the hands of the enemy and reducing the chances of accidental explosions.

ABOVE BOTTOM:
L6/40 tank, Gjirokastër Fortress, Albania
The L6/40 light tank was an Italian armoured vehicle that saw combat service in the Balkans, the Soviet Union, North Africa and the Italian campaign. The vehicle here is one of only three surviving L6/40s and is located in the Gjirokastër Fortress in Albania, a fortress that dates back to the twelfth century.

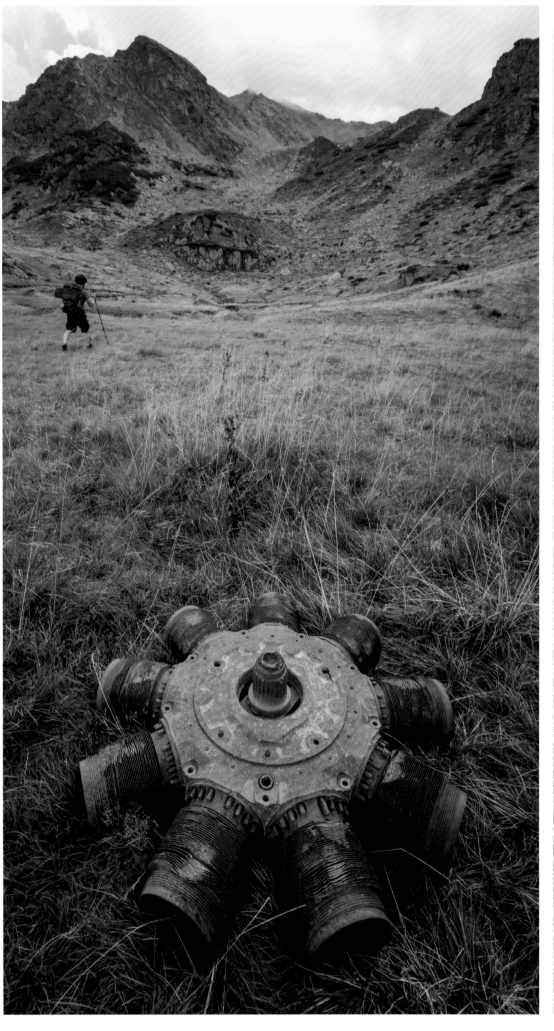

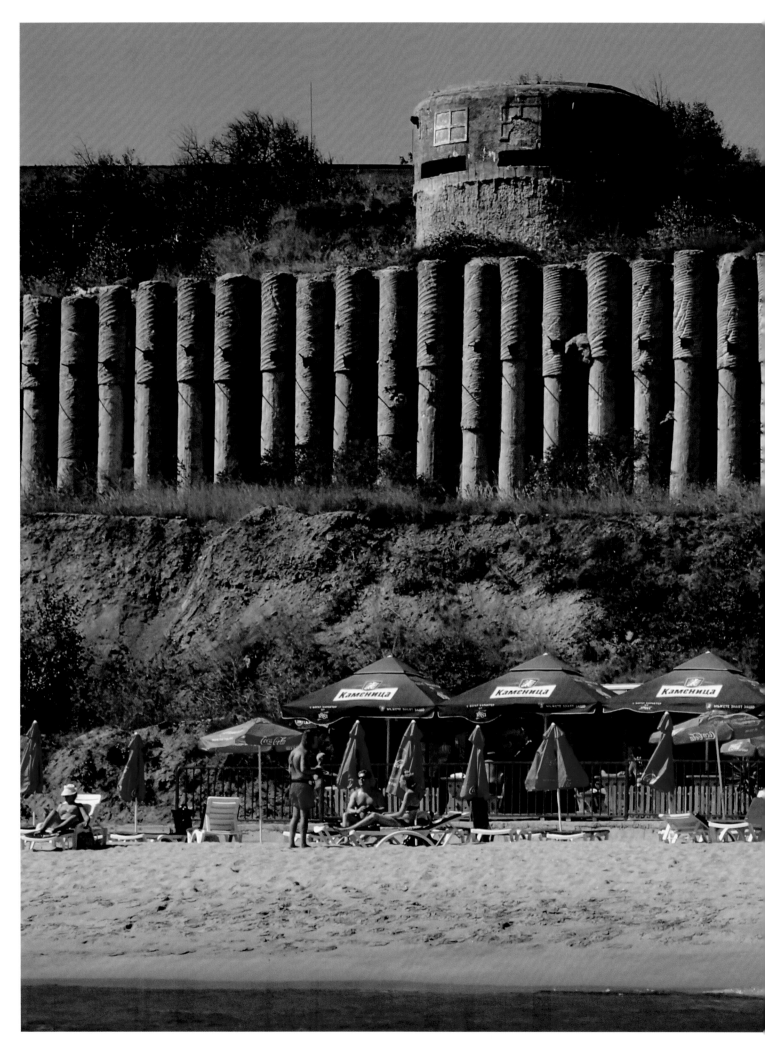

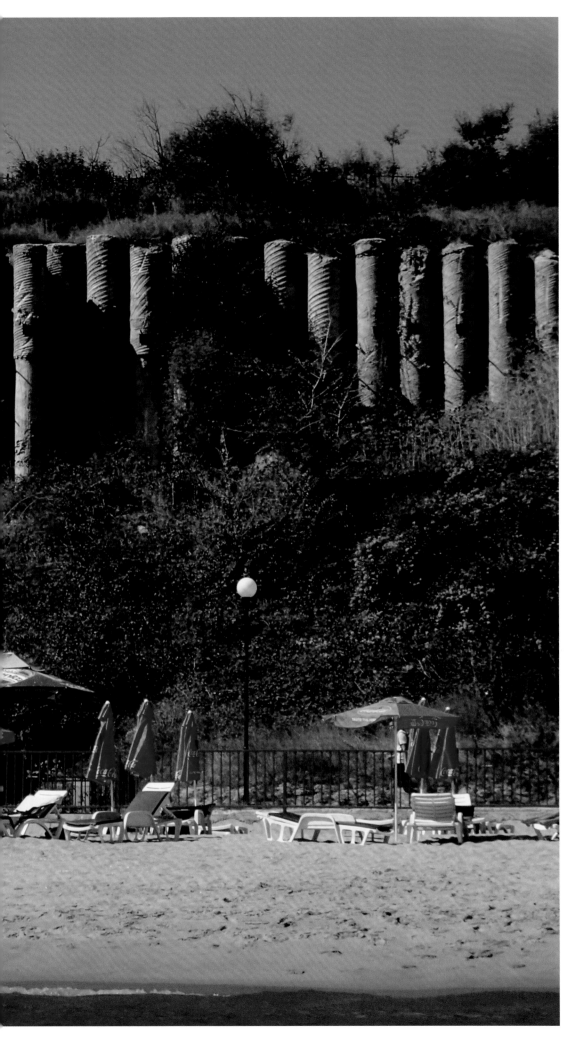

PREVIOUS PAGE LEFT:
Crashed aircraft, Parâng Mountains, Romania
The front part of an aircraft radial engine speaks of a violent end to a sortie in World War II. Romania, as an ally of Germany and a centre for Axis oil refining, was a major target of the US Fifteenth Air Force, headquartered in Italy.

PREVIOUS PAGE RIGHT:
StuG III, Fakiya, Bulgaria
Being steadily swallowed by the countryside, this wreck of a German Sturmgeschütz III (StuG III) assault gun shows its main armament to good effect – a 7.5cm StuK 40 L/48. The StuG III was a capable vehicle in both infantry-support and tank-destroying roles, and more than 11,000 were built during the war.

LEFT:
Obzor Fort, Bulgaria
A small town nestling on Bulgaria's Black Sea coast, Obzor has the remnants of a medieval fortress, but here we see World War II beach defences, including a concrete pillbox with embrasures to deliver all-round fire, juxtaposed incongruously with beach umbrellas and loungers.

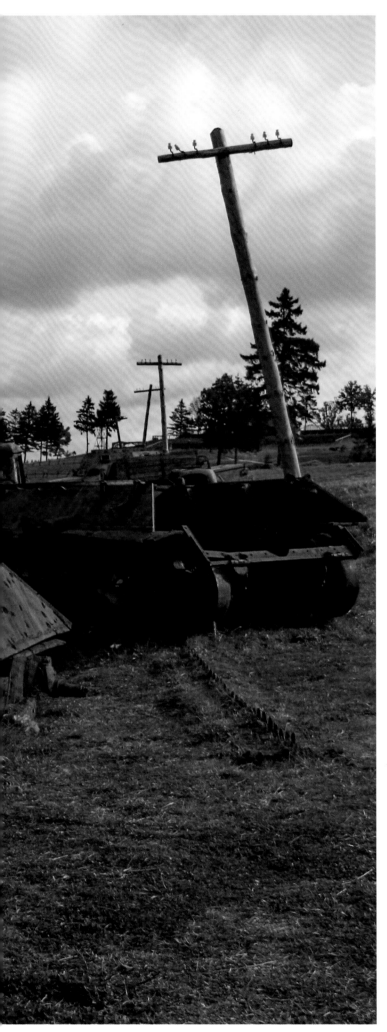

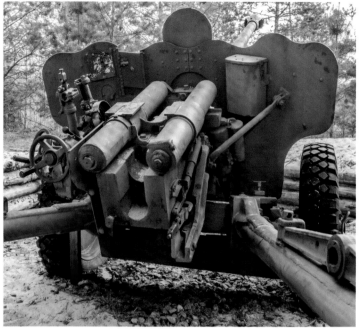

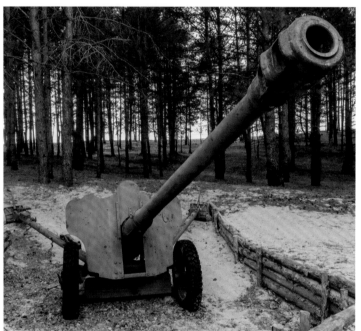

LEFT:

Tank hulls, Stalin Line, Minsk, Belarus

The Stalin Line was a chain of defensive fortifications built during the 1920s and 1930s to protect the Soviet Union's western border, although this border later shifted further westward and demanded the construction of new defences, called the Molotov Line, in 1940–41. Here we have the hulls of Soviet tanks, anything mechanically or militarily useful having been stripped out.

ABOVE (BOTH PHOTOGRAPHS):

D-44 anti-tank gun, Memel-Nord Museum, Klaipeda, Lithuania

The D-44 was a high-velocity 85mm (3.35in) field artillery gun, produced between 1944 and 1953. It was capable of acting as both a general field gun and an anti-tank gun, depending on the ammunition type, and it could fire 20 rounds per minute in the hands of a well-oiled crew.

RIGHT TOP:

German coastal battery, near Klaipeda harbour, Lithuania, Baltic Sea coast

The Memel-Nord Battery was a German coastal installation, built after the Klaipeda Region was transferred to Germany by Lithuania in March 1939. Today the bunker complex is a popular museum site, featuring a variety of equipment and artefacts from the war years.

BOTTOM LEFT:

76mm M1914/15, Kerch Strait, Crimea

This compact artillery piece, still affixed to its rotating mount, was a Russian anti-aircraft gun. Although manufacture of these weapons ceased in 1934, they provided air defence at key installations and bases during World War II, either as a static gun or mounted on trucks, trains or ships.

OPPOSITE BOTTOM RIGHT:

Concrete bunker, Liepaja, Latvia

A Soviet pillbox stands abandoned in the forest near Liepaja. The full weight of the German Army Group North passed through Latvia in June–July 1941, despite stubborn resistant from the defending Red Army.

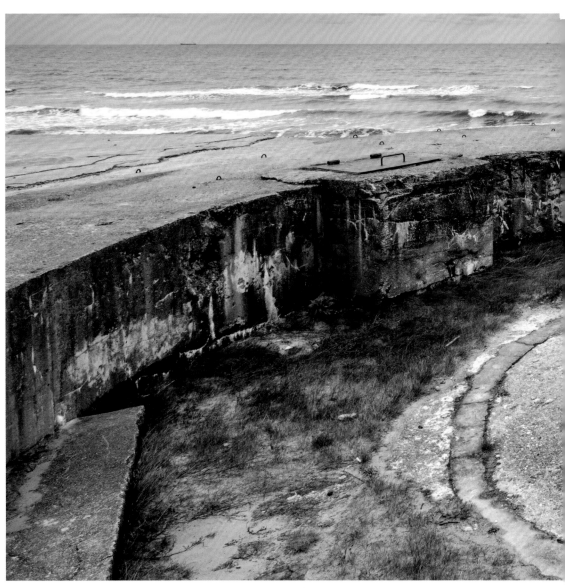

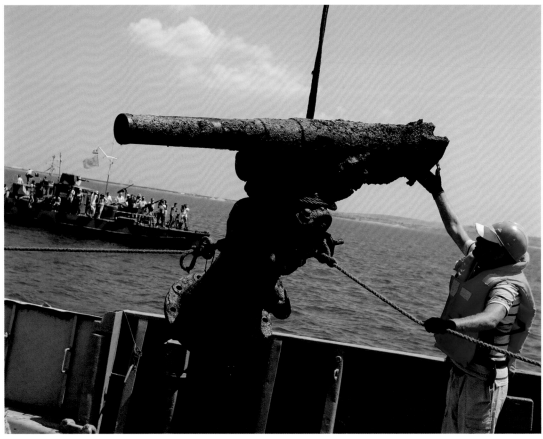

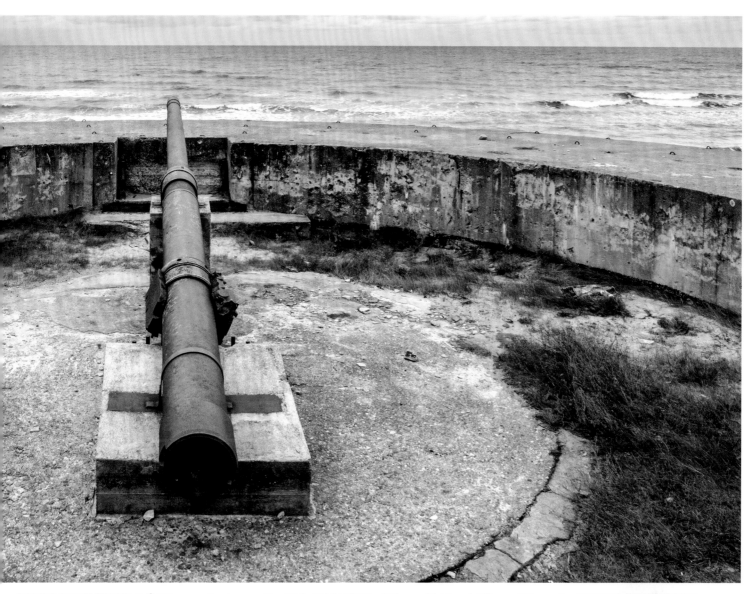

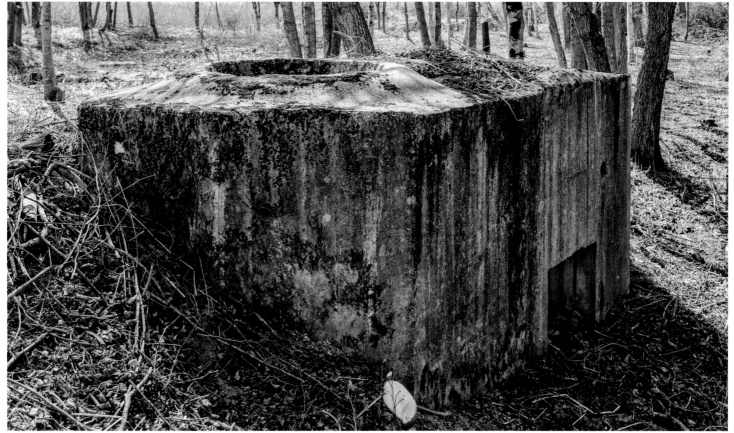

RIGHT:

Totleben Fort, Kronstadt, Russia

Totleben Fort, playing its part in the outer defensive ring for St Petersburg/Leningrad, became operational in 1910 and remained so until the 1950s. It was upgraded with heavier artillery in 1923, and in the Winter War of 1939–40 between Russia and Finland its 203mm (8in) naval guns delivered long-range fire in support of the Red Army's offensive on the Karelian Isthmus. It also held out against the German siege of Leningrad in 1941–44.

BELOW:

228mm (9in) gun, Suomenlinna Fortress, Helsinki, Finland

Construction on the Suomenlinna ('Castle of Finland') Fortress began in 1748 and continued off and on until the 1970s, when it was handed over to civilian administration. Such is the extent and continuing power of the fortifications that they were added to UNESCO's World Heritage List in 1991. The powerful 9in (228mm) gun seen here, set on a gliding mount, was one of several heavy-calibre weapons emplaced in the late nineteenth century, but which continued to serve during World War II, when the fortress was a base for the Finnish submarine fleet.

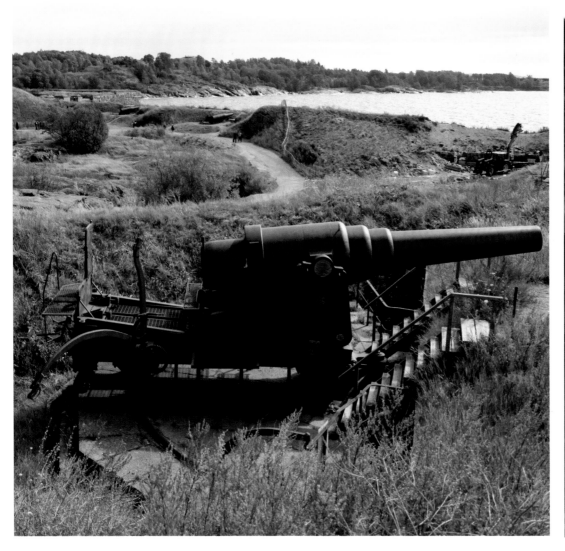

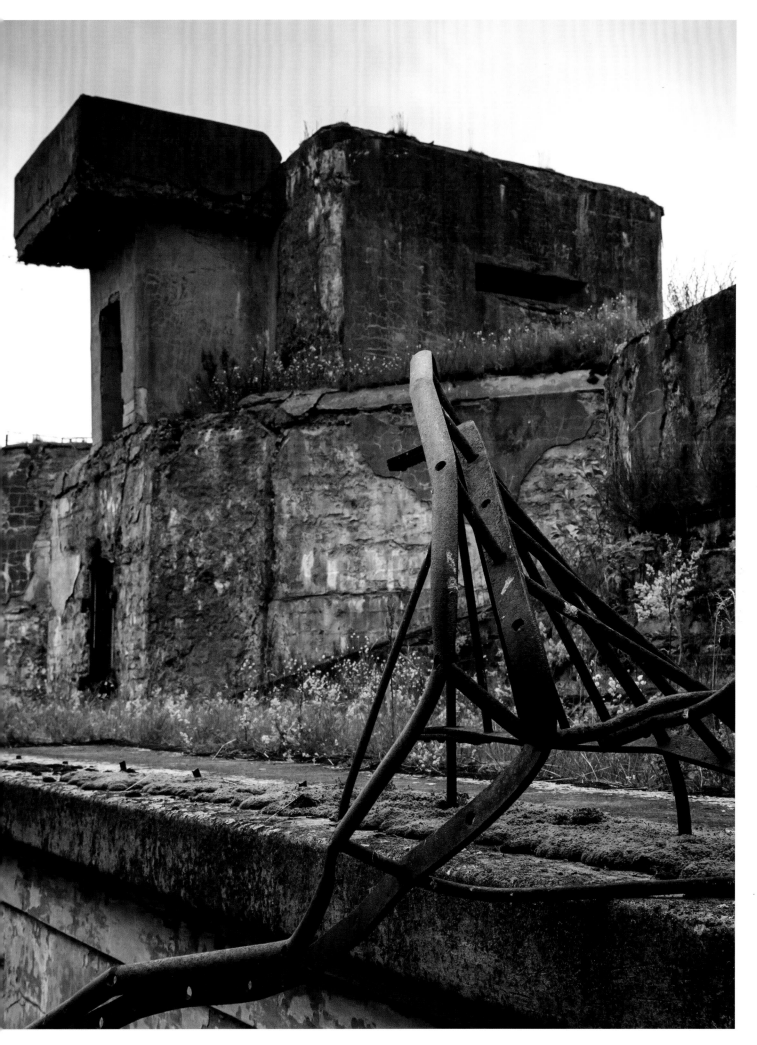

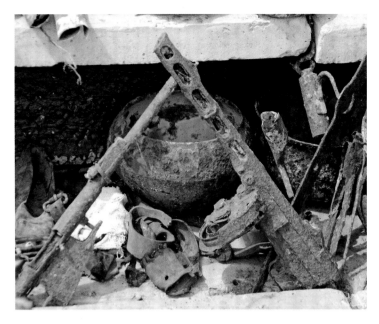

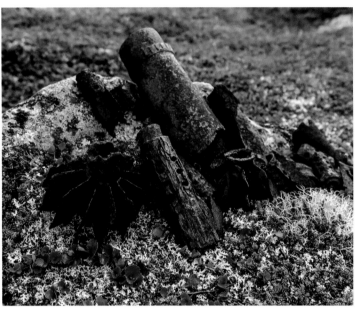

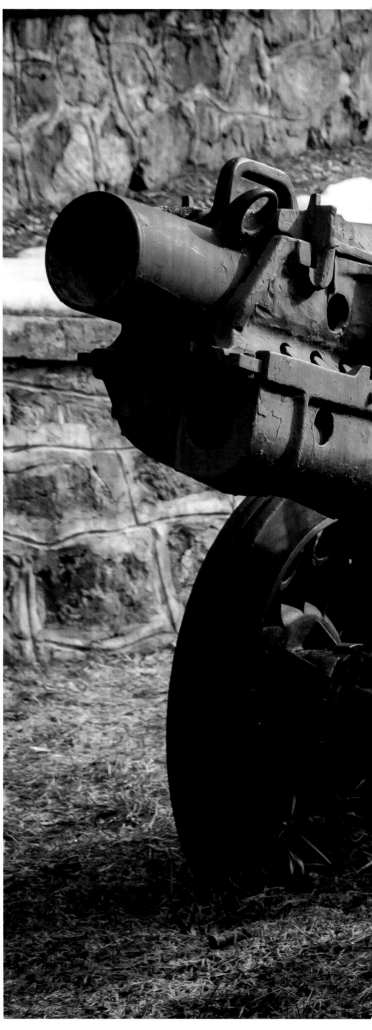

ABOVE TOP:
War materials, Volgograd (formerly Stalingrad), Russia
The battle of Stalingrad was one of the most apocalyptic engagements in human history, with an estimated casualty count of more than a million dead. Today, the city landscape still yields tons of militaria, such as the items seen here, which include a Soviet PPSh-41 submachine gun.

ABOVE LOWER:
Munitions, Rybachy Peninsula, northwest Russia
German and Soviet forces fought over the Rybachy Peninsula for three years in a brutal positional campaign. The evidence of this struggle is still scattered across the landscape, including these pieces of artillery shells and mortar bombs. The shell at top centre still has its driving band attached.

RIGHT:
M1 pack howitzer, Mokra Gora, southwest Serbia
The 75mm Pack Howitzer M1 (redesignated the M116 during the 1960s) was a light US artillery piece designed for airborne deployment or for movement through difficult and mountainous terrain. It saw widespread service across most European and Pacific theatres, including in the Balkans in the bands of British-trained Yugoslavian partisans.

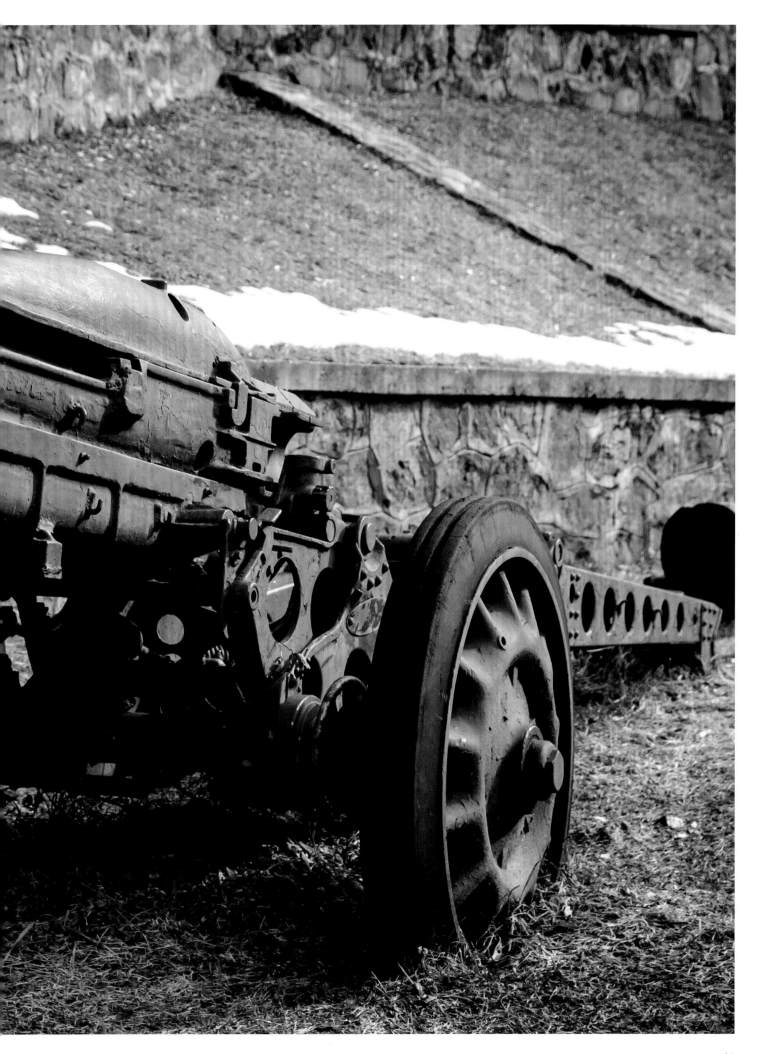

**Bell P-39 Airacobra, Kalamita
Bay, Crimea, Black Sea**
This American-made Bell P-39
Airacobra fighter aircraft was a
small element of the millions of
tons of equipment supplied to the
USSR during the war. It served
with the Black Sea Fleet from
1943, but was forced to ditch the
following year because of engine
trouble. The remains of the
aircraft were discovered in 2017
and lifted from the water.

**Pillbox, Kiev Defensive
Line, Ukraine**
The Kiev Defensive Line, also
known as the Kiev Fortified
Region, stretched 85km (53
miles) along the Dnieper River
and was built between 1929 and
1931. Consisting of dozens of
pillboxes, artillery emplacements,
observation posts and other
defensive structures, the line was
neglected during the 1930s, but
was heavily redeveloped under
the emergency conditions of the
German invasion in 1941.

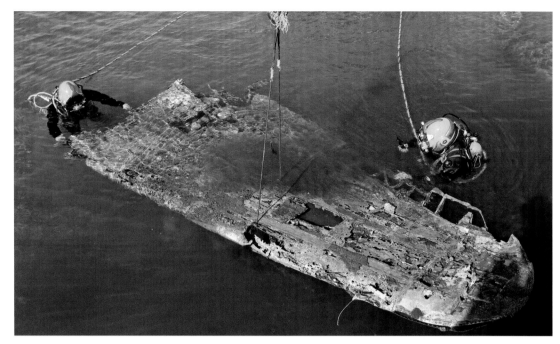

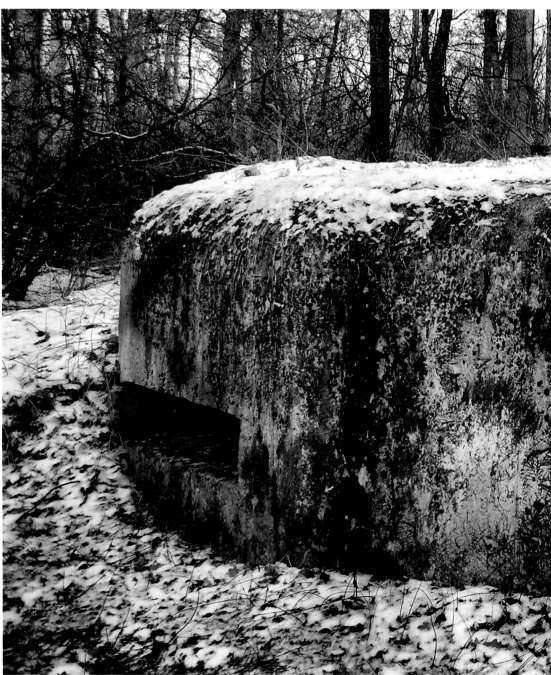

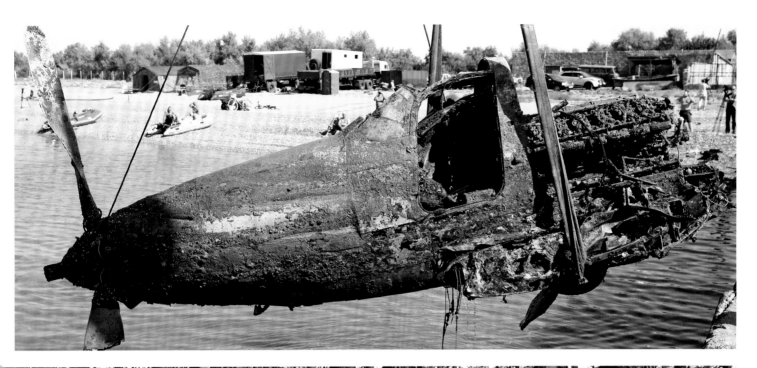

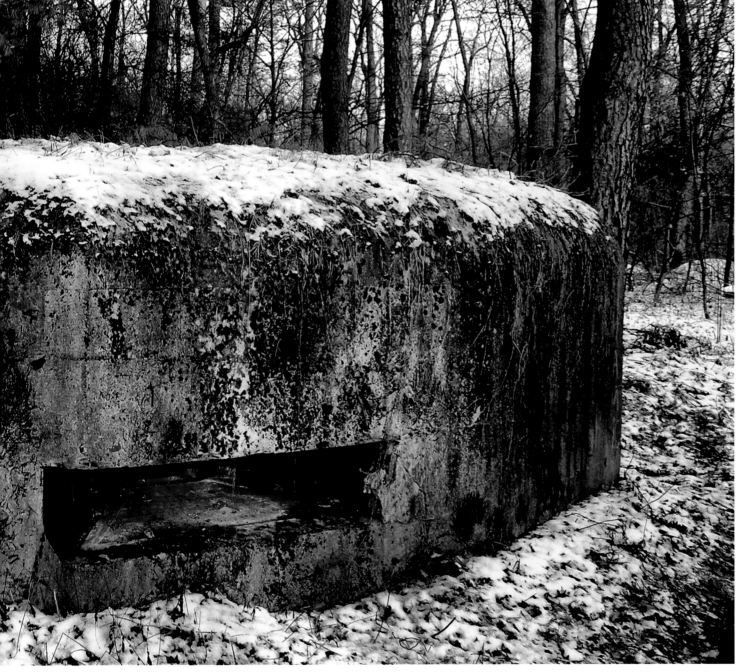

ISU-152 self-propelled gun, Chernobyl, Ukraine

Chernobyl is historically famed for its tragic and devastating nuclear accident in 1986, but it was also the scene of heavy fighting between German and Soviet forces in 1943. The ISU-152 was a World War II creation, designed as an armoured monster with a crushing 152mm (5.98in) main gun to take on the German Tigers and Panthers. This specimen was used in 1986 to demolish radioactive concrete buildings after the disaster at the power plant, in the tragically mistaken belief that the thick armour would protect the crews inside.

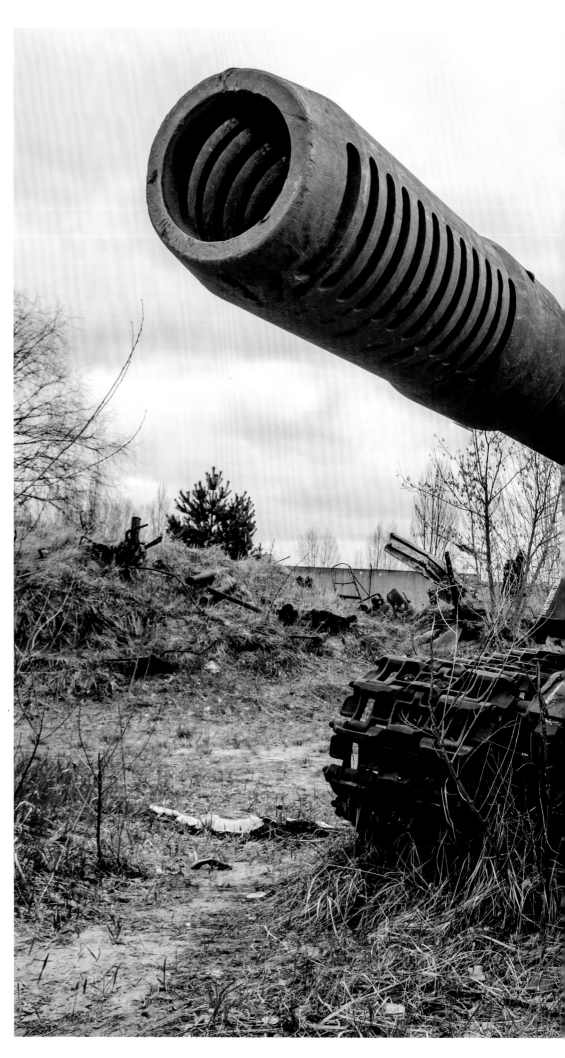

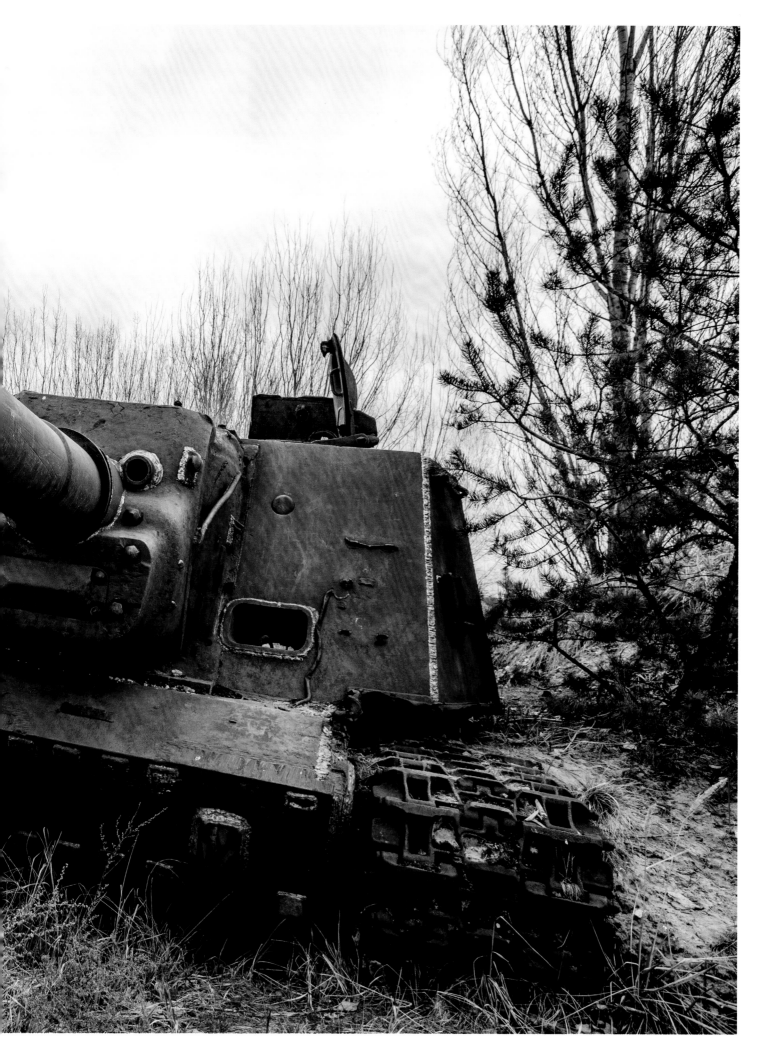

G-5 class motor torpedo boat, Karantynna Bay, Sevastopol, Crimea
Emerging from the waters of the Black Sea after more than seven
decades, this Soviet G-5 motor torpedo boat was deployed in the defence
of Sevastopol in 1941–42. The G-5 was a sleek and fast design – it
could attain speeds of up to 96km/h (60mph). It was equipped with two
torpedoes, but these versatile craft were principally used for raiding and
troop transportation purposes.

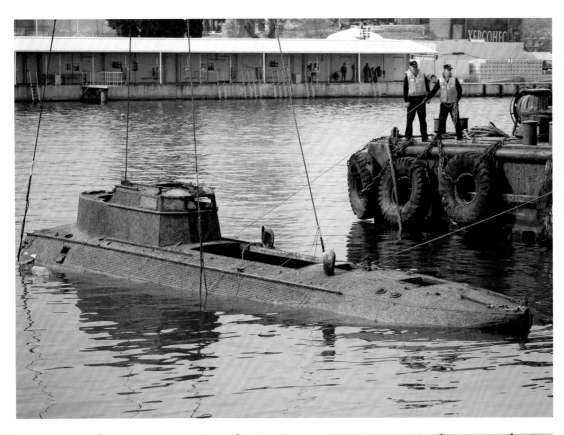

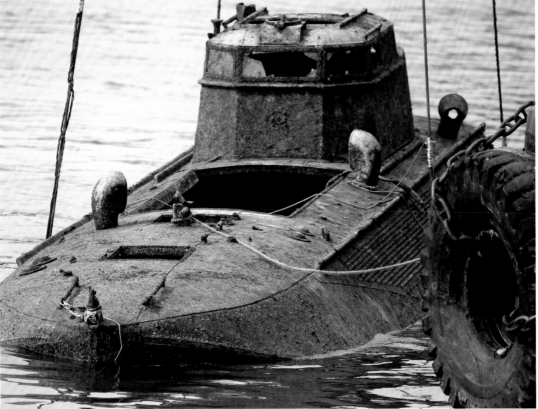

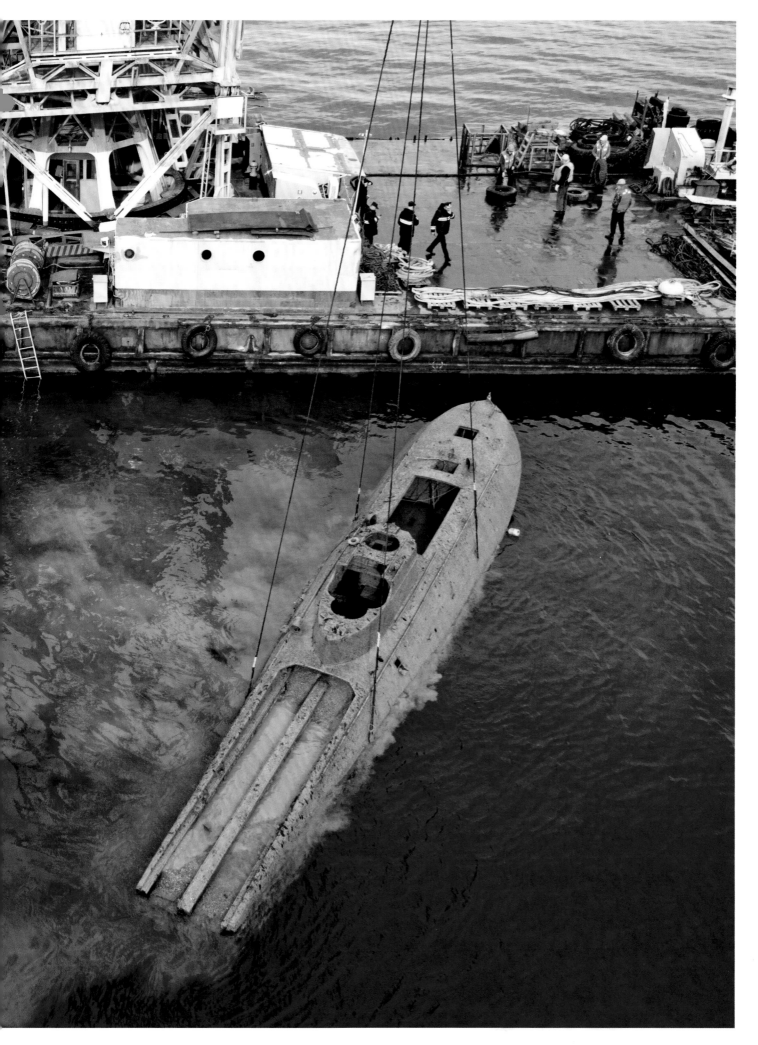

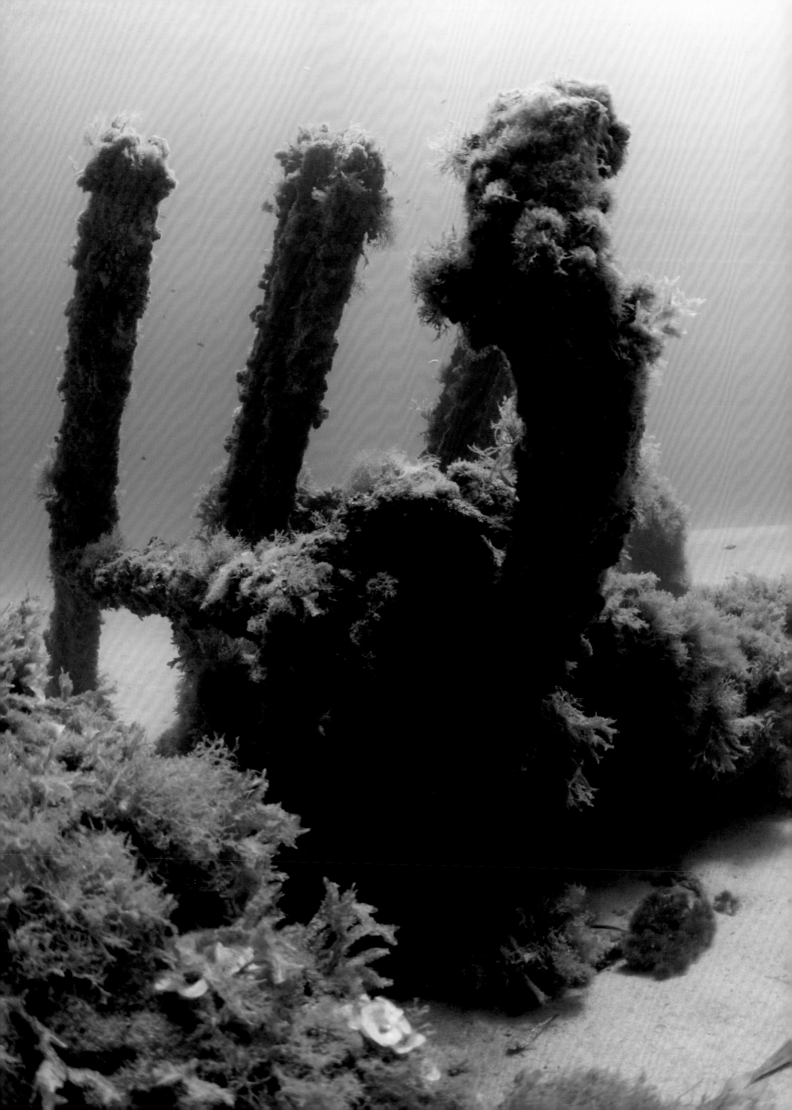

Mediterranean, Middle East and Africa

The war in and around the Mediterranean, particularly in North Africa, was quite unlike the fighting elsewhere in World War II. In many cases, the combat either took place in barren desert regions or out on open blue waters, and consequently the local civilian populations were for the most part spared the casualties that typically exceeded military dead and wounded in other theatres. As such, the Mediterranean/ Middle Eastern war was regarded as something of a 'gentleman's war', a military clash seemingly free from the horrific ideological actions of the Eastern Front, or the carpet bombing of civilian areas in Western Europe. This being said, the fighting in the Mediterranean and Middle Eastern theatre of operations, and in wider Africa, had no mercy for the combatants, not least because the men as much fought the climate as they did the enemy. Blistering equatorial sunshine, dehydration, clouds of flies, constant disease, choking dust, endless scorched horizons – for those from gentler climes, it was often hard enough to survive nature in the region, let alone fight in it. But fight they did, the advantage passing from one side to the other until the final expulsion of the Axis forces from North Africa in 1943. Today, there are plentiful reminders of that time scattered across the landscape. A selection of visible memories are seen here, still baking under the sun, but in many places thousands of invisible land mines sit beneath the red soils and shifting sands – the threat of war remains.

OPPOSITE:

HMS *Maori*, Valetta, Malta
HMS *Maori* was a Tribal-class destroyer with an intensive but short war career, taking part in the Norwegian campaign of 1940 and engaging the German battleship *Bismarck* in May 1941 before the German ship's sinking the following day. *Maori* herself was sunk at her moorings in Malta's Grand Harbour by German air attack on 12 February 1942, subsequently being raised and scuttled off Valetta in July 1945.

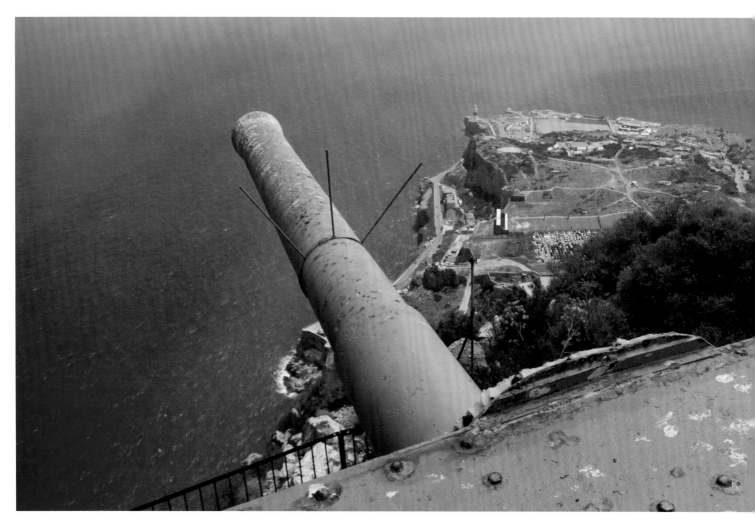

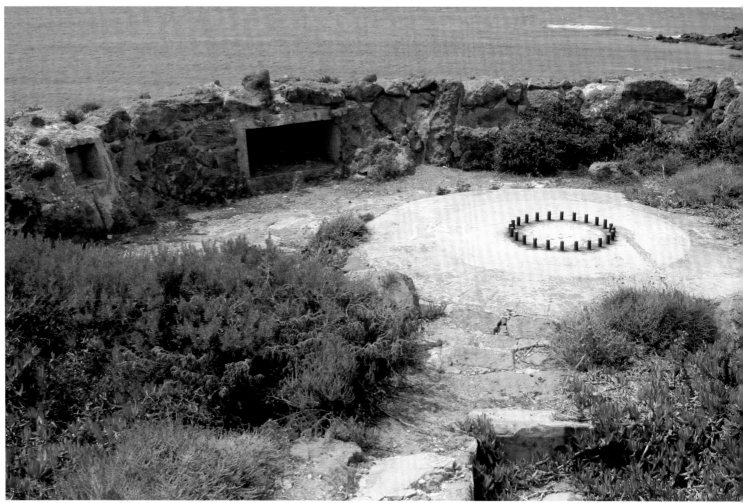

TOP LEFT:

O'Hara's Battery, Gibraltar

Built in 1890 and named after the former governor of Gibraltar, Charles O'Hara, this battery sits high up on 'the Rock', 421m (1381ft) above sea level. From 1901 it was armed with a 233mm (9.2in) Mark X BL gun to defend the Straits of Gibraltar, with a range sufficient to fire across to North Africa.

BOTTOM LEFT:

Artillery post, Calasetta, Sant'Antioco island, Sardinia

The island of Sant'Antioco was, like many Italian islands, heavily fortified between 1940 and 1943. Here we see a typical, now-empty, coastal gun emplacement. Although naval guns were often emplaced to repel possible invasions, it was anti-aircraft guns that bore the brunt of the combat, engaging Allied air raids.

BELOW:

Bristol Blenheim, off Xrobb I-Ghagin, Malta

Malta's skies witnessed air battles every bit as intensive as those fought over Britain in 1940. This Blenheim bomber was critically damaged by Italian fighter aircraft on 13 December 1941, on a mission to Kefalonia in Greece. With its port engine damaged, the pilot ditched the aircraft, and all crew survived.

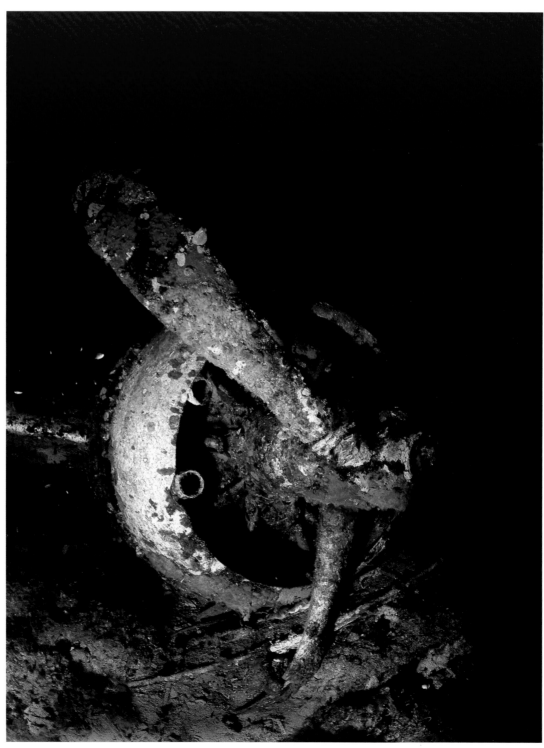

**Douglas DC-3 Dakota,
Kas, Turkey**
This World War II-vintage DC-3
was later used as a transporter for
Turkish paratroopers, but was
deliberately sunk off Kas, Turkey,
in July 2009. A popular dive site
today, the 20m (65ft) long aircraft
sits upright and virtually intact,
25m (82ft) below the water's
surface on the sandy seabed.

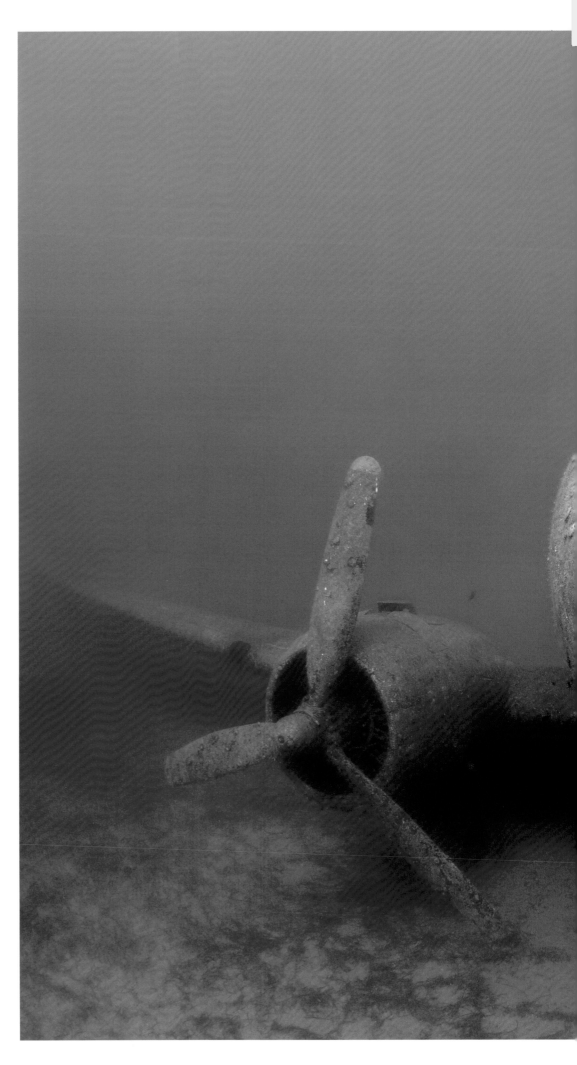

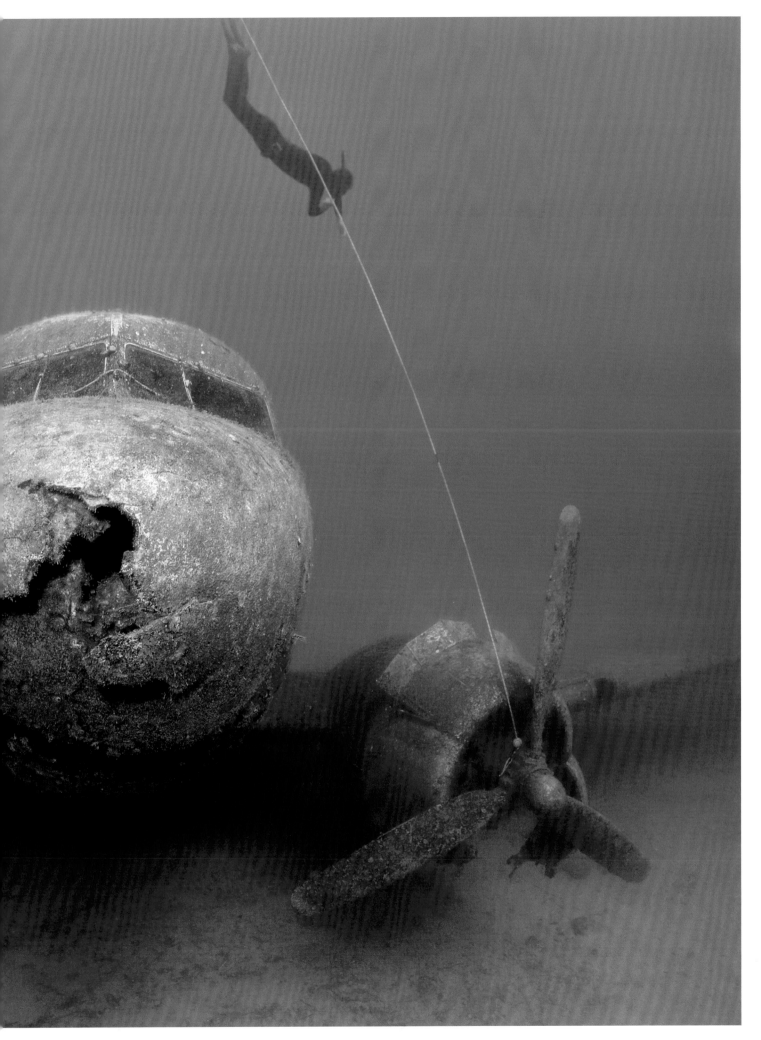

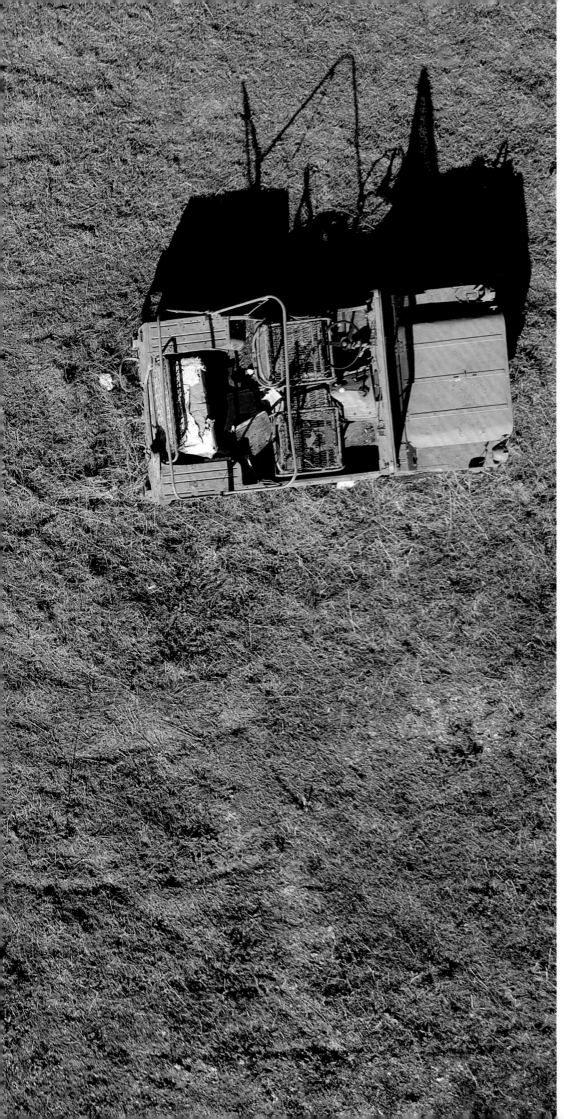

Military vehicles, Kalpaki village, Konitsa, Greece
Greek army vehicles from World War II still look purposeful in this aerial photograph. Just outside the village of Kalpaki, outnumbered Greek forces fought a major battle against the Italians in November 1940, stopping the Axis advance and eventually putting it into retreat, at least prior to German involvement.

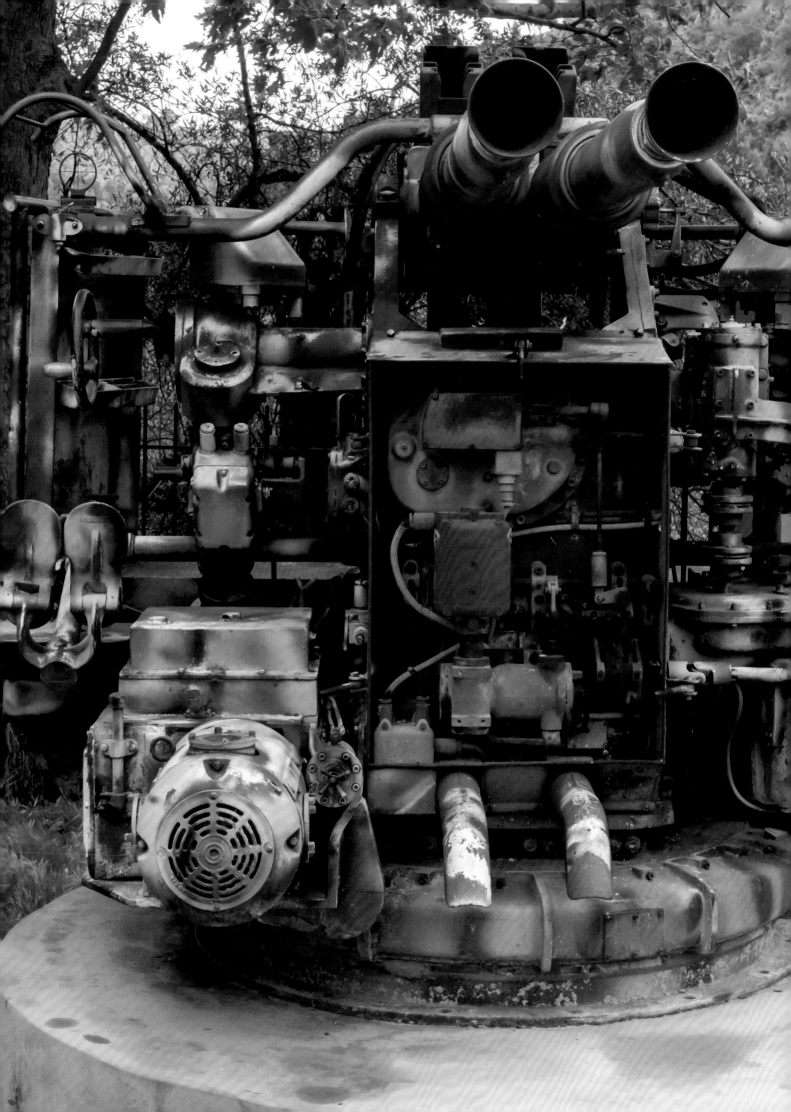

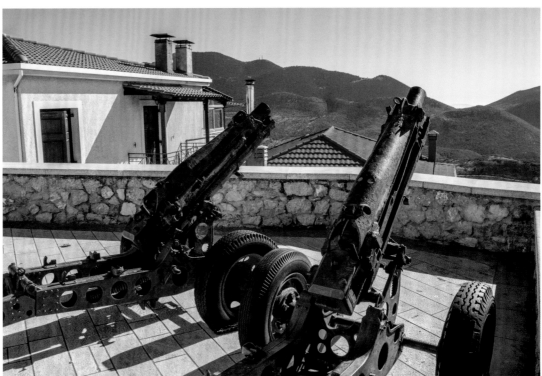

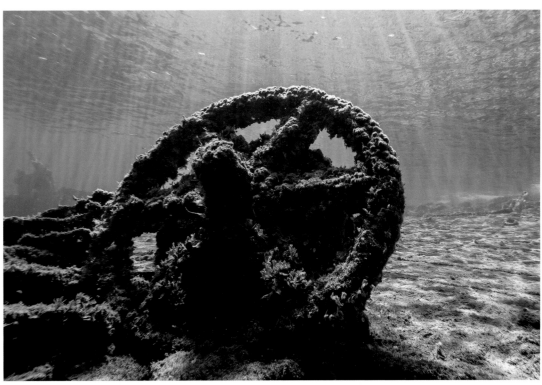

LEFT:

Bofors guns, Theriso, Crete
The Bofors gun was a fine anti-aircraft weapon, firing 40mm (1.57in) shells at a rate of 120rpm at ranges of 7000m (22,966ft) and beyond. Batteries of these weapons, however, were unable to stop the German airborne invasion of Crete in May 1941, although they did impose heavy casulties on lumbering German transport aircraft.

ABOVE TOP:

M1 Pack Howitzers, Arachova village, Boeotia, Greece
The excellent American 75mm (2.95in) M1 Pack Howitzer saw action across most Allied theatres, on account of its useful firepower and welcome portability. The practicality of the design for mountain warfare made it ideal for army operations in Greece.

ABOVE BOTTOM:

LCT, Falassarna, Crete
The wreck of a British Landing Craft, Tank (LCT) off Falassarna, Crete, attests to the severity of the fighting around this idyllic Greek island in 1941. The fate of this particular vessel is unclear, but many were lost to German bombing raids as the Allies evacuated in late May and early June of that year.

RIGHT AND OPPOSITE:

Gun emplacement, Chorio, Symi, Greece
Set high up on a hill above the village of Chorio on Symi island, this weapon is the remnants of an Allied M45 quadmount that originally held four .50-cal Browning machine guns, which when combined provided devastating short-range anti-aircraft fire or medium-range ground fire.

BELOW:

German shell, Pedi Harbour, Symi, Greece
This mighty-looking German shell, likely from heavy naval or coastal artillery, is today applied for far more peaceable purposes – local sailors use it as a mooring bollard in the harbour.

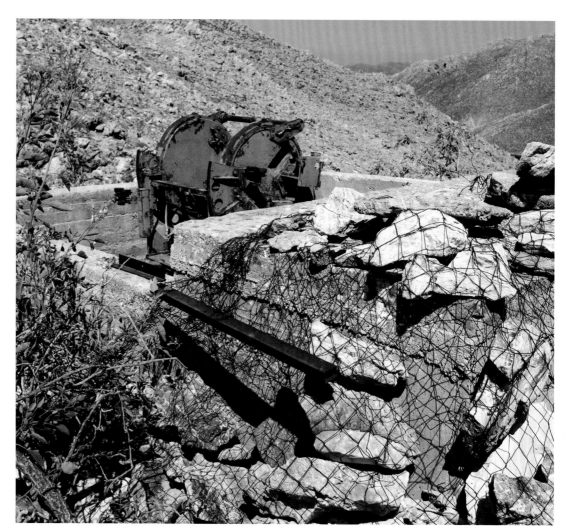

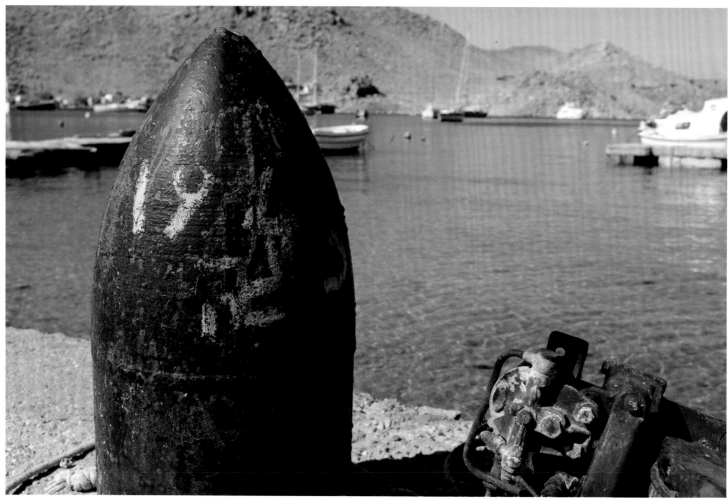

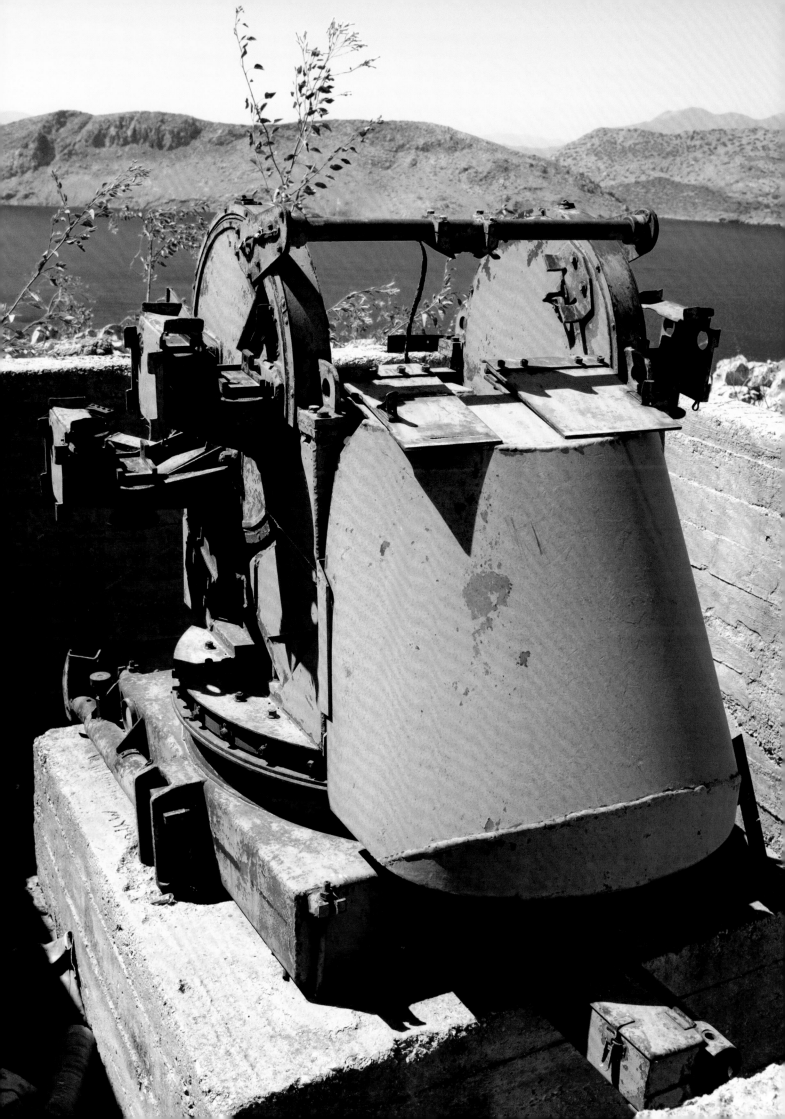

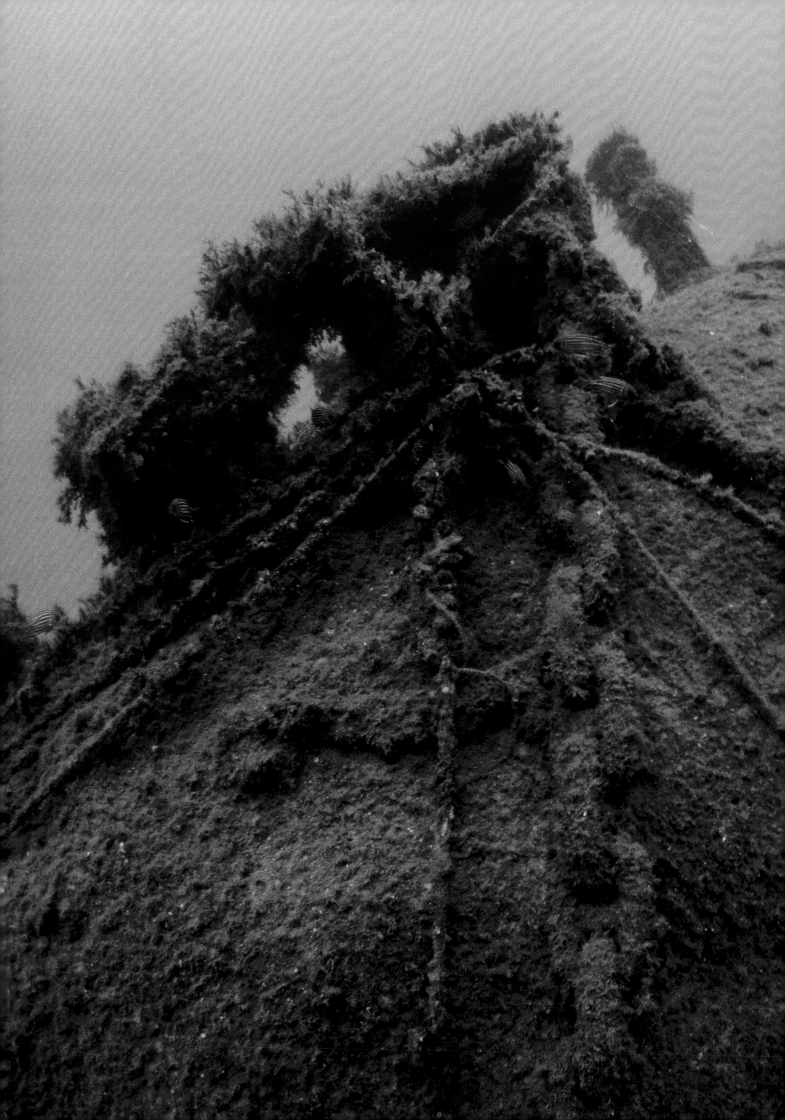

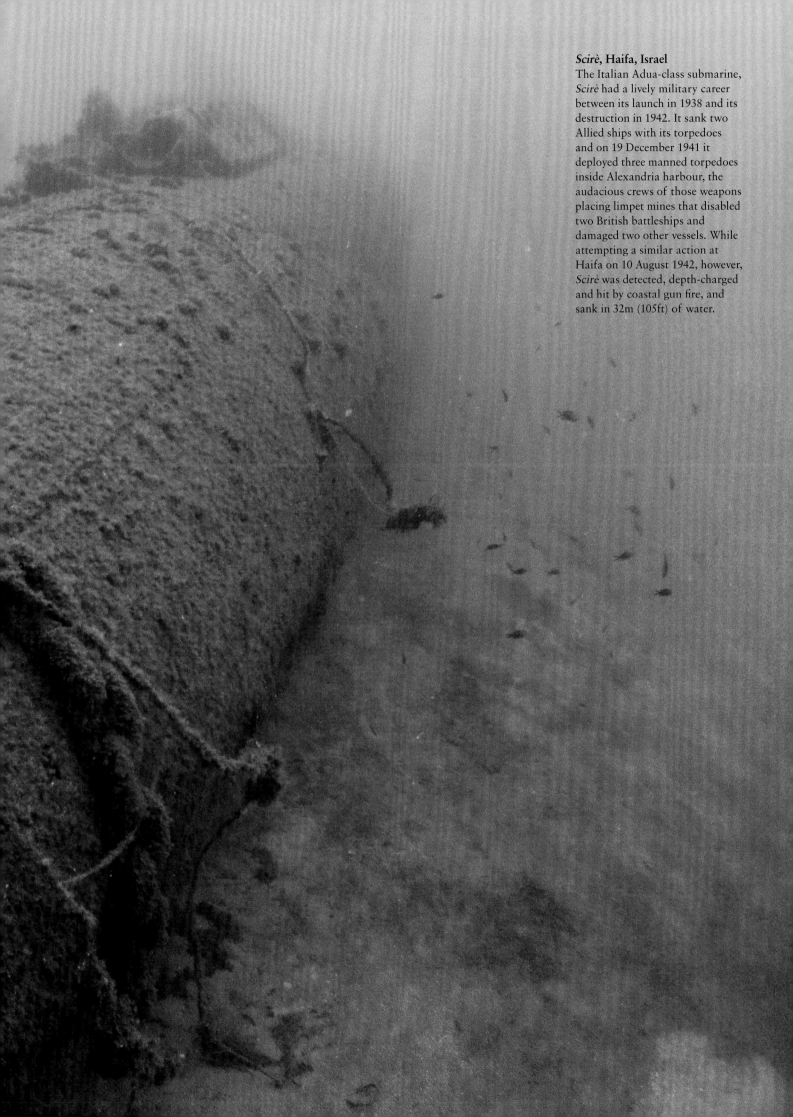

Scirè, Haifa, Israel
The Italian Adua-class submarine, _Scirè_ had a lively military career between its launch in 1938 and its destruction in 1942. It sank two Allied ships with its torpedoes and on 19 December 1941 it deployed three manned torpedoes inside Alexandria harbour, the audacious crews of those weapons placing limpet mines that disabled two British battleships and damaged two other vessels. While attempting a similar action at Haifa on 10 August 1942, however, _Scirè_ was detected, depth-charged and hit by coastal gun fire, and sank in 32m (105ft) of water.

Curtiss P-40 Tomahawk, Egypt
The Western Desert region is still littered with ordnance and military wrecks from World War II, the metals often strikingly well-preserved in the dry conditions. Here we see the nose section of a downed Curtis P-40 Tomahawk, an aircraft that the Allies used heavily in a close-support role in North Africa.

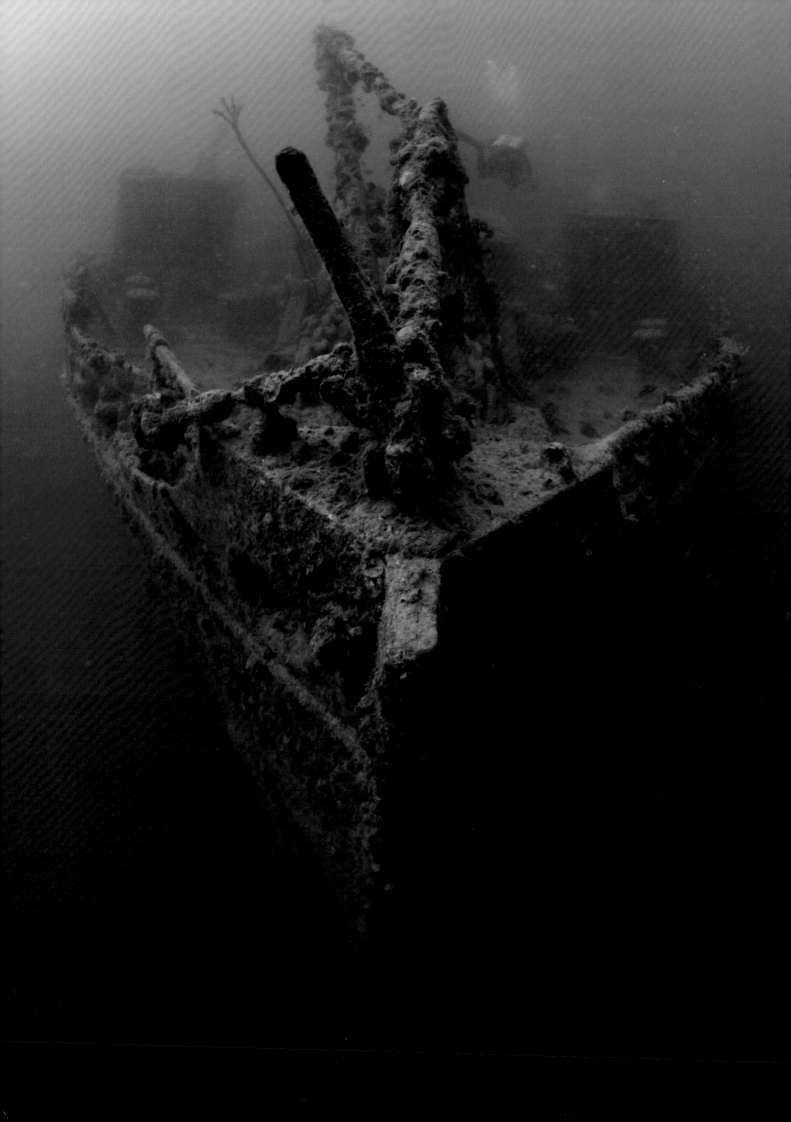

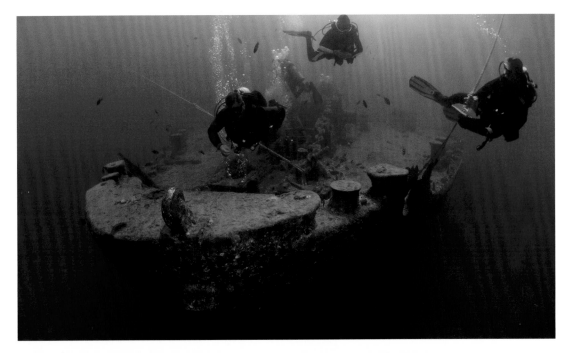

OPPOSITE:

Rosalie Moller, Red Sea

The *Rosalie Moller* was a coaling vessel, transporting Welsh coal around Royal Navy bases in the UK and out to the Mediterranean and Red seas. On 7 October 1941, while hazardously static at anchor in the Red Sea, waiting for a blockage to clear in the Suez Canal, the ship was bombed and sunk by two Heinkel He 111 bombers making a low-level strike.

LEFT (ALL):

SS *Thistlegorm*, near Ras Muhammad, Red Sea

The wreck of the British merchant navy ship SS *Thistlegorm* was discovered by none other than the legendary French diver Jacques Cousteau in the early 1950s, although its location was subsequently lost then rediscovered in the 1990s. Following her launch in April 1940, the ship made three perilous voyages across war-torn waters – to the United States, Argentina and the West Indies – carrying everything from rum to aircraft parts.

On her fourth voyage, from June 1941 to Alexandria, she carried a huge stock of trucks, weapons, ammunition and even two steam locomotives. On 6 October, however, the ship was bombed while at anchorage near the Straits of Gubal. She caught fire, exploded and sank in less than a minute; nine of her crew died. As these photographs indicate, the wreck is today an undeniably fascinating dive site, within easy reach for Egypt's tourist divers.

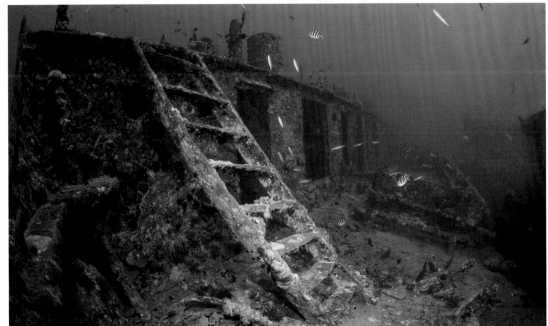

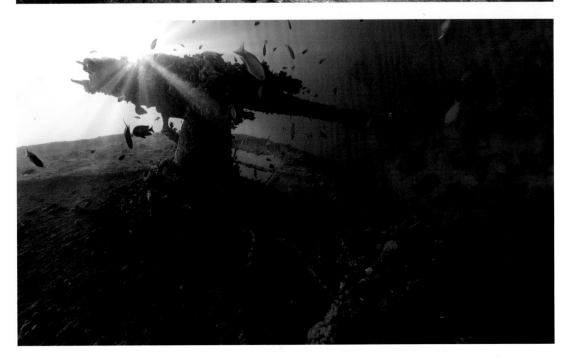

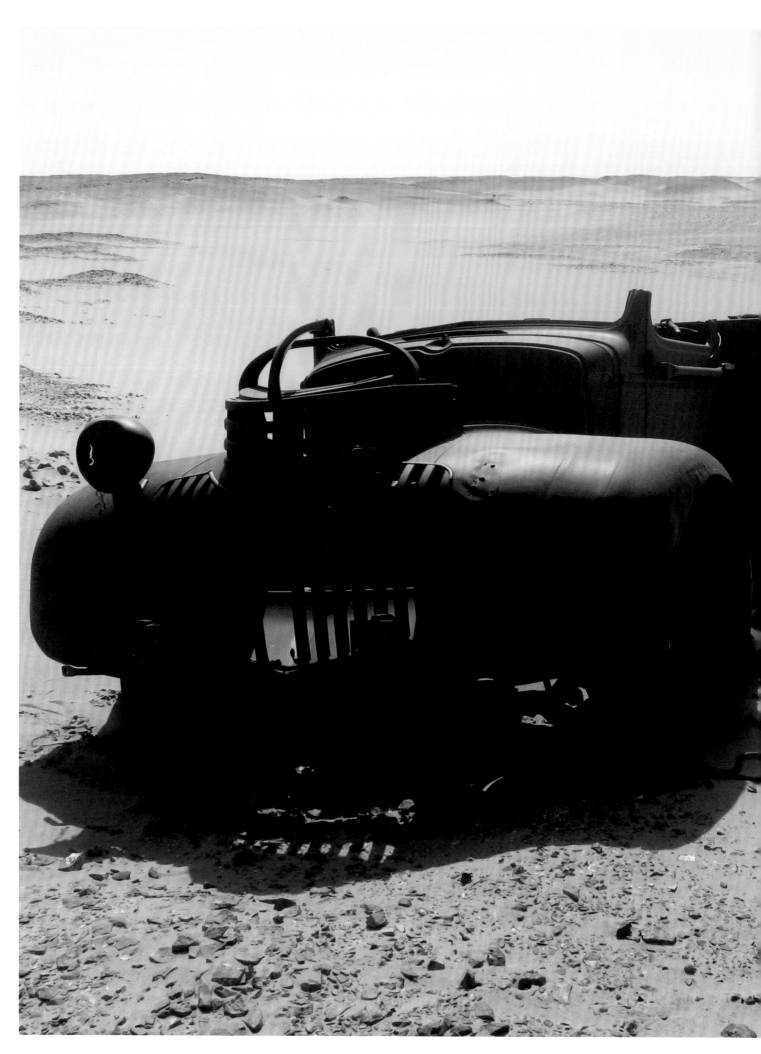

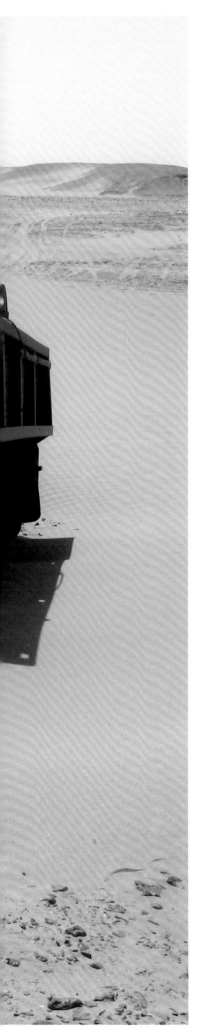

LEFT AND BELOW TOP:

Wrecked vehicles, Tobruk, Libya

Tobruk was one of the most contested places in the North African war, under Axis siege for 241 days. Military equipment is still scattered around the port city, including these Allied trucks. The one on the left appears to be a Chevrolet Modified Conventional Pattern (MCP), a Canadian-produced vehicle.

BELOW BOTTOM:

Bunker, Mareth, Tunisia

Blending perfectly into the red soil of the landscape, this basic bunker complex was part of the Mareth Line, a network of French defences built in southern Tunisia in the late 1930s. The Germans renovated and strengthened the line in 1941–42, and it was the site of major fighting before the Allies finally broke through in March 1943.

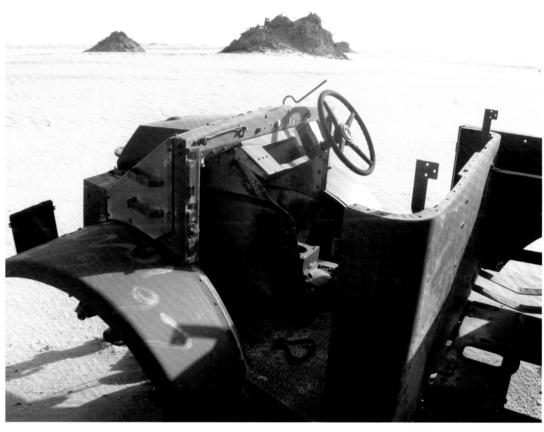

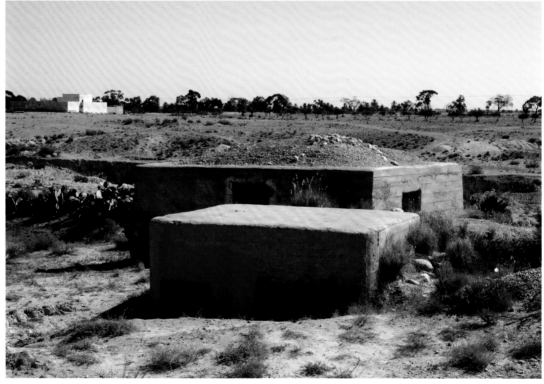

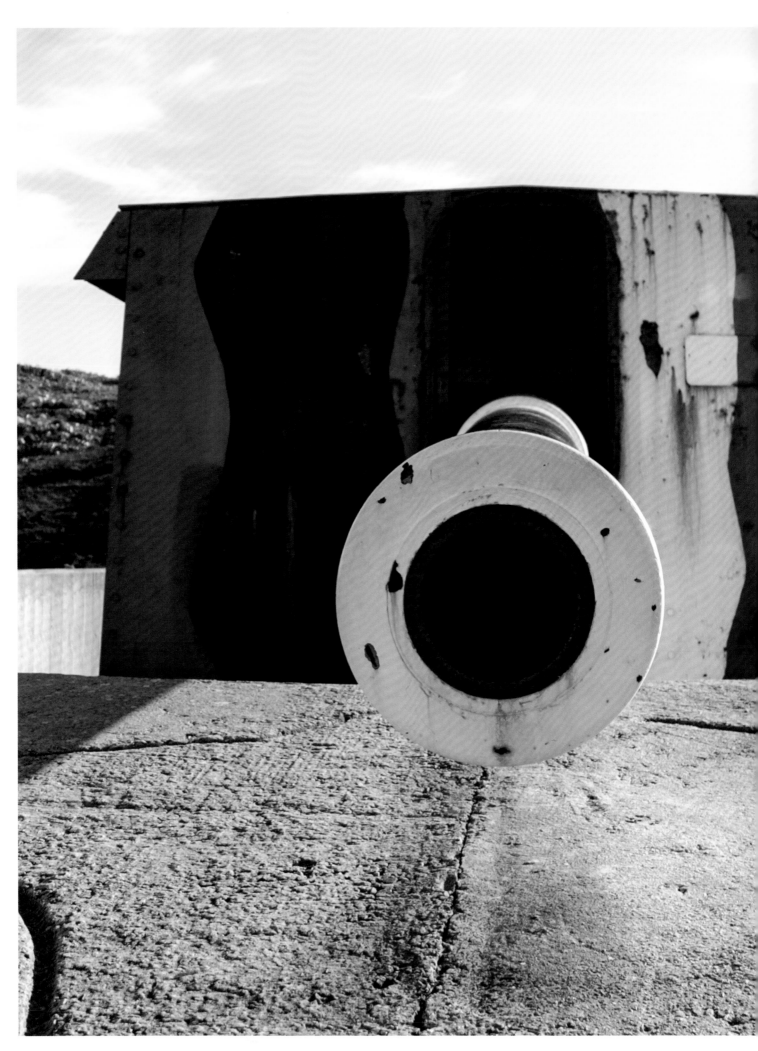

LEFT:
Scala Battery, Simon's Town, South Africa
Scala Battery was just one of several major coastal gun emplacements around Naval Base Simon's Town on the southern coast of South Africa. This mighty piece is a 9.2in Redhill gun, and the battery was in operation from 1906 to 1947.

OVERLEAF:
Aristea, **Hondeklipbaai, South Africa**
The *Aristea* is today unrecognizable as the ship that it was. It was originally a humble fishing vessel, but during the war it was repurposed as a minesweeper, clearing Axis naval mines from South African coastal waters. The ship's end, however, came not from battle but from – according to the prevailing story – a drunken captain who failed to navigate the ship properly during a storm. The ship ran aground, with one crew member dying in the subsequent wreck.

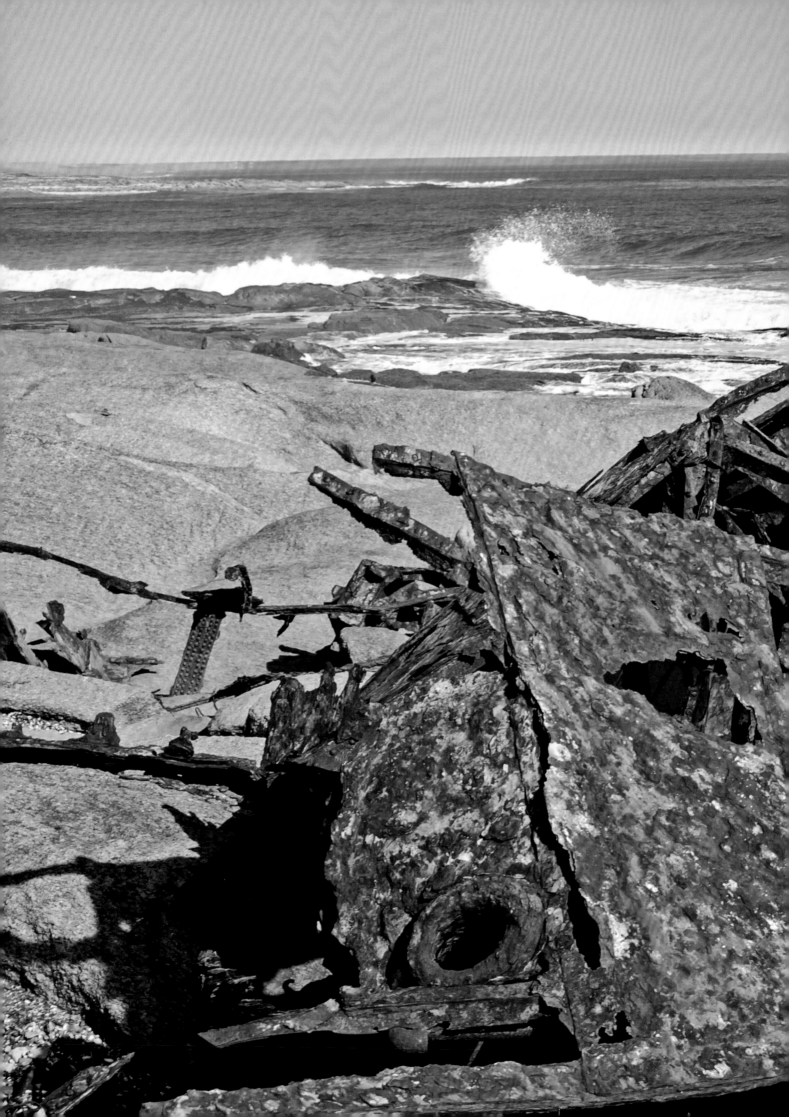

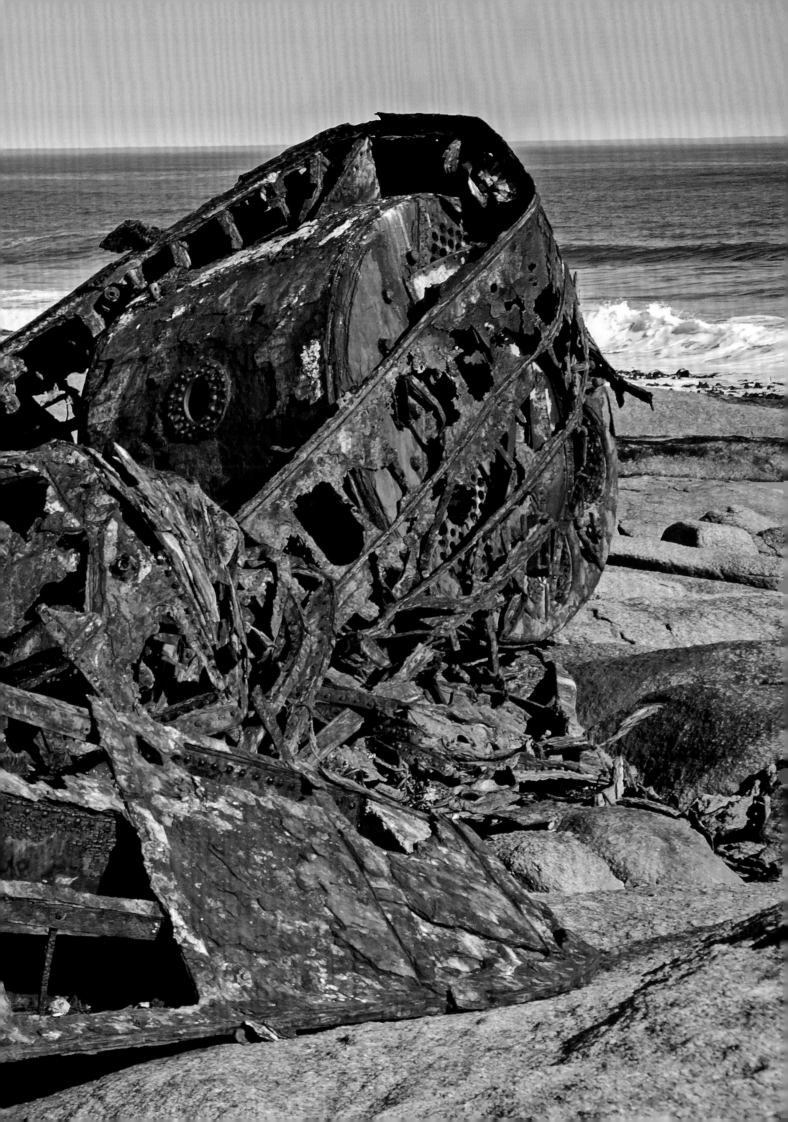

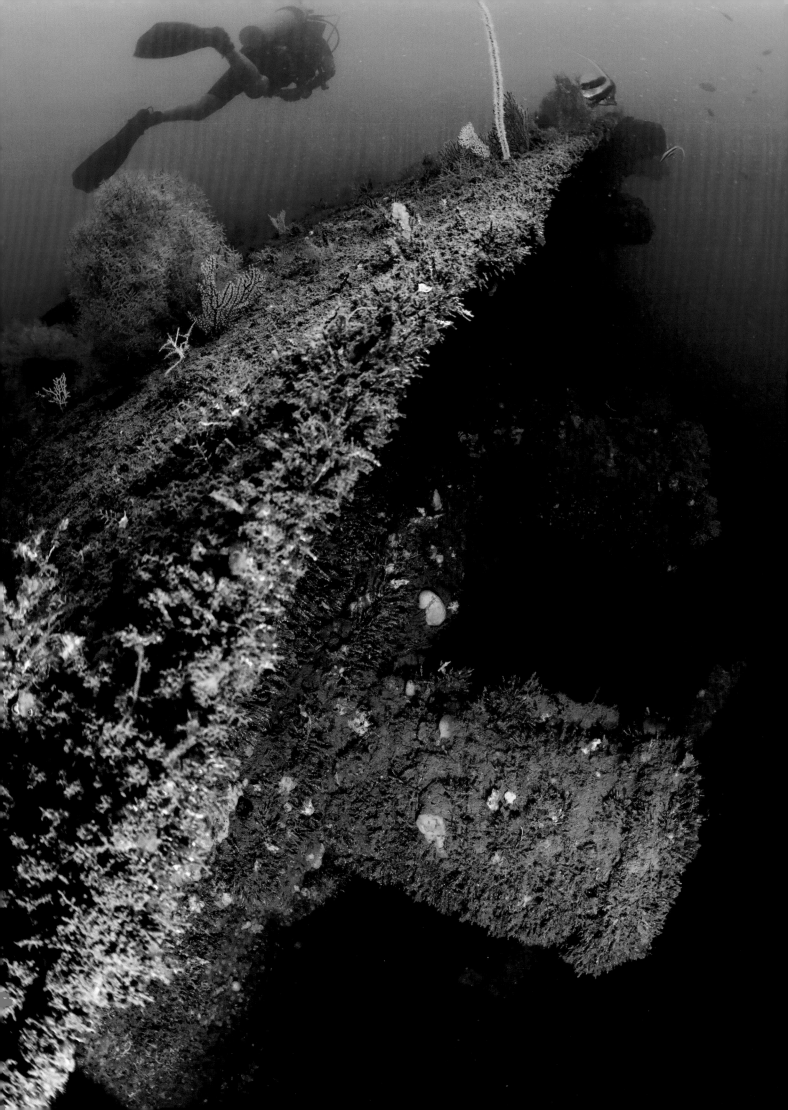

Asia and the Pacific

The Pacific climate is largely unfriendly to the preservation of the wrecks and materiel of World War II. High temperatures and equally high humidity in many of the key former battlegrounds produce aggressive rusting, while objects submerged in the seas and ocean are heavily and colourfully smothered in aquatic life. Yet such was the scale of warfare in this region, and such is the remoteness of many of the battlefields (which protects the sites from tourists and scavengers), that this vast expanse of our planet is still replete with reminders of the world war.

The Pacific War began on 7 December 1941 with the Japanese carrier attack on the US Pacific Fleet base at Pearl Harbor, a predatory event that initiated a vast Japanese offensive across Southeast Asia and the Pacific territories. (War between China and Japan had already been ongoing since 1937.) The new Japanese Empire had reached its territorial peak by mid-1942, after which the United States and European allies began the agonizing and brutal three-year effort to claw back Japanese gains, which they did at exceptional cost in human suffering. The battles for the Pacific territories were of great ferocity, often in geographically confined spaces. The battle for Iwo Jima (19 February–26 March 1945), for example, was for an island of just 21 square kilometres (8 sq miles), but cost more than 18,000 Japanese dead and 26,000 US casualties. Only the two atomic bombs in August 1945 brought this dreadful conflict to a close.

OPPOSITE:
Seian Maru, northwest of the Bonin Islands, Pacific
A diver passes quietly over the encrusted hull of the Japanese transporter *Seian Maru*, torpedoed and sunk by the submarine USS *Snapper* on 1 October 1944.

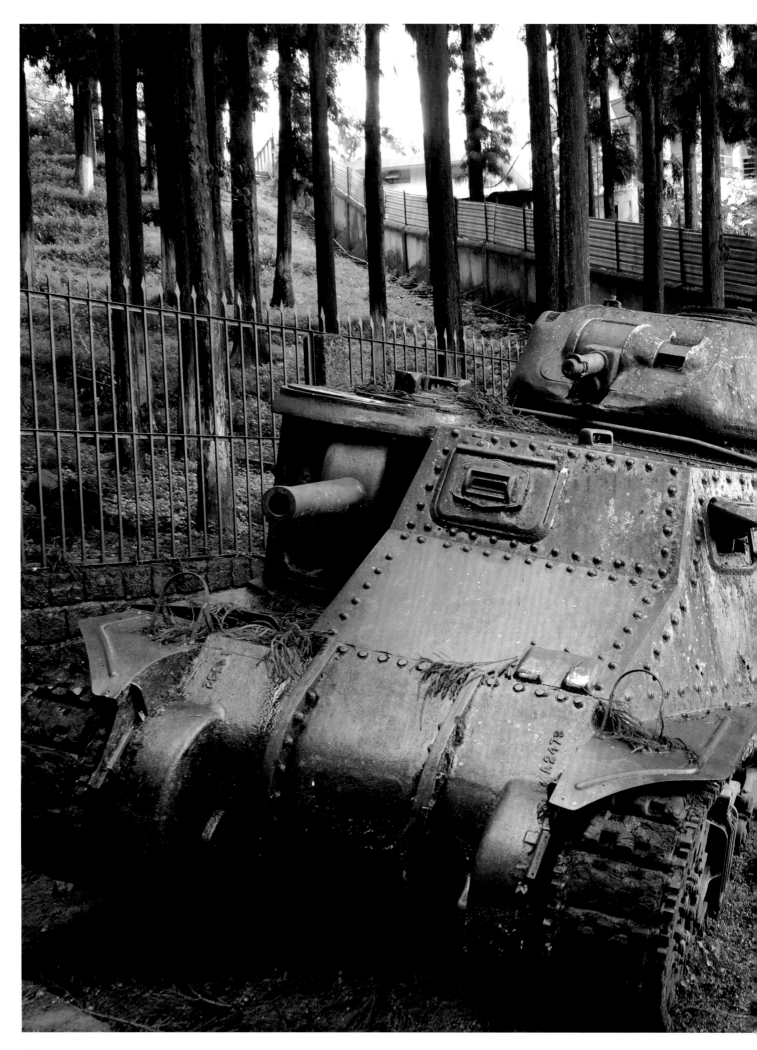

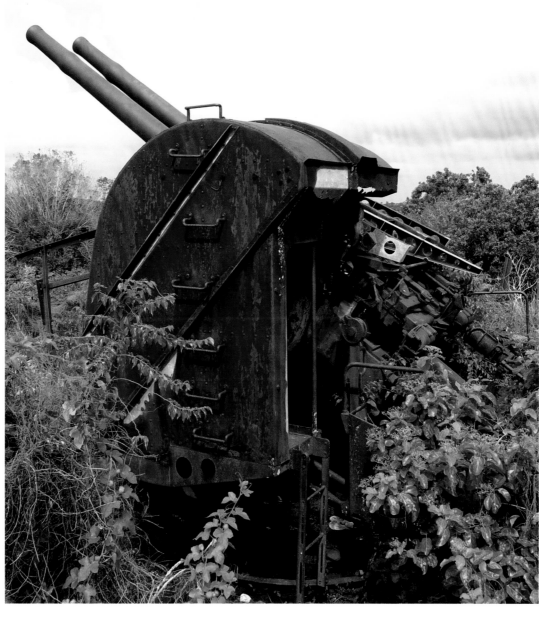

LEFT:

M3 Grant, Kohima, India
This Grant M3 medium tank
today stands in exactly the same
place as it was abandoned on
6 May 1944, during the ferocious
fighting around Kohima. The tank
had been climbing Kohima Ridge
to support British troops of the
2nd Division, but it struck a tree
and was disabled.

ABOVE:

**British naval guns, Naura,
Punjab, India**
India, still a British colony during
World War II, was readied by the
Allies for a Japanese invasion,
although the only attempt at such
made by the Japanese was repelled
at Imphal in 1944. This position
consists of QF 4in (50mm) naval
guns in a twin mount.

Showa/Nakajima L2D Subic Bay, Philippines

Stripped of its surrounding cockpit, the pilot's seat of a Showa /Nakajima L2D lies in the remains of the aircraft at the bottom of Subic Bay. This twin-engine aircraft was a Japanese licence-built copy of the Douglas DC-3, and was given the reporting name 'Tabby' by the Allies.

Oryoku Maru, **Subic Bay, Philippines**

Natural beauty can mask the tragedy of the Pacific underwater wrecks. Here bigeye trevally fish school around the remnants of the transporter *Oryoku Maru*, sunk by US carrier aircraft on 15 December 1944 with 1620 Allied POWs on board. About 270 of them died aboard the ship, and many more from subsequent Japanese mistreatment.

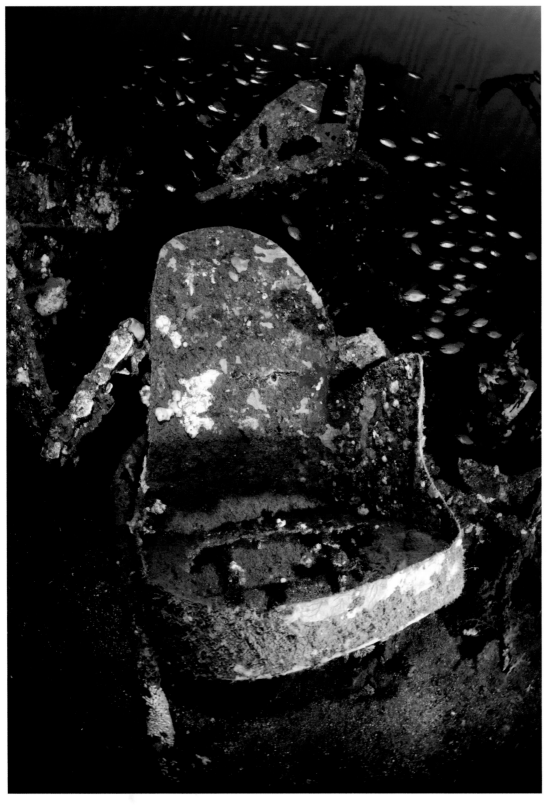

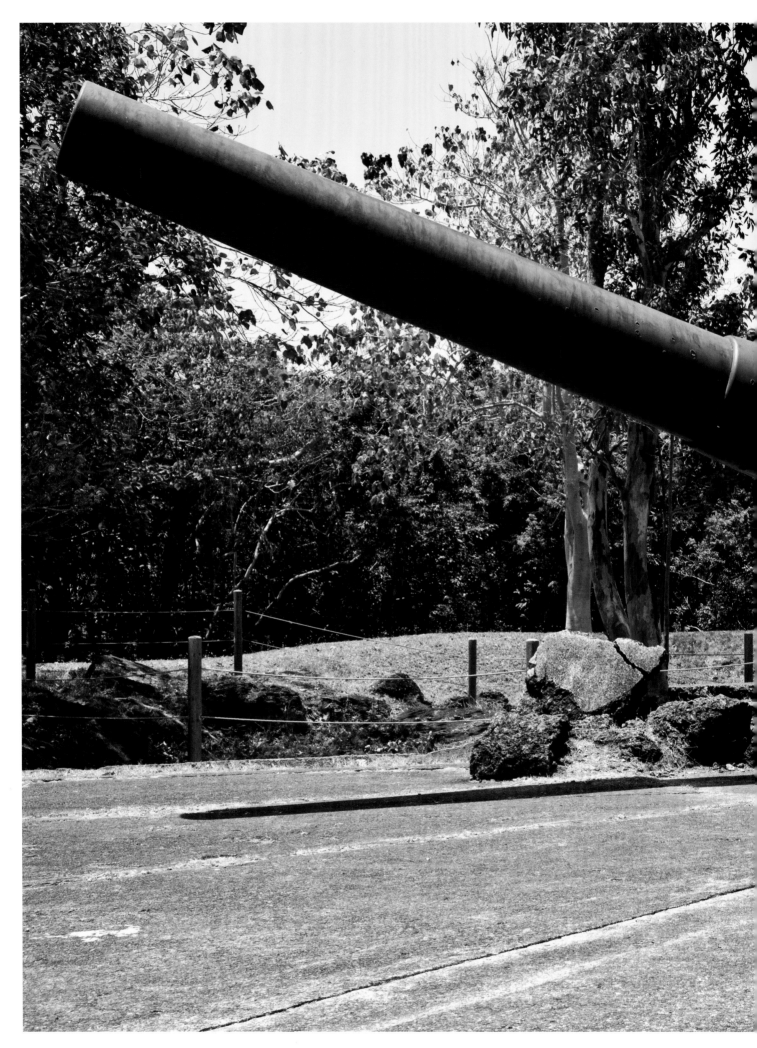

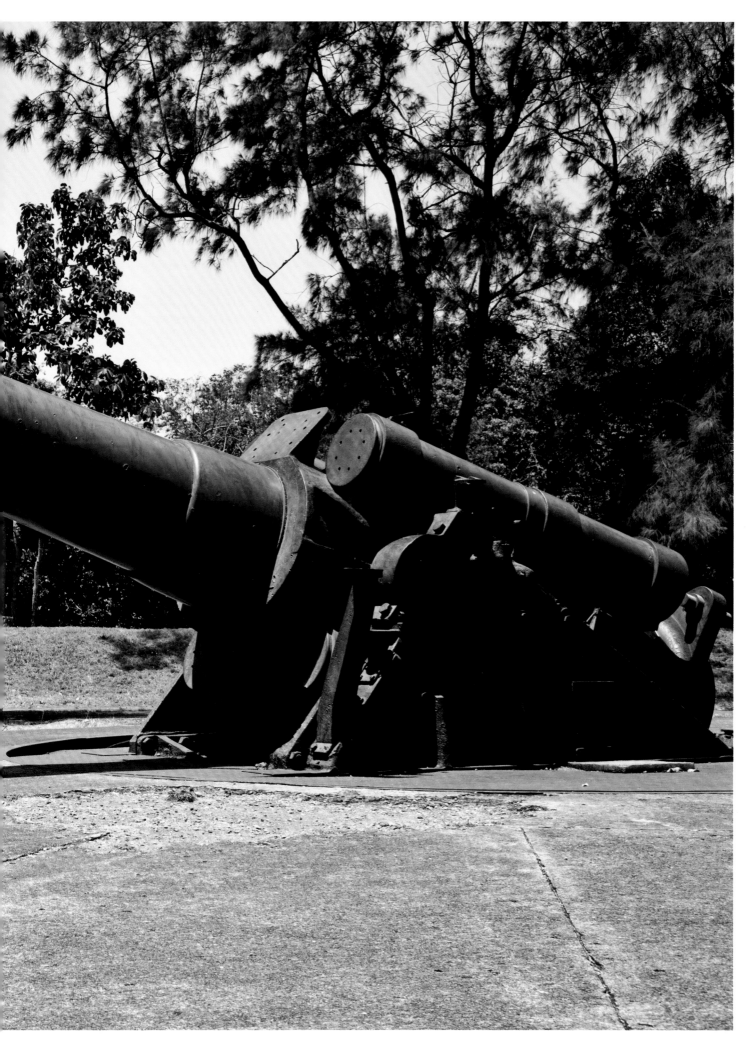

Fort Mills, Corregidor island, Philippines

Fort Mills was a complex of US-built defences on Corregidor Island, constructed from 1904. This gun, a 12in M1895, was a 1940 addition to the site; batteries 'Smith' and 'Hearn' each had one of these guns.

RIGHT TOP:

Wreck, Coron Bay, Philippines

The waters of Coron Bay in the Philippines are replete with Japanese wartime wrecks. Most of the ships were destroyed in a concerted attack on a supply fleet by 24 Helldivers and 96 Hellcats on 24 September 1944.

RIGHT BOTTOM:

Wreck, Coron Bay, Philippines

A diver explores another of the Japanese wrecks of Coron Bay. The victims of the US attack included the *Akitsushima Maru*, a seaplane tender, and the 170m (558ft) long tanker *Okikawa Maru*.

OPPOSITE:

***Akitsushima Maru*, Coron Bay, Philippines**

The *Akitsushima Maru* had already survived bomb hits during its operational life, in September 1942 and February 1944, but in both cases had survived and was repaired. There was no surviving the attack of September 1944, however, as the ship took a single bomb hit that triggered massive secondary explosions, and it capsized in minutes. Here we can see engine room gauges.

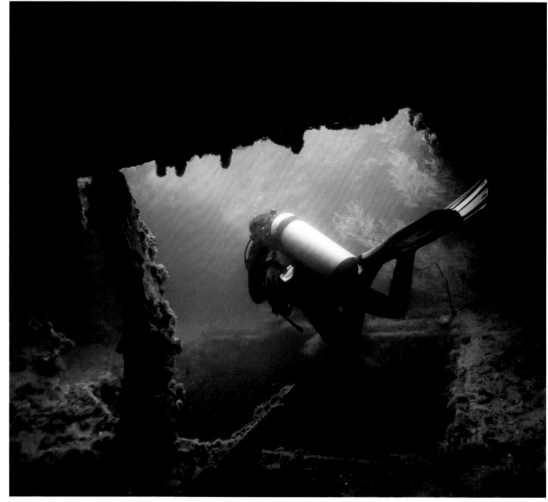

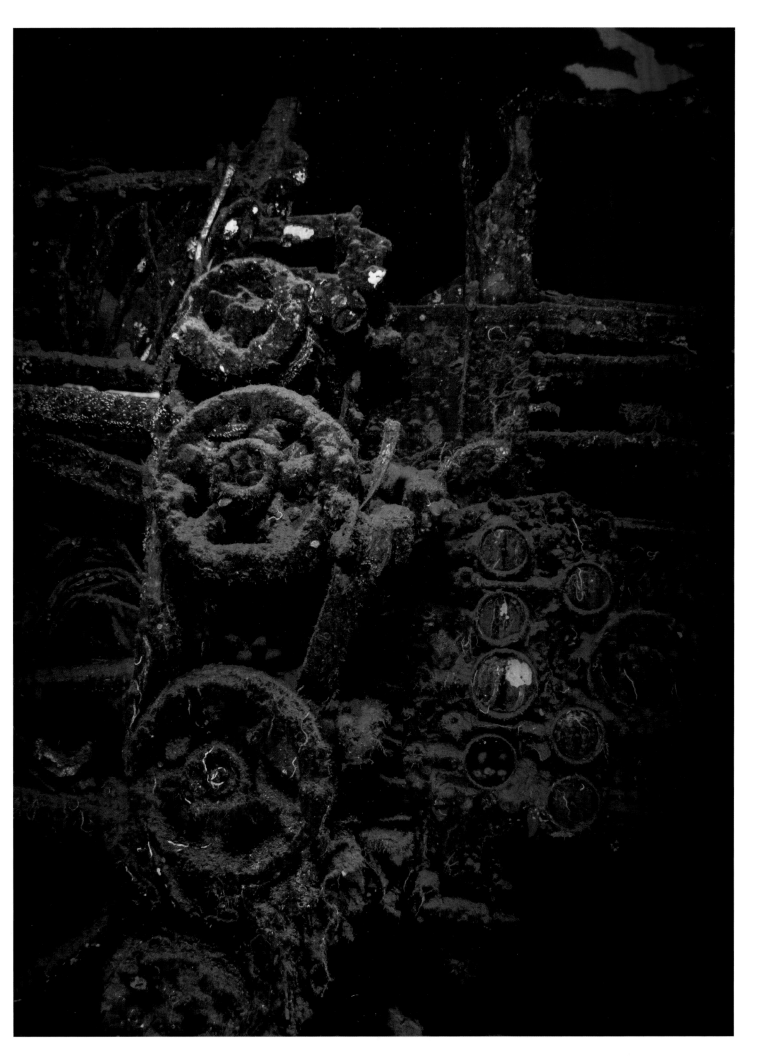

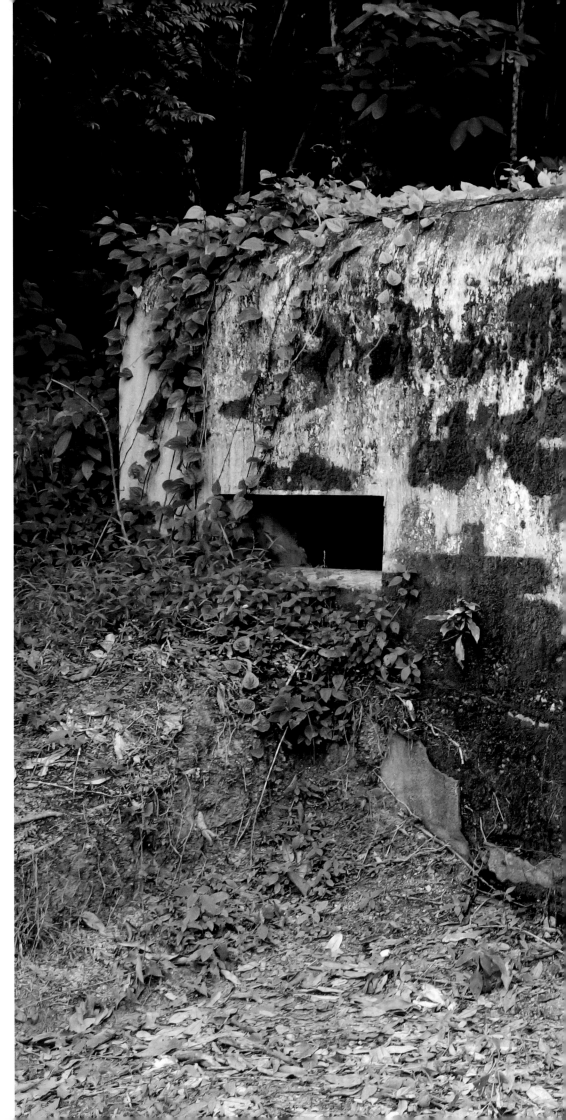

Concrete pillbox, Sidili, Johor, Malaysia
British colonial forces constructed multiple pillbox defensive positions around Malaya's vulnerable coastline regions in preparation for a possible Japanese invasion. In the end, Japanese skills in amphibious warfare meant that they could leapfrog down the coast in stages, often bypassing the British defences in the process.

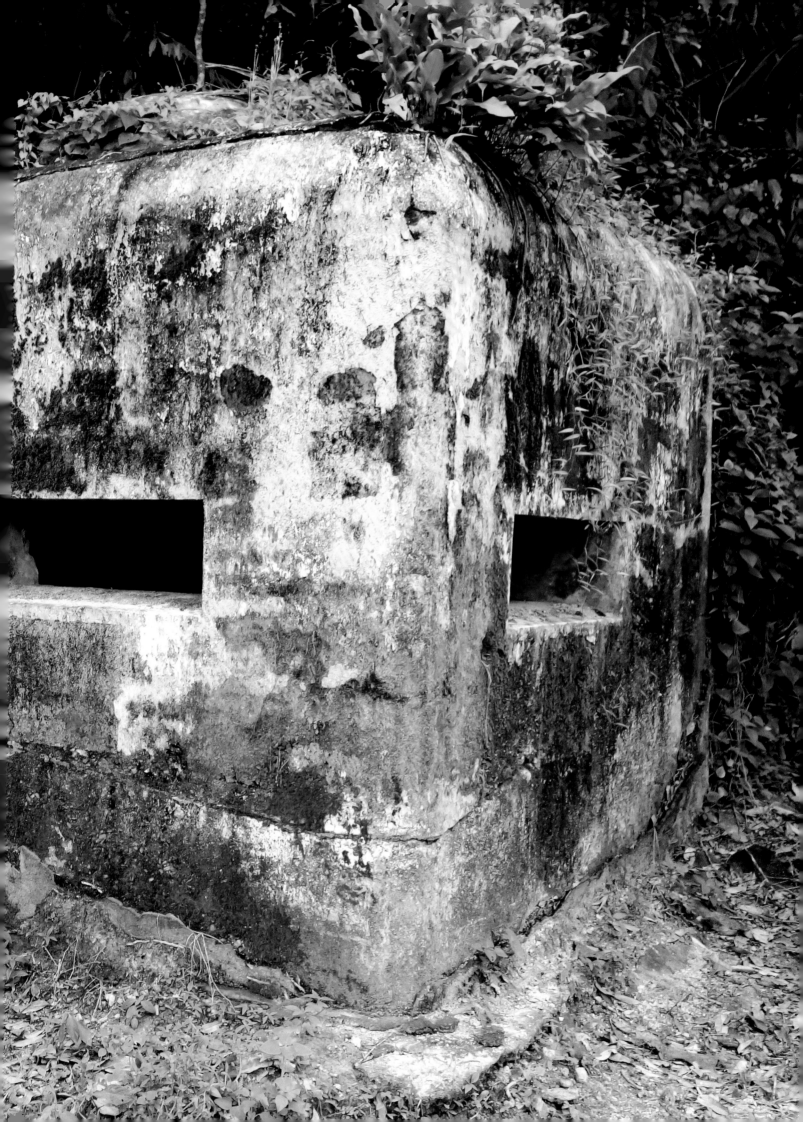

Consolidated B-24 Liberator, Kadidiri Island, Indonesia
The engine cowling of a US B-24 Liberator lies in the waters off Kadidiri Island, Indonesia. The aircraft was on a bombing mission on 3 May 1945 when its No.1 engine caught fire. Despite ditching all excess weight and equipment, the crew could not save the aircraft and the pilot was forced to ditch.

Consolidated B-24 Liberator, Kadidiri Island, Indonesia
More images of the B-24 (see previous page), including its upper ball turret. The pilot's crash report noted that 'We decided to ditch the plane rather than parachute because all these islands were heavily wooded with rough terrain. We would not have been able to carry all the necessary survival equipment with us and there was too much chance of parachutists becoming scattered and subject to serious injury alone.' All the crew survived and were rescued within hours by US aircraft.

USAT *Liberty*, Tulamben, Bali
On 11 January 1942, the USAT *Liberty* cargo ship was torpedoed by the Japanese submarine *I-66* near the Lombok Strait. The damaged ship was towed to the north coast of Bali by US destroyers and beached, but in 1963 an earthquake resulted in the boat slipping back into the water and sinking.

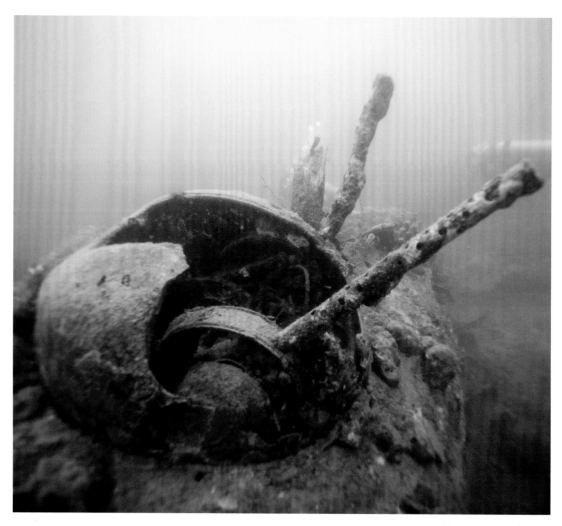

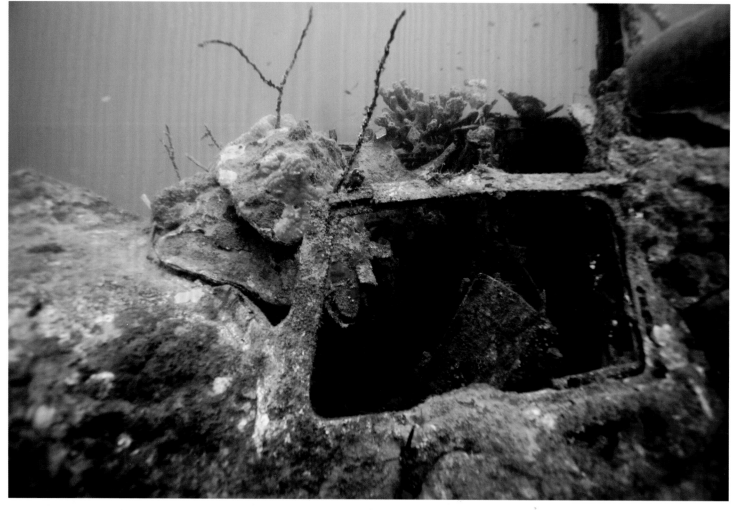

**Japanese bomb, Biak,
West Papua, Indonesia**
A rusting but reassuringly defused
Japanese bomb nestles under the
wing of a wreck at the site of the
Japanese airfield on Biak, West
Papua. The airfield itself was
captured by the US forces in 1944.

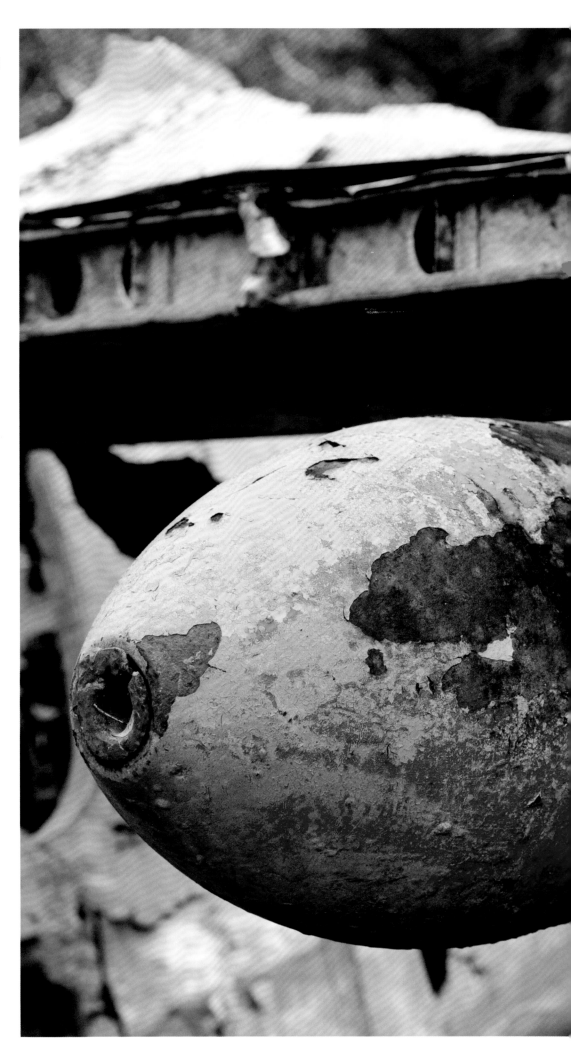

LEFT:

Automatic cannon, Sai Kaew Beach, near Pattaya, Thailand
The muzzle of this World War II cannon remains trained on Sai Kaew Beach (also known as the 'Navy Beach'). The specific weapon type appears to be a Japanese Type 99 20mm (0.79in) cannon, set in a double shield mount.

OVERLEAF:

Douglas DC-3, Jar Island, Vansittart Bay, Kimberley Coast, Western Australia
This wartime DC-3 aircraft, remarkably preserved under the dry climate of Western Australia, came to grief in February 1942 when the pilot, flying from Perth to Broome, made a navigational error and was forced to crash land, happily without casualities.

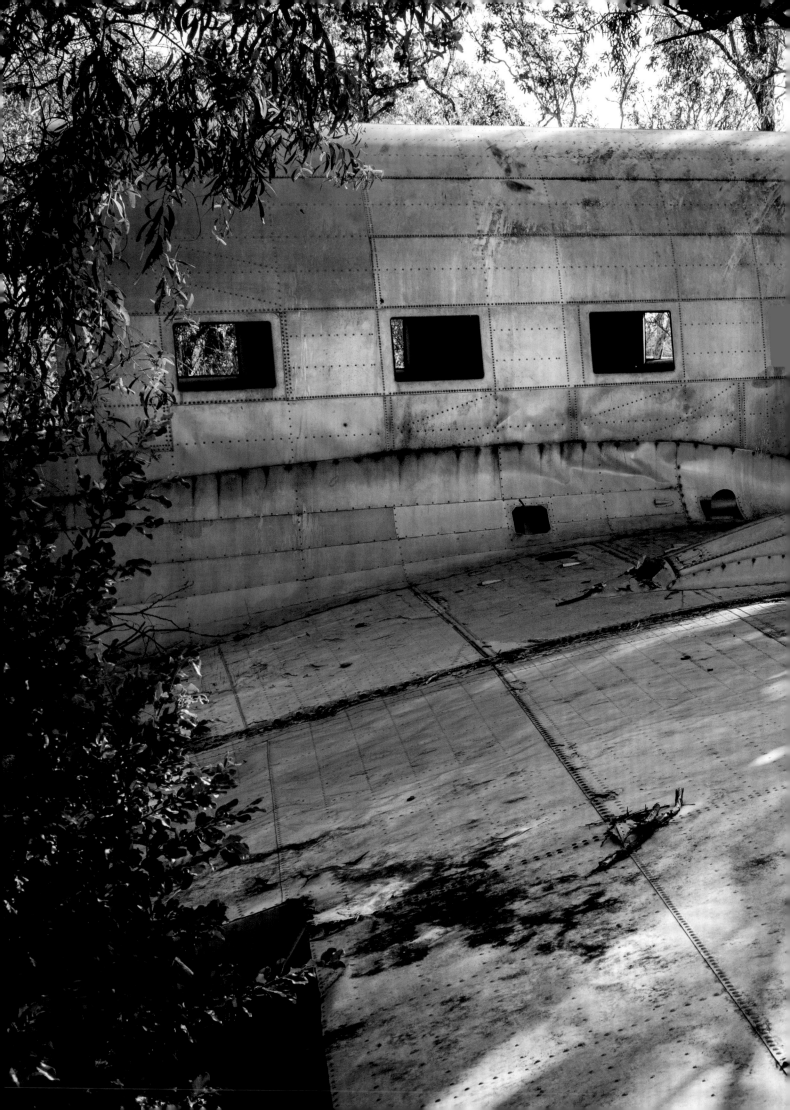

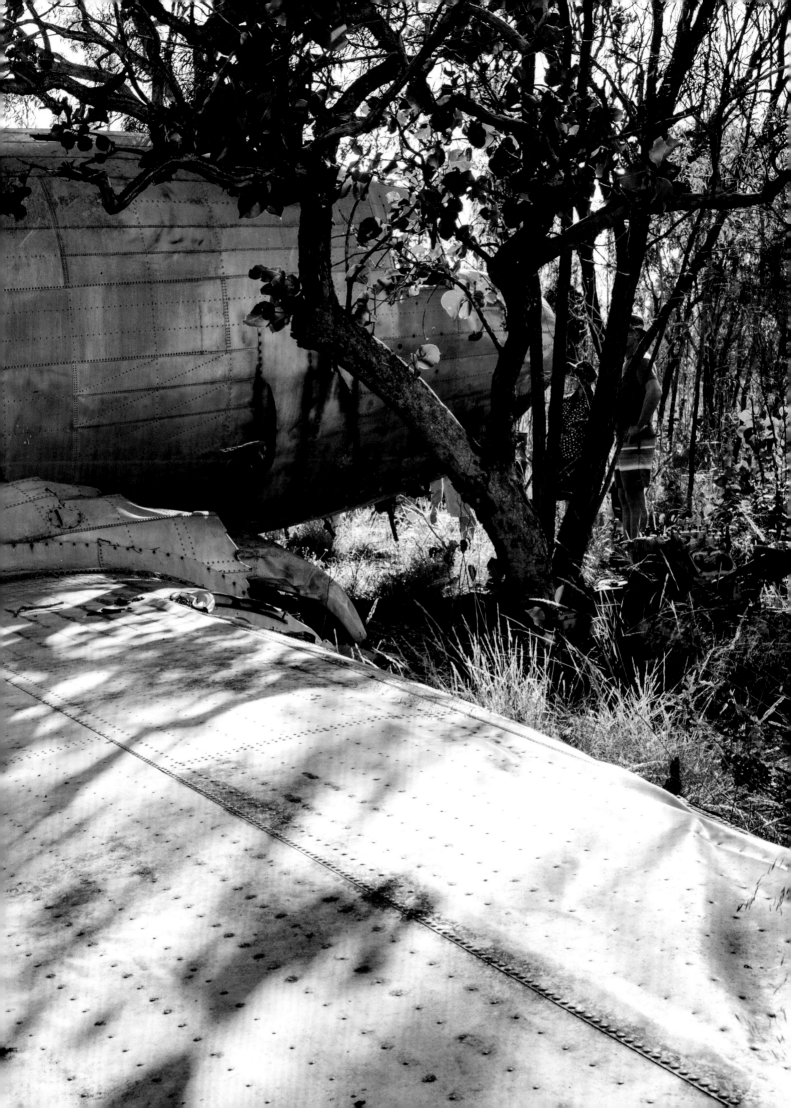

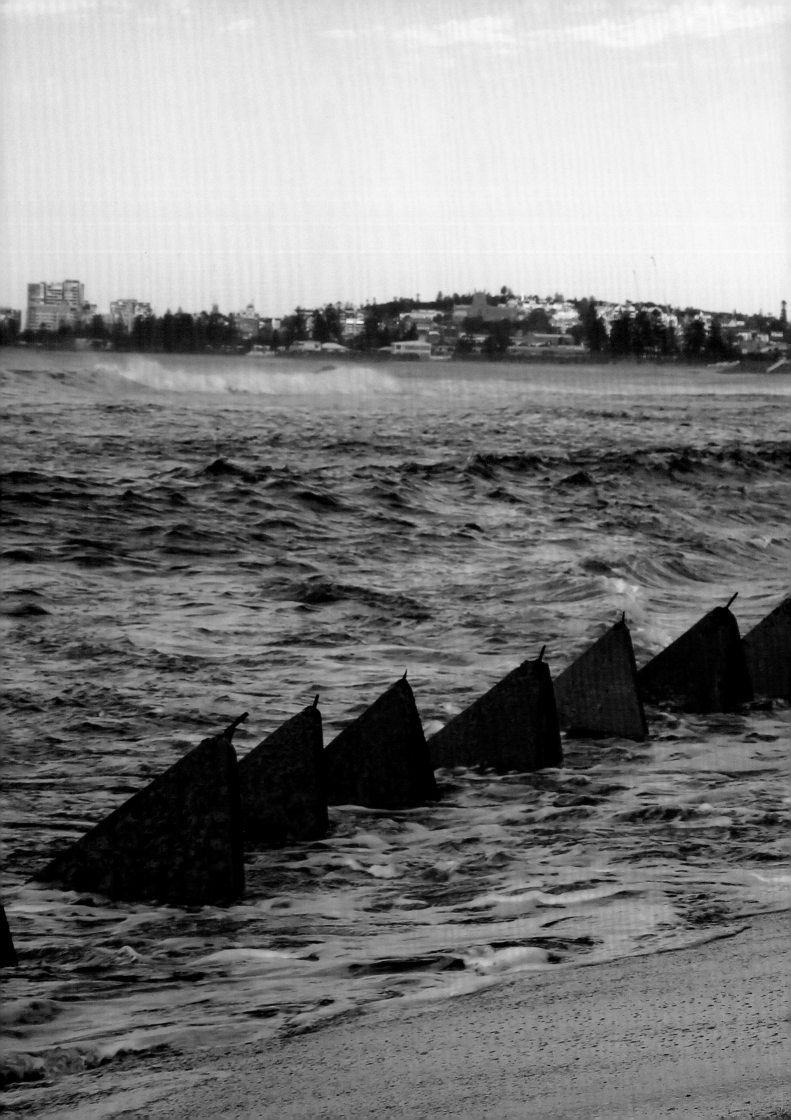

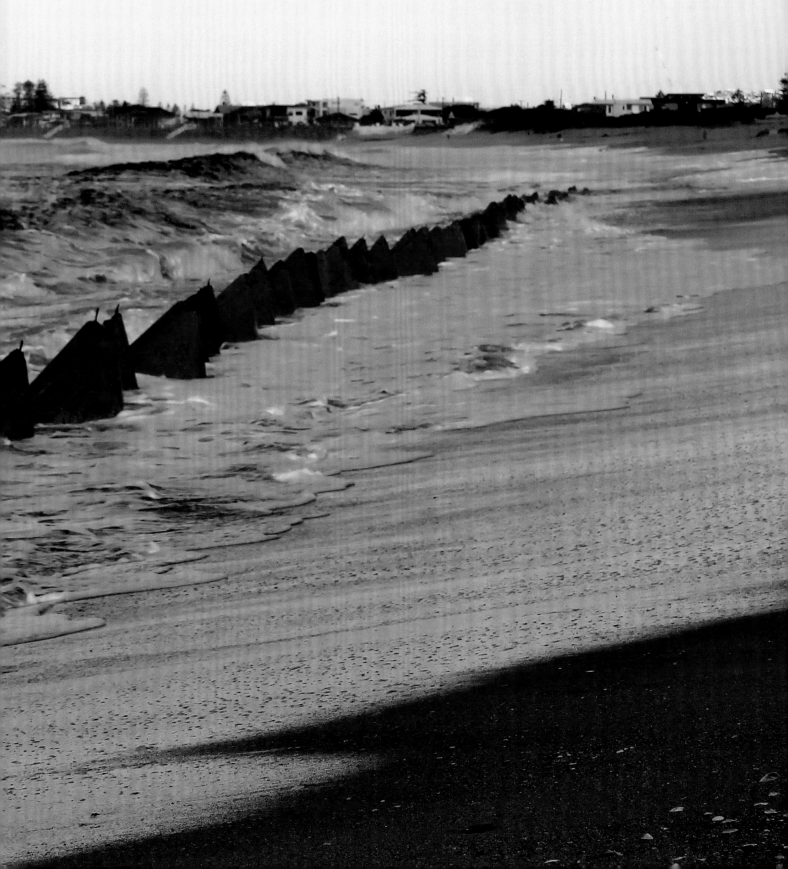

Tank traps, Stockton Beach, New South Wales, Australia
This line of tank traps were first revealed in May 2015, when stormy weather clawed away the beach and left them jutting out of the sand. The traps were emplaced on the beach in 1942, when a Japanese invasion of Australia was a genuine fear, albeit one not ultimately realized.

**BL 6-inch Mark VII gun,
Fort Scratchley, Newcastle,
New South Wales, Australia**

Fort Scratchley was a coastal
defence station set on the south-
eastern Australian coastline. It was
built in 1882, but heavily modified
over subsequent decades. Two
BL 6-inch Mark VII guns were
installed during World War II, and
both opened fire on 7–8 June 1942,
trading shots with an offshore
Japanese submarine.

BELOW:

DC-3, near Bamaga, Queensland

The remains of this DC-3 aircraft
stand as a brutal memorial to the
four crew and two passengers who
died when the aircraft crashed on
4 May 1945. VH-CXD departed
Archerfield in Brisbane en route
to New Guinea, but the aircraft
crashed after it clipped some trees.

OPPOSITE BELOW RIGHT:

**Coastal gun, Green Hill Fort,
Thursday Island, Australia**

Green Hill Fort was actually built
in the late nineteenth century to
guard against a potential Russian
invasion. During World War II,
Thursday Island served as the
headquarters for Allied military
operations in the Torres Strait.
Here we see one of three coastal
guns mounted at the site.

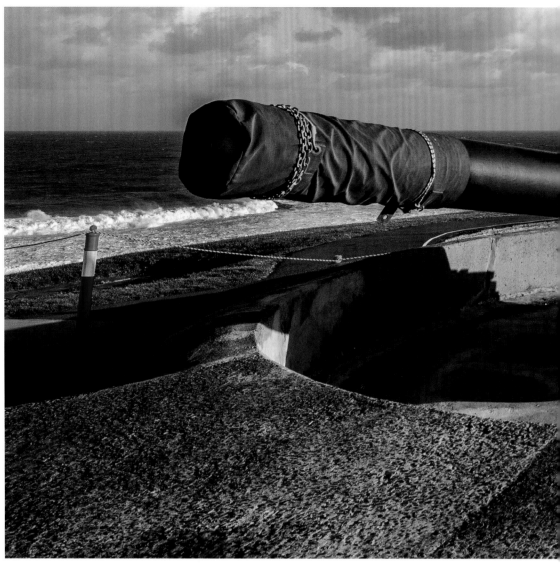

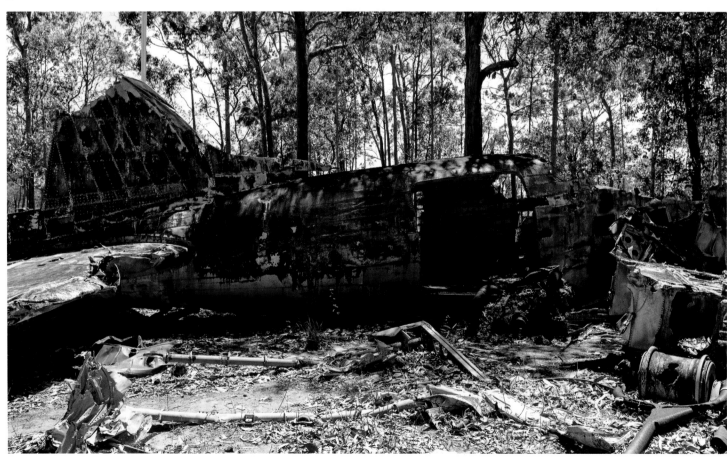

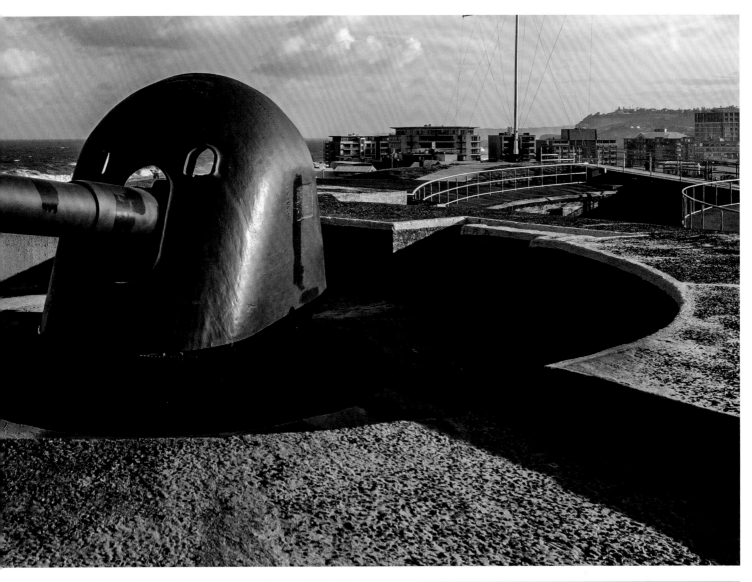

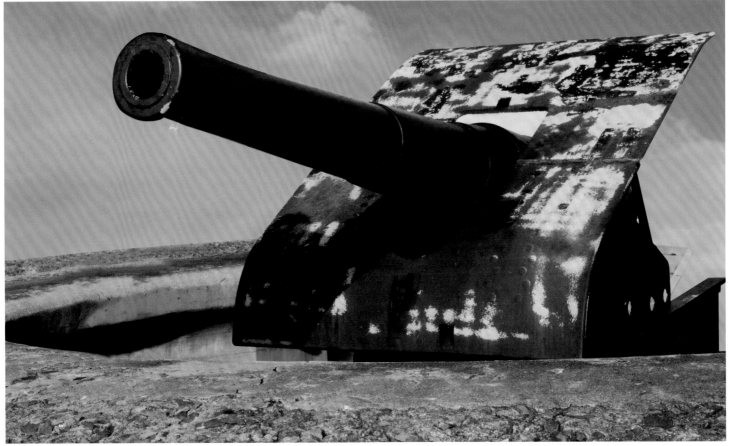

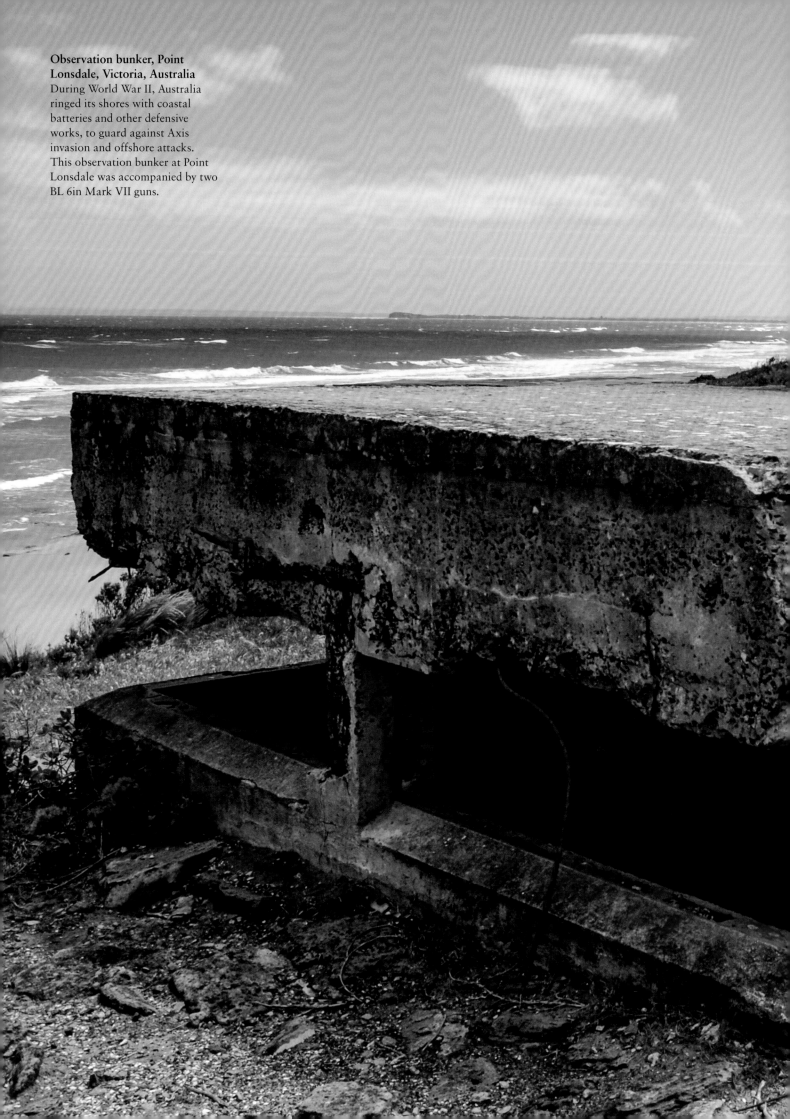

Observation bunker, Point Lonsdale, Victoria, Australia
During World War II, Australia ringed its shores with coastal batteries and other defensive works, to guard against Axis invasion and offshore attacks. This observation bunker at Point Lonsdale was accompanied by two BL 6in Mark VII guns.

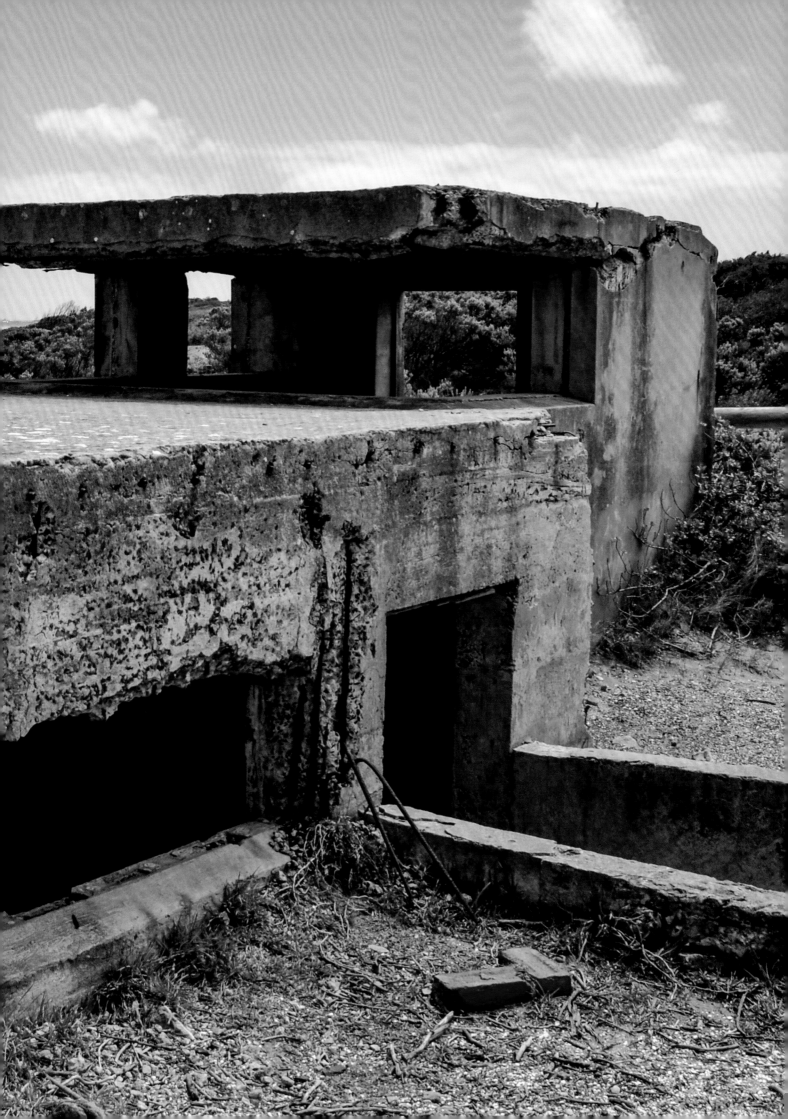

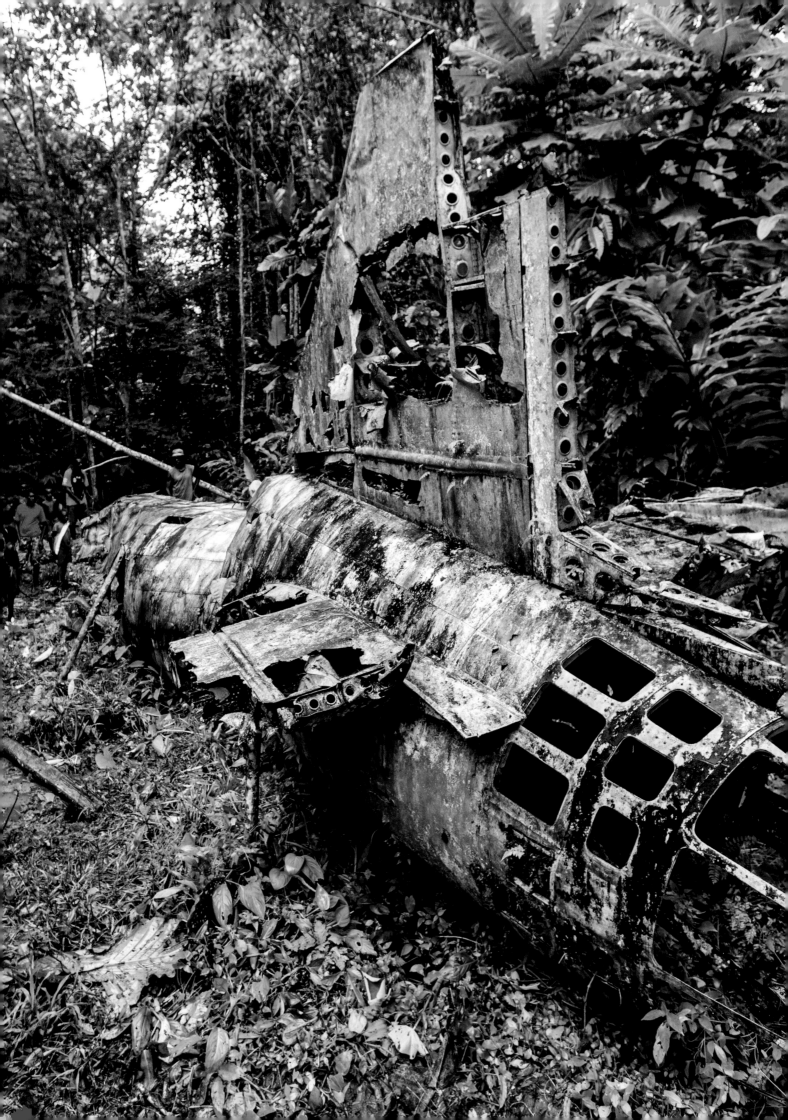

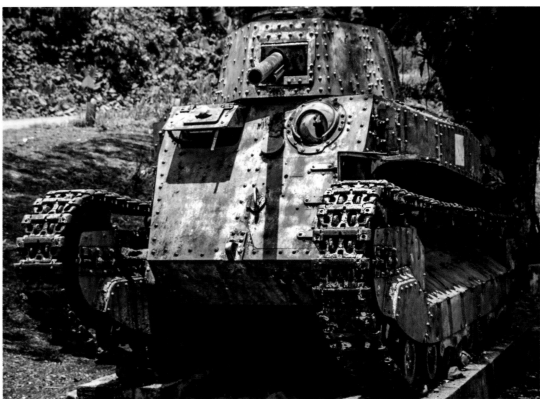

LEFT:
Mitsubishi G4M 'Betty', Bougainville, Papua New Guinea
This Japanese aircraft wreck, buried in the jungles of Bougainville, actually carries special historical weight. When it was shot down on 18 April 1943, it was carrying Admiral Isoroku Yamamoto, commander of the Imperial Japanese Navy and architect of the Pearl Harbor attack – he died in the crash.

ABOVE TOP:
Type 89 I-Go tank, Bougainville, Papua New Guinea
Japanese armour was often lagging behind the curve of development in World War II. The Type 89 medium tank was designed in the late 1920s and, by the Japanese campaign of 1941–42, was obsolete. Its 57mm (2.24in) cannon, however, was useful for knocking out bunkers and other defences at close range.

ABOVE BOTTOM:
120mm Type 10 gun, Muschu Island, Papua New Guinea
On the night of 11 April 1945, eight Australian Z Special Unit commandos made a covert amphibious landing on Muschu, with the intention of destroying the two naval guns emplaced there. They were quickly detected, however, and only one of the commandos actually survived the raid.

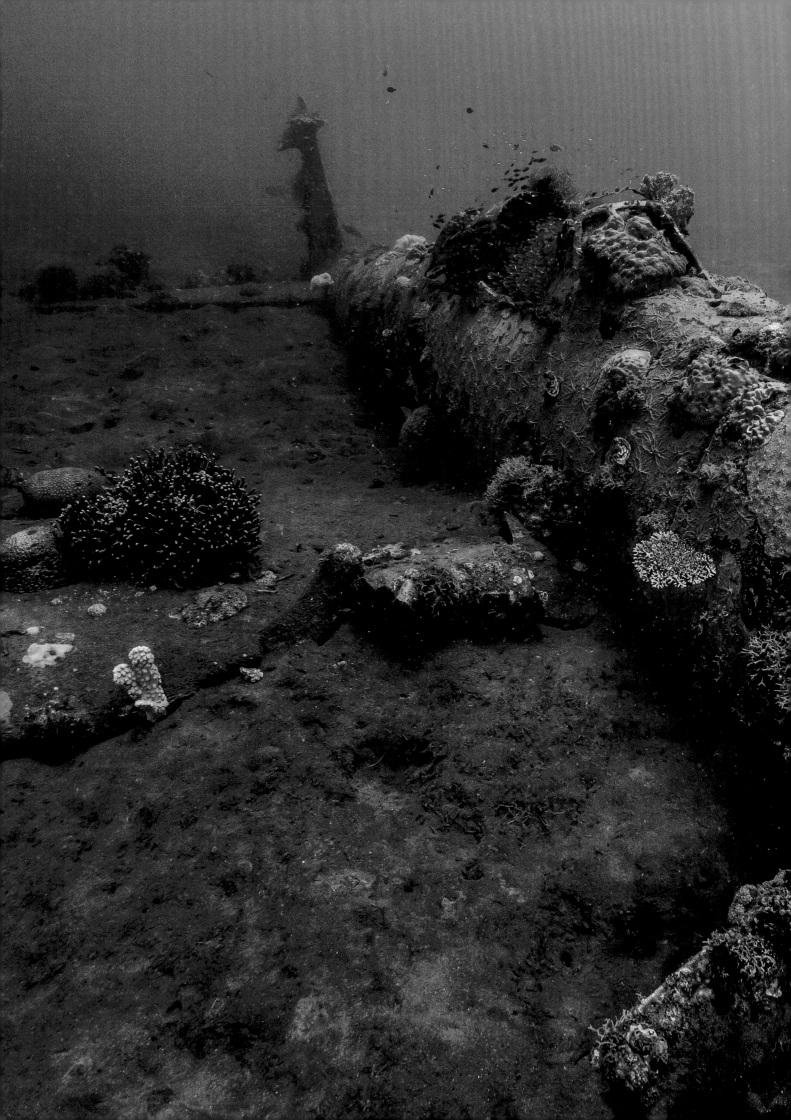

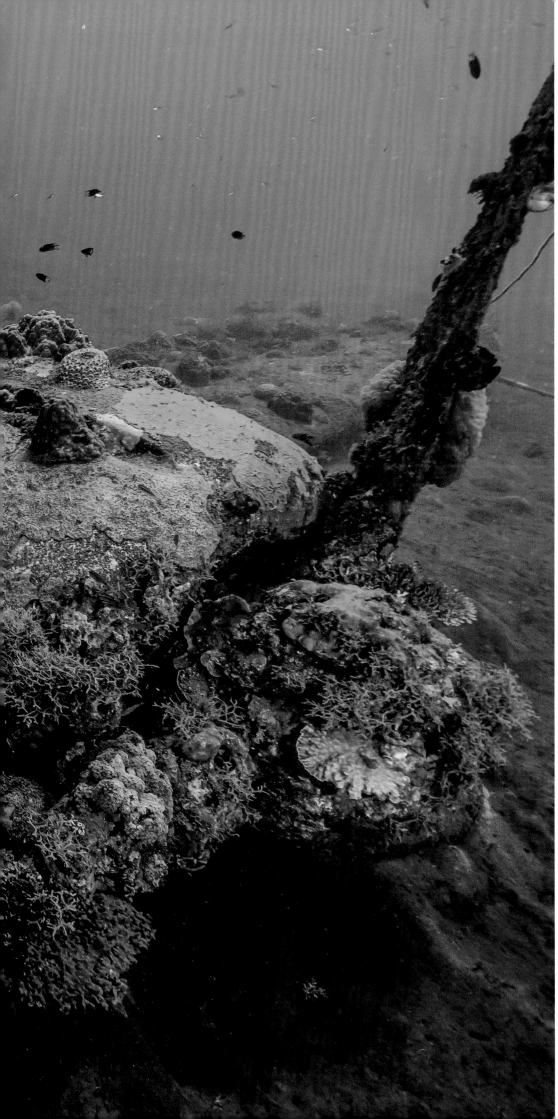

**Mitsubishi A6M 'Zero',
Kimbe Bay, Papua New Guinea**
With its fuselage impressively
intact, this submerged Zero fighter
still evokes a sense of aerial power.
A study of the aircraft found
the throttle in the 'off' position,
suggesting that the fighter ran out
of fuel and ditched.

153

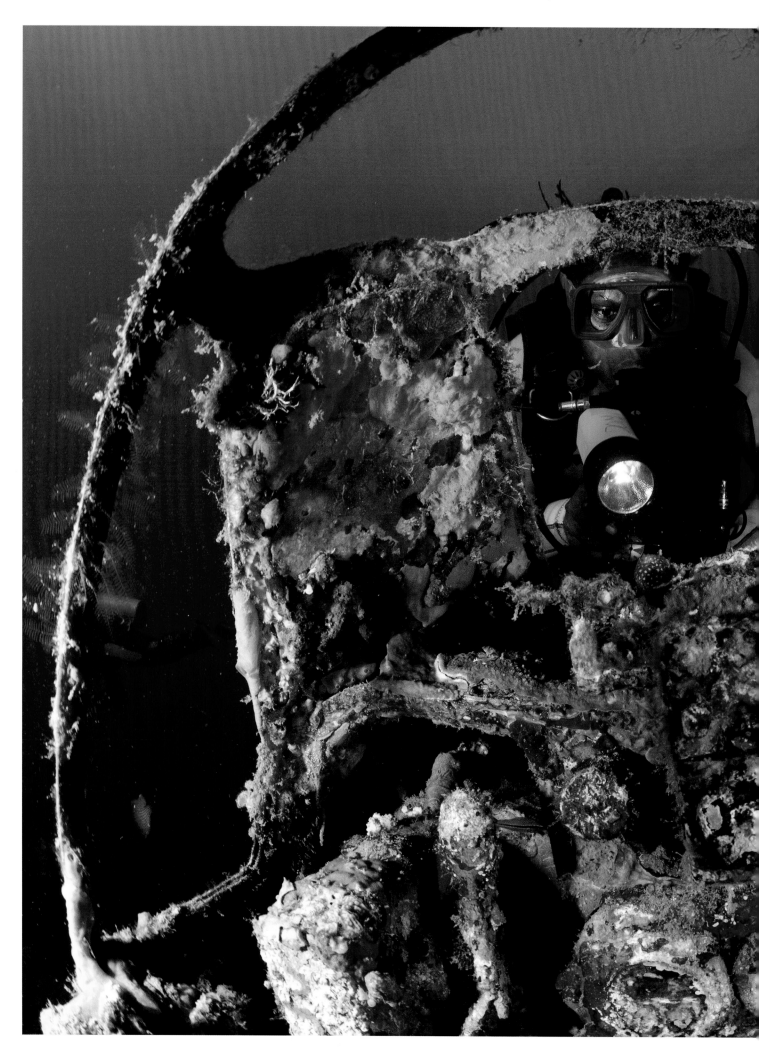

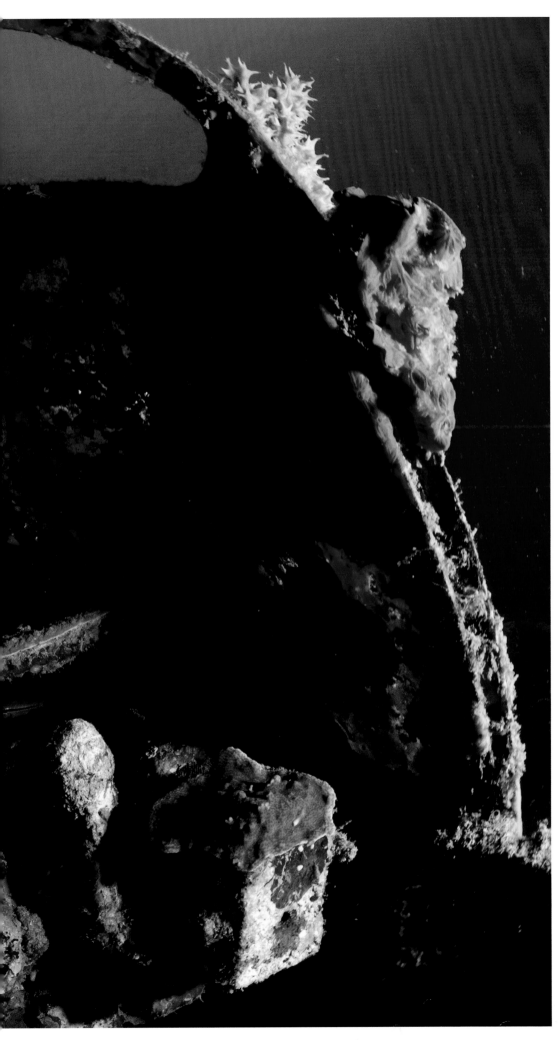

**Mitsubishi A6M 'Zero',
Kimbe Bay, Papua New Guinea**
This viewpoint is from the pilot's
seat of an A6M Zero, with hints
of instrumentation still visible.
Although the Zero was a capable
fighter aircraft, by 1944 it was
outclassed by US aircraft, as were
its often ill-trained pilots by their
well-trained US opponents.

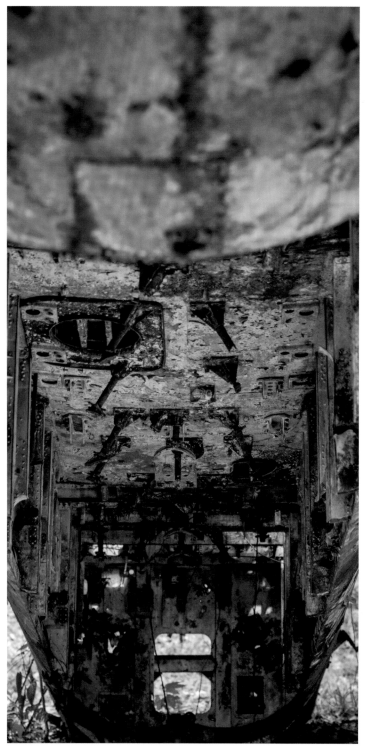

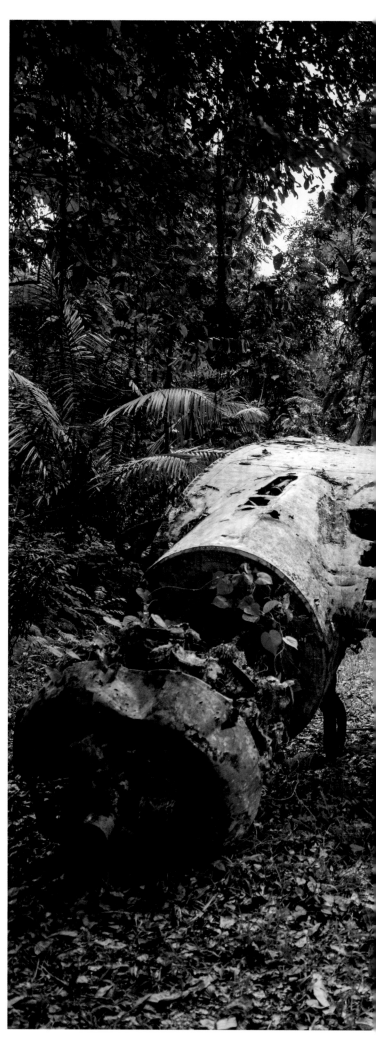

ABOVE AND RIGHT:
Nakajima Ki-49 *Donryu*, near Madang, Papua New Guinea
While officially classed as a heavy bomber by the Japanese, the Ki-49 (US reporting name 'Helen') was more of a medium bomber type in terms of operational capabilities. When flown in its unescorted bombing role, it was acutely vulnerable to Allied fighters, and it tended to be diverted into logistical roles by war's end.

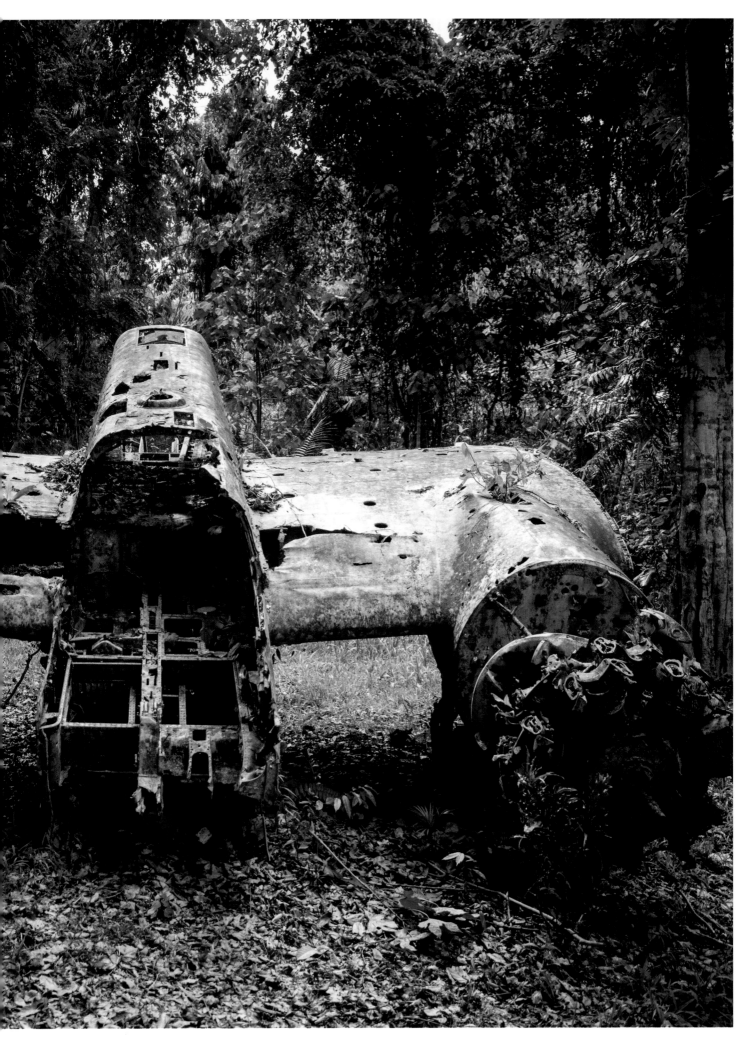

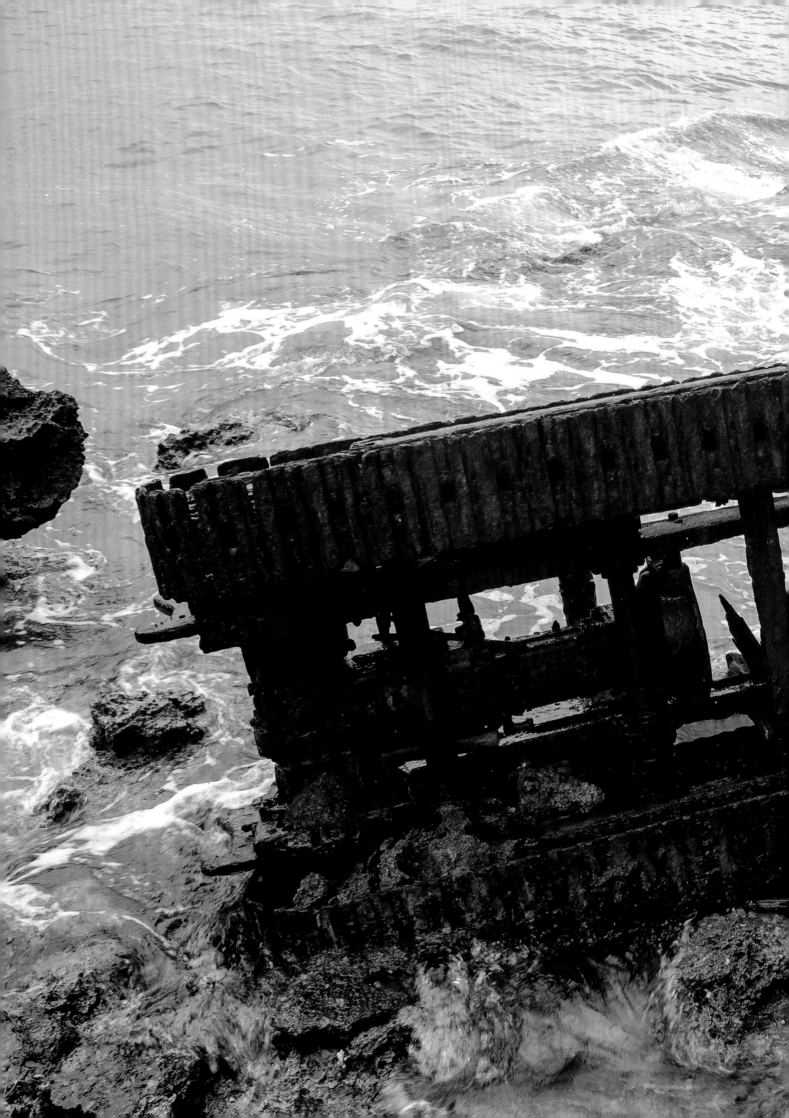

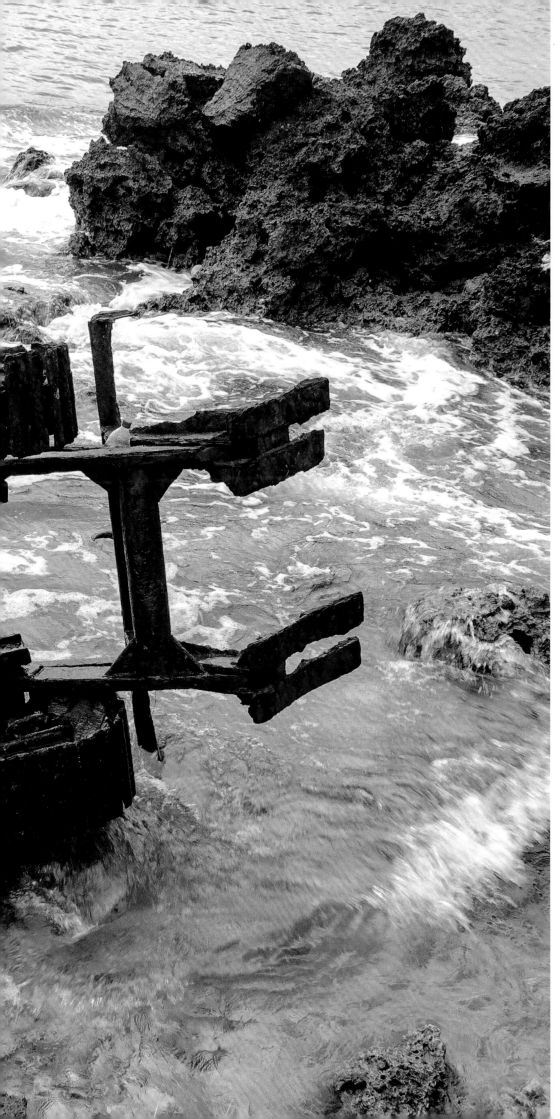

LEFT:

Tractor, Madang, Papua New Guinea

While this is not the most glamorous piece of war debris, vehicles such as this tractor made the Pacific War possible. Without tractors, the construction of US Pacific airfields and logistics bases would have been a tortuous process, if not impossible.

OVERLEAF LEFT (BOTH IMAGES):

USS *Saratoga*, Bikini Atoll, Marshall Islands

First commissioned in 1927, the aircraft carrier USS *Saratoga* served with distinction throughout World War II, playing a major role in the Solomon Islands and Guadalcanal campaigns, as well as taking some heavy hits from *kamikaze* attacks during the battle for Iwo Jima in 1945. In mid-1946, having been decommissioned, the ship was a target for nuclear weapons tests during Operation Crossroads. She survived the first test with little damage, but was sunk by the second test. The image at top shows some of the *Saratoga*'s 40mm (1.57in) Bofors anti-aircraft armament.

OVERLEAF TOP RIGHT:

Mitsubishi Ki-21 'Sally', Rabaul, Papua New Guinea

The Ki-21 'Sally' was arguably the best Japanese bomber in service. A five-seat medium type, it could carry a 1000kg (2205lb) bombload for a range of 2700km (1680 miles). While it was a capable weapon at the beginning of the Pacific War, by the end, however, it was either prey for US fighters or was used in *kamikaze* attacks.

OVERLEAF BOTTOM RIGHT:

Japanese landing barge, Rabaul, Papua New Guinea

Landing barges were the most nimble form of naval logistics for the Japanese armed forces, especially later in the war when US air and naval superiority made conventional merchant ship operations almost suicidal. Barges such as this one, rotting in a shelter at Rabaul, were used to ferry troops and cargo; a Daihatsu large landing barge could transport up to 70 fully equipped men or even a light tank.

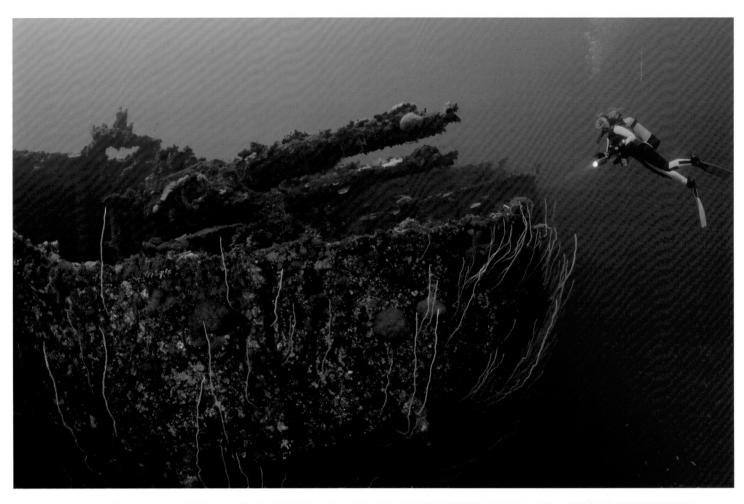

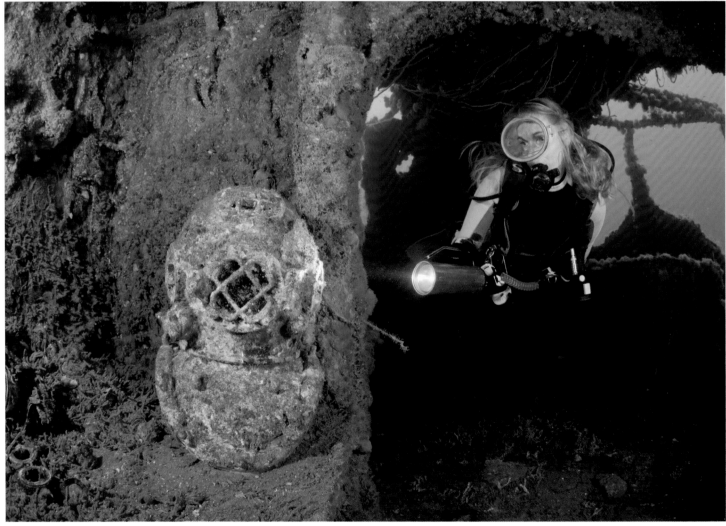

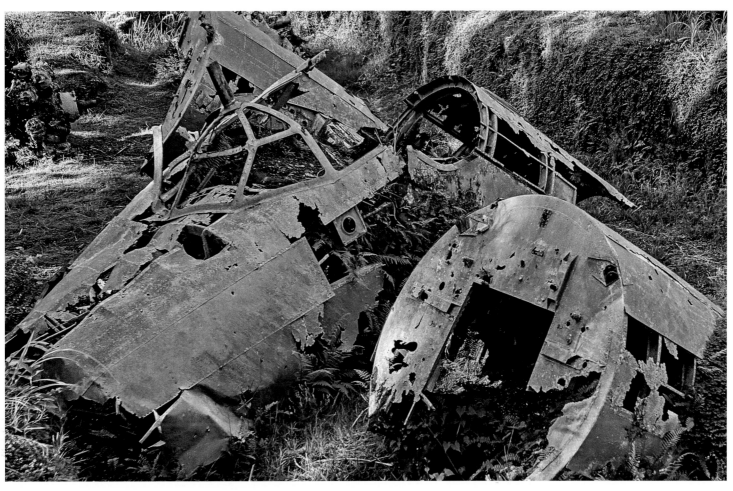

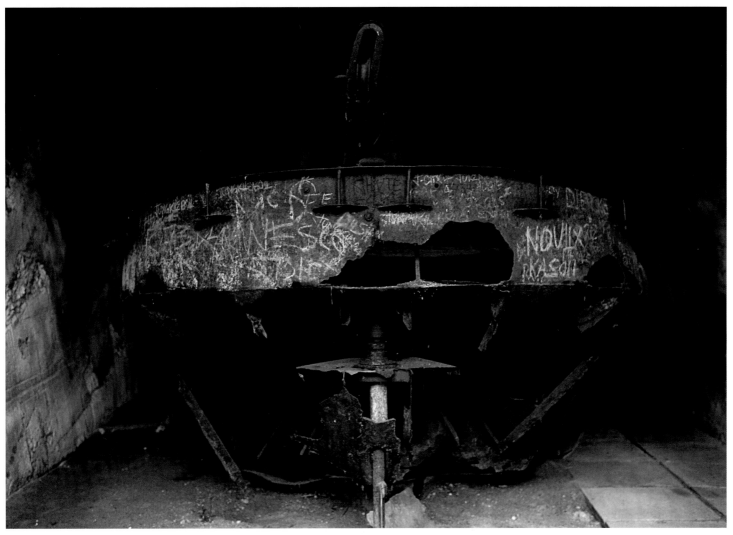

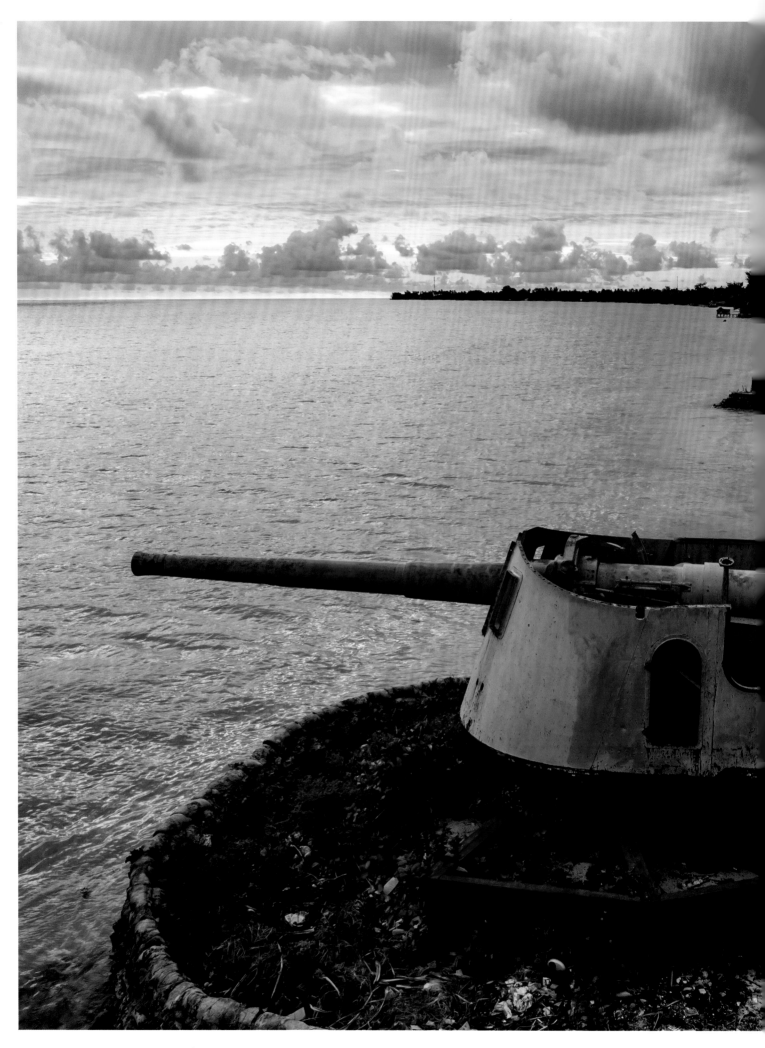

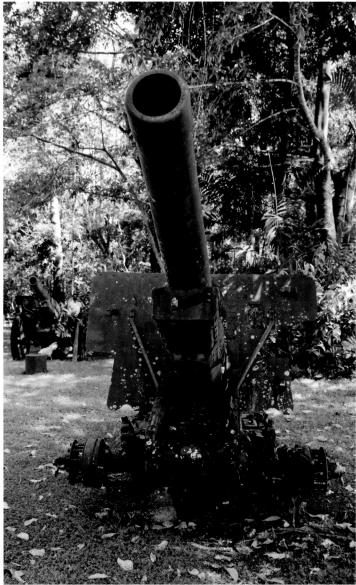

LEFT:

Vickers 8in guns, Betio, Tarawa Atoll

Four British-made Vickers 8in (203mm) guns formed the heaviest element of the Japanese defences at Tarawa. The guns fired at approaching US landing forces on 20 November 1943, but their fire-control systems had already been damaged by preparatory US air strikes, and invasion counter-battery fire quickly knocked out all the guns.

ABOVE:

Type 96 15cm howitzer, Guadalcanal, Solomon Islands

The Type 96 howitzer was the backbone of Japanese heavy field artillery regiments. These weapons were used to pound American positions on Guadalcanal in and around Henderson Field in the second half of 1942.

OVERLEAF:

Kinugawa Maru, Ironbottom Sound, Guadalcanal, Solomon Islands

The ethereal outline of the Japanese military transport ship *Kinugawa Maru* belies the violence of its end. On 15 November 1942, while attempting to land Japanese troops on the island, the ship was destroyed by relentless US shore fire and naval aircraft bombardment. The wreck was stranded on a reef for many years, but eventually slipped back into the sea.

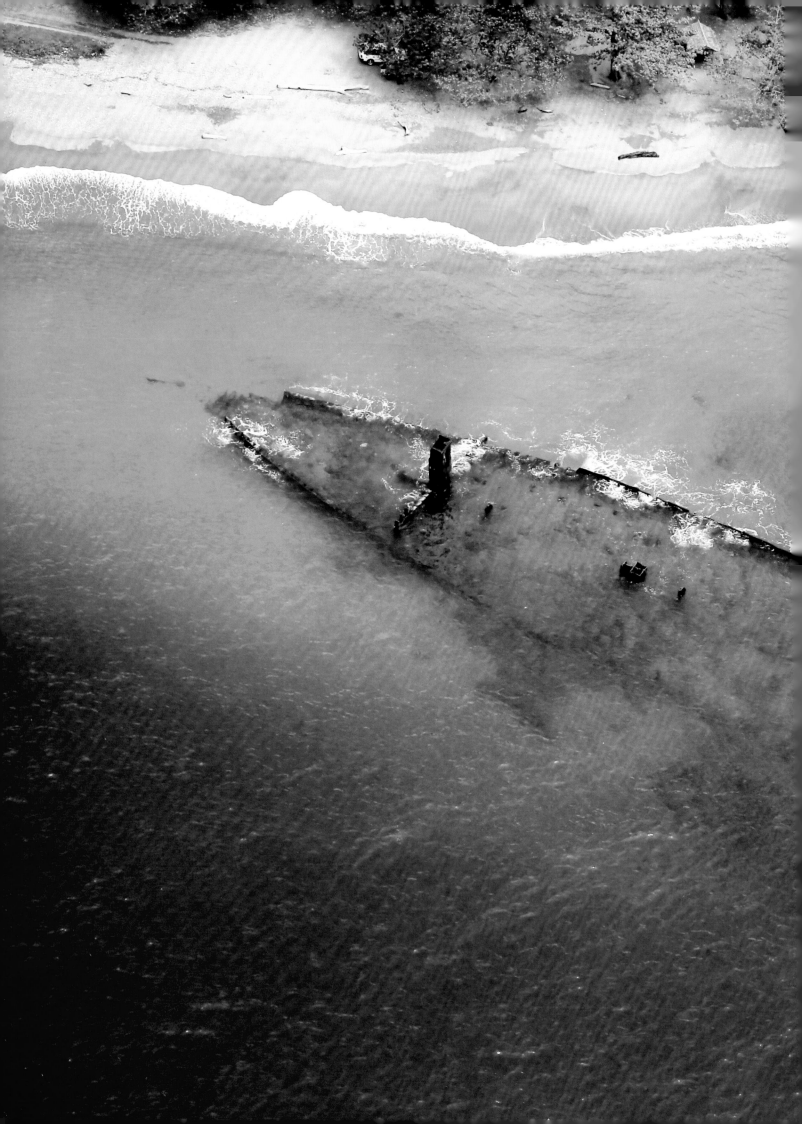

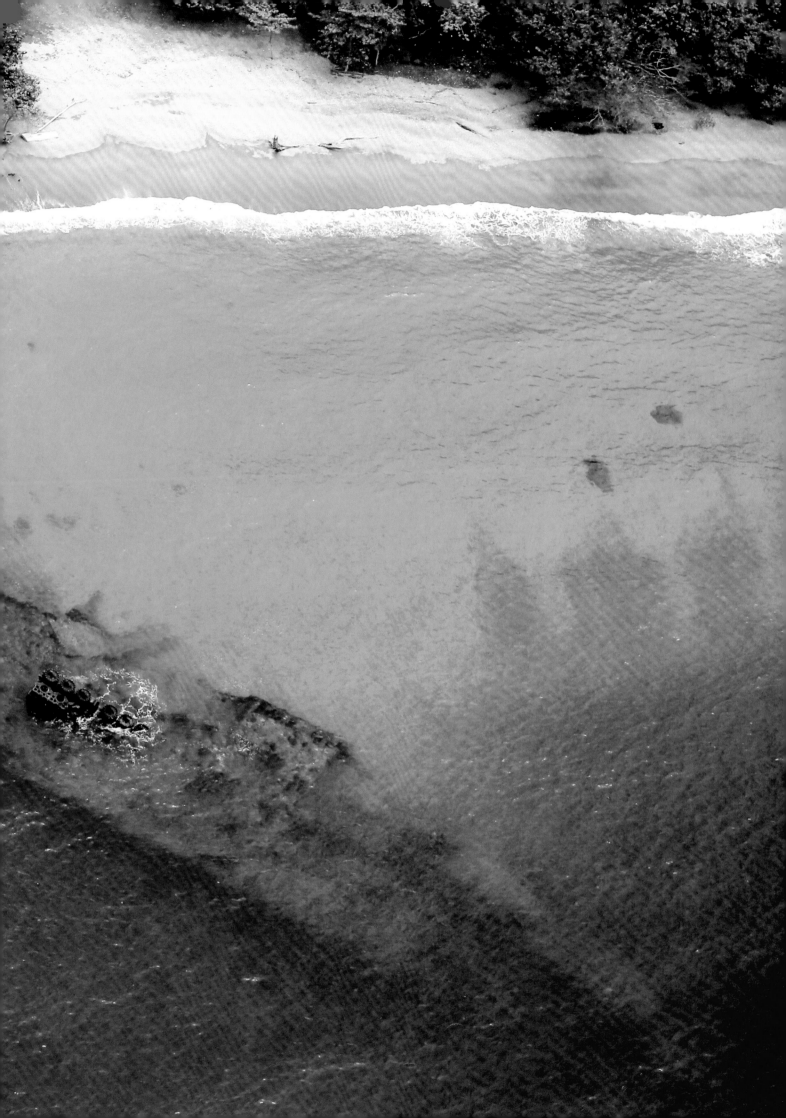

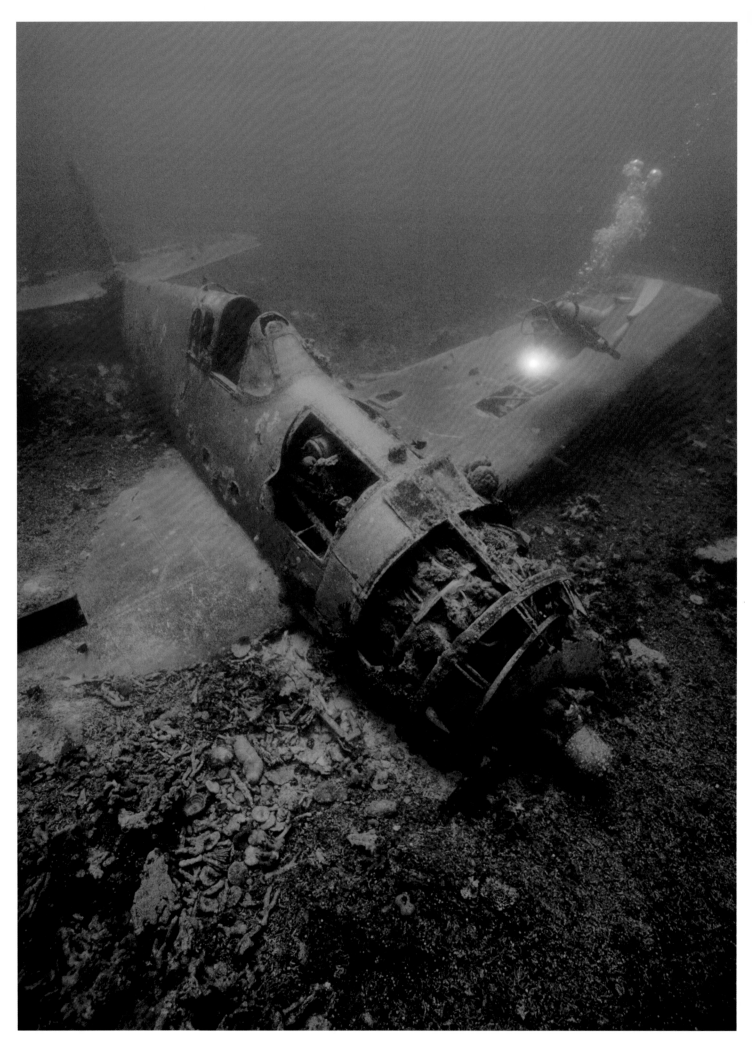

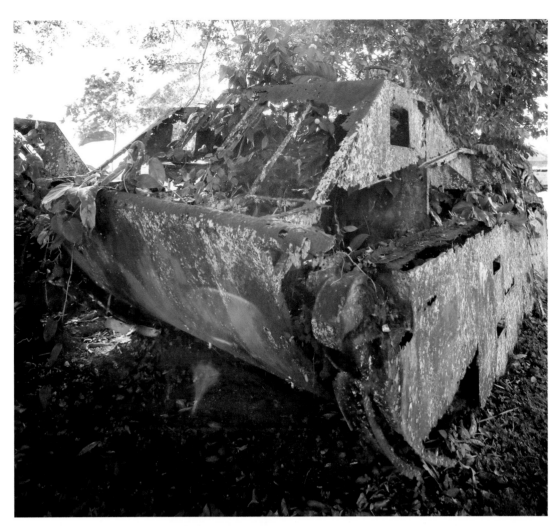

OPPOSITE:
**Vought F4U Corsair,
Solomon Islands**
The Corsair was the finest
carrier fighter aircraft of World
War II, known for its firepower,
manoeuvrability and resilience.
In the Pacific theatre, it gained
an 11:1 kill to loss ratio, and was
much feared by Japanese pilots.

LEFT:
**LVT-1, Guadalcanal,
Solomon Islands**
The Landing Vehicle, Tracked
(LVT) series transformed the
US capability in amphibious
landings. The vehicle here is an
LVT-1, which could carry 18 fully
equipped men or 2000kg (4400lb)
of cargo. The Guadalcanal
landings by the US Marines in
February 1942 were the first
operational use of this vehicle.

BELOW:
**M3 Stuart light tank,
Solomon Islands**
Eternally merging with the jungle
around it, this M3 Stuart light
tank was hit by anti-tank gunfire
and disabled in battle on 17
September 1942 – shell holes in
the forward hull are still visible.

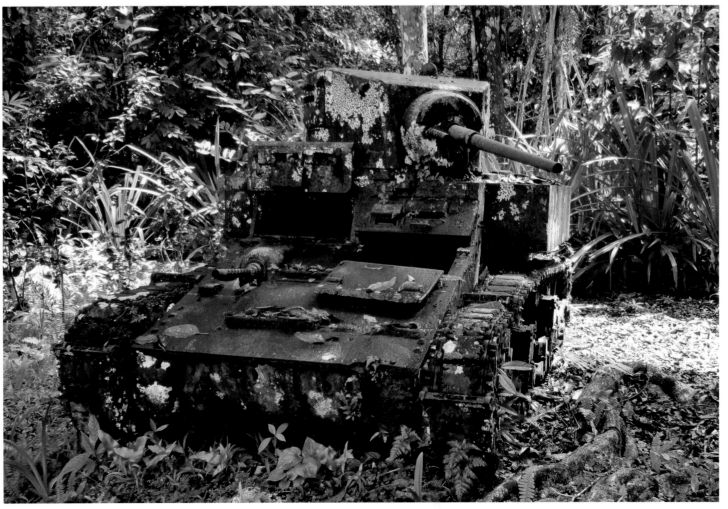

LST-342, Nggela Islands, Solomon Islands

This US Landing Ship, Tank (LST) was commissioned into service in December 1942, and subsequently saw intensive combat experience at Guadalcanal, New Georgia, Rendova and Vangunu. On 18 July 1943, the day after leaving Guadalcanal, she was torpedoed by a Japanese submarine and blown in half by secondary explosions, killing 90 soldiers and sailors. The still-floating bow section was towed back to land for salvage. It rests there to this day, its bow doors still open and gasping.

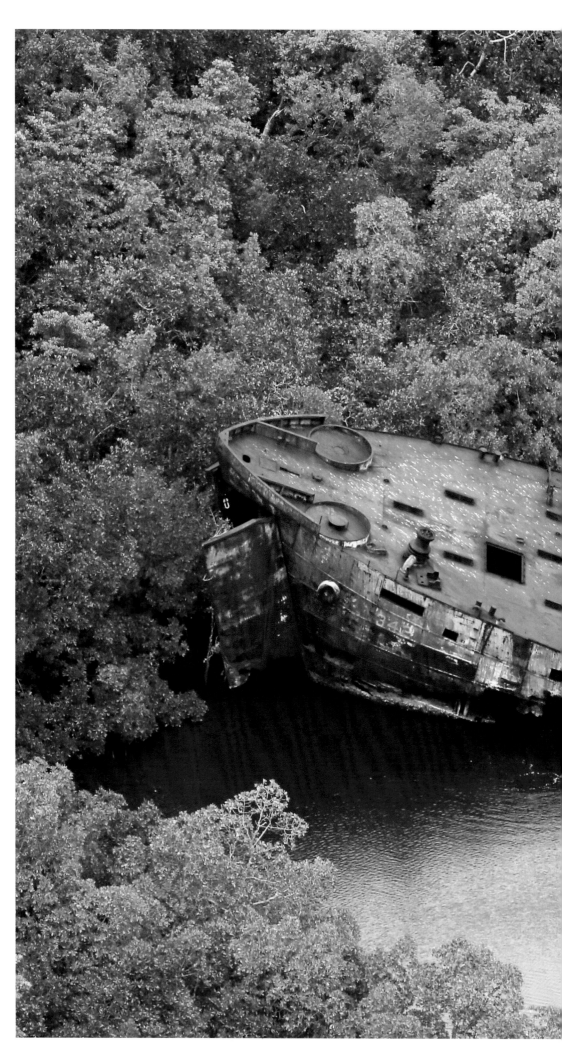

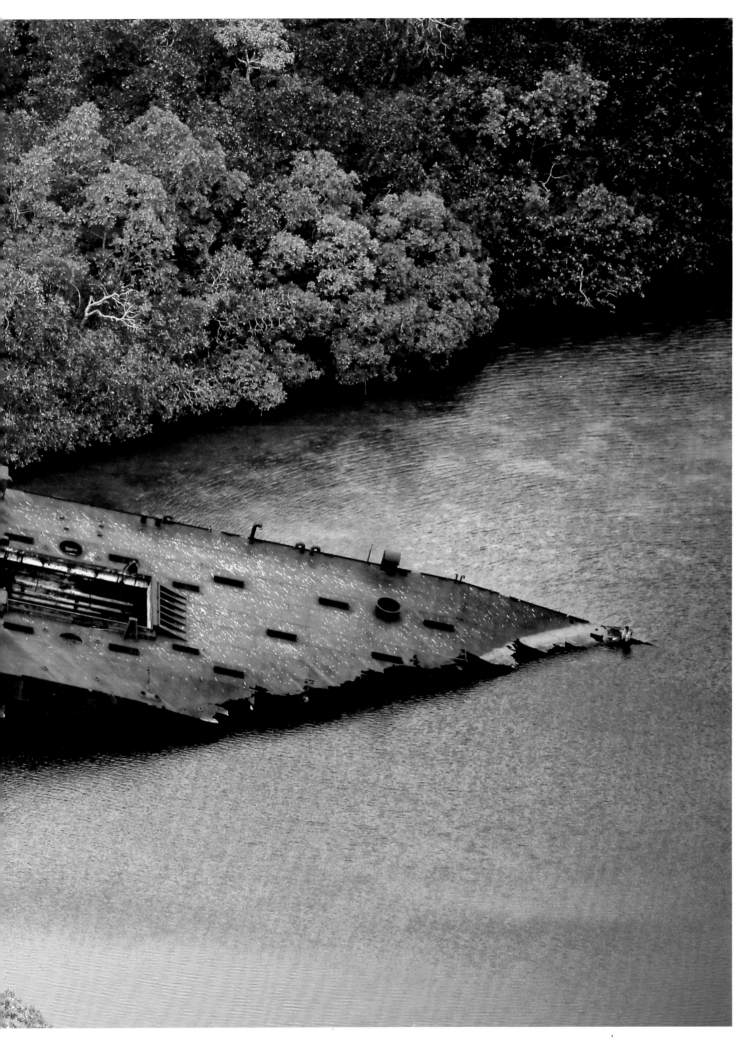

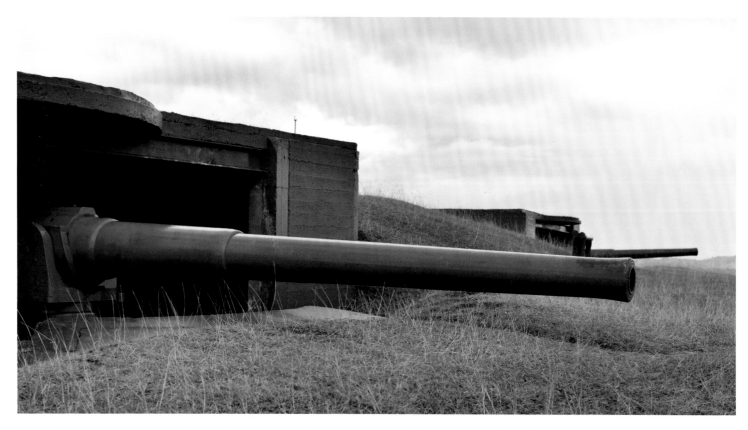

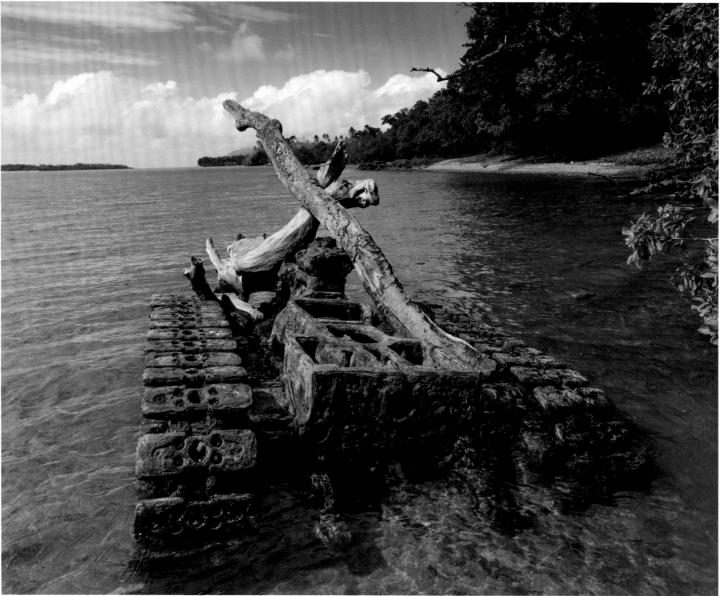

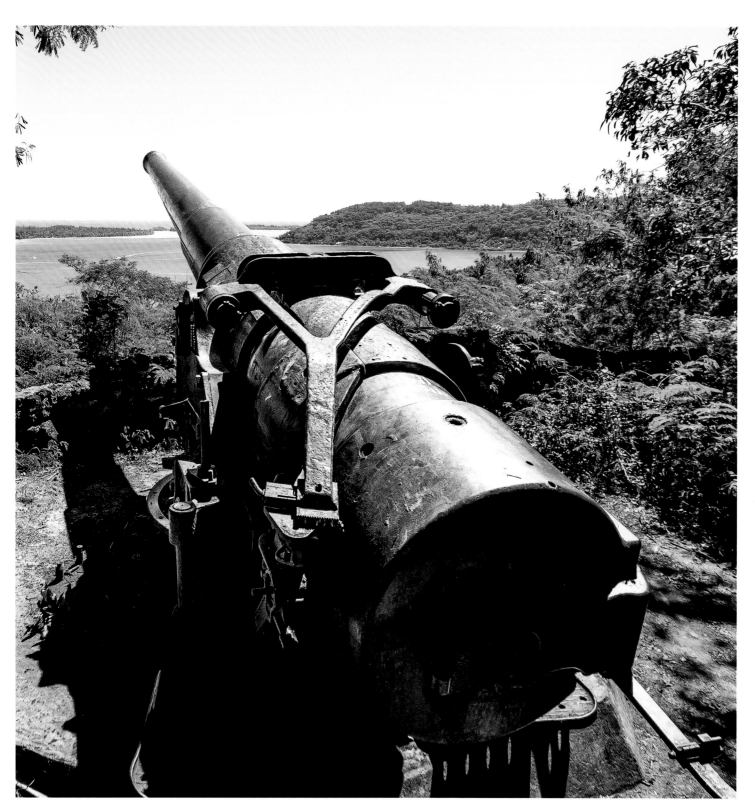

OPPOSITE TOP:

**BL 6in Mark VII guns,
Momi Battery, Fiji**

The Momi battery was established
in 1940 on the western coast of
Fiji, providing defensive overwatch
across the Navula passage, a
possible Japanese invasion site.
The two 6in (152mm) guns, still
in pristine condition, were
emplaced in 1941, and fired few
shots during the war.

OPPOSITE BOTTOM:

**US vehicle, Efate, Vanuatu,
New Hebrides**

As a bulwark against the Japanese
expansion, the United States
established major military bases
on Efate and Espiritu Santo (two
of the islands of Vanuatu) from
May 1942, building up a total
force of 50,000 troops. In 1945, the
Americans pulled out and dumped
much material into the sea,
including this vehicle, of which
only the chassis and tracks remain.

ABOVE:

**7"/44 caliber gun Mark 1,
Bora Bora, South Pacific**

Never fired in anger, the eight
7"/44 caliber Mark 1 naval guns
emplaced by US forces on the
island of Bora Bora are today
popular, but rather hidden, tourist
attractions. This gun type was
used as secondary armament
aboard US pre-dreadnought
battleships.

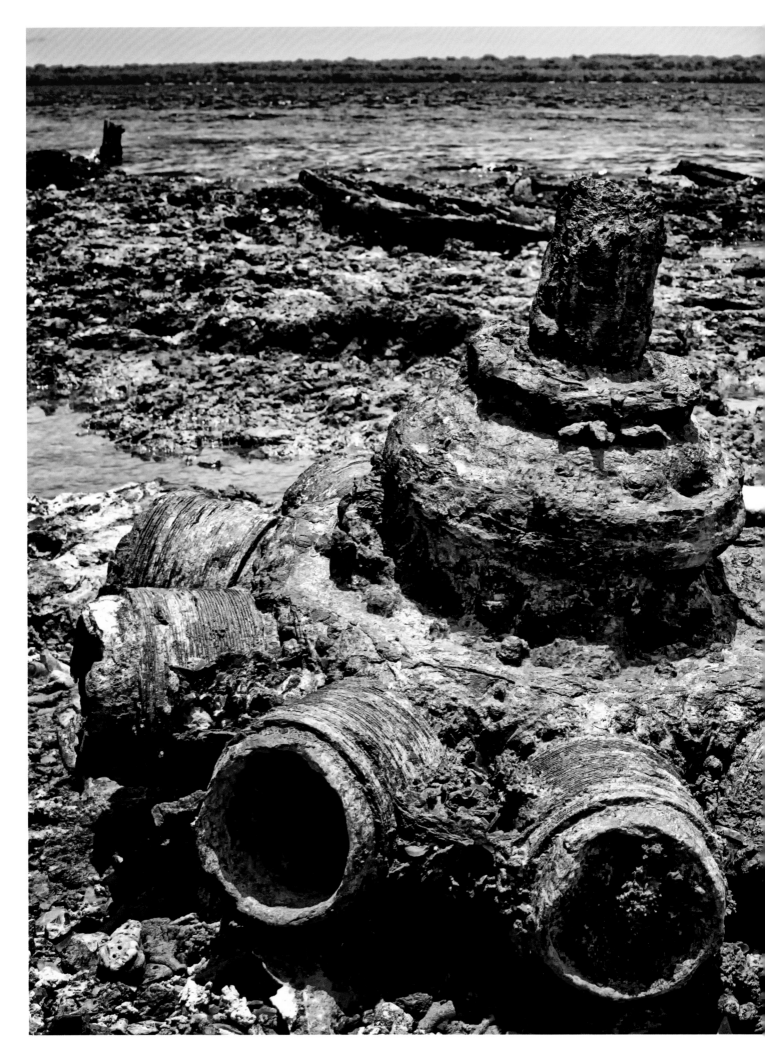

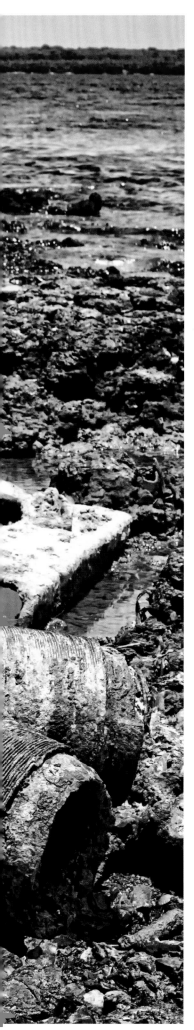

LEFT:

Aero engine, Espiritu Santo, Vanuatu, New Hebrides
Such was the volume of materiel dumped into the sea by the US forces on Vanuatu in 1945 that this coastal area of Espiritu Santo came to be known as 'Million-Dollar Point'. In addition to items such as this aero engine, the military waste included trucks, jeeps, bulldozers and even crates of Coca-Cola.

BELOW TOP:

Ammunition, Espiritu Santo, Vanuatu, New Hebrides
The detritus of the US abandonment at Million-Dollar Point included tons of ammunition. Here we see an assortment of rusting ordnance, including artillery shells and mortar bombs, plus an old-style US Brodie steel helmet.

BELOW BOTTOM:

Vehicle, Espiritu Santo, Vanuatu, New Hebrides
What appears to be the wheelbase of a military truck lies in the waters of Million-Dollar Point. According to veteran accounts, the sight of driving millions of dollars worth of equipment into the sea reduced some US combat engineers to tears. The materiel was abandoned when the US forces could not find a post-war buyer for it.

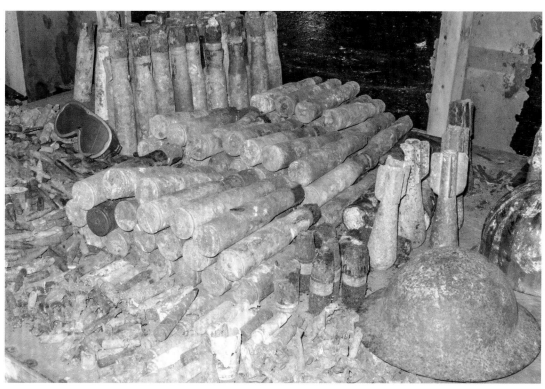

OPPOSITE AND ABOVE:

SS *President Coolidge*, Espiritu Santo, Vanuatu, New Hebrides

The SS *President Coolidge* was an American luxury ocean liner launched in February 1931. For more than a decade she ploughed the world's oceans, before being pressed into service in December 1941 as a troopship for US forces in the Pacific. On 26 October 1942, while carrying more than 5300 men, the great ship struck Japanese mines near the harbour of Espiritu Santo. The ship sank, but nevertheless only two men died in the whole event, one from the immediate torpedo detonations and another who became trapped aboard the ship while helping others to escape. All the rest of the soldiers and crew were safely evacuated.

**Machine-gun pillbox,
Waitara, New Zealand**
This machine-gun pillbox was
built on West Beach, Waitara,
in 1942, as part of widespread
defensive arrangements around the
coast of New Zealand. Manned
by Home Guard units, the pillbox
featured a central embrasure for
a machine gun, and had three
apertures each side for riflemen to
present their own weapons.

OVERLEAF:
**Wrights Hill Fortress,
Wellington, New Zealand**
This sweeping, empty gun
emplacement is part of the
Wrights Hill Fortress, a coastal
artillery position built between
1942 and 1947. The fortress
received two 9.2in (234mm)
Mk XV guns on Mk IX mountings
– the largest land batteries ever
constructed in New Zealand –
but the weapons were only test-
fired after the war, and ironically
were later sold as scrap metal to
the Japanese.

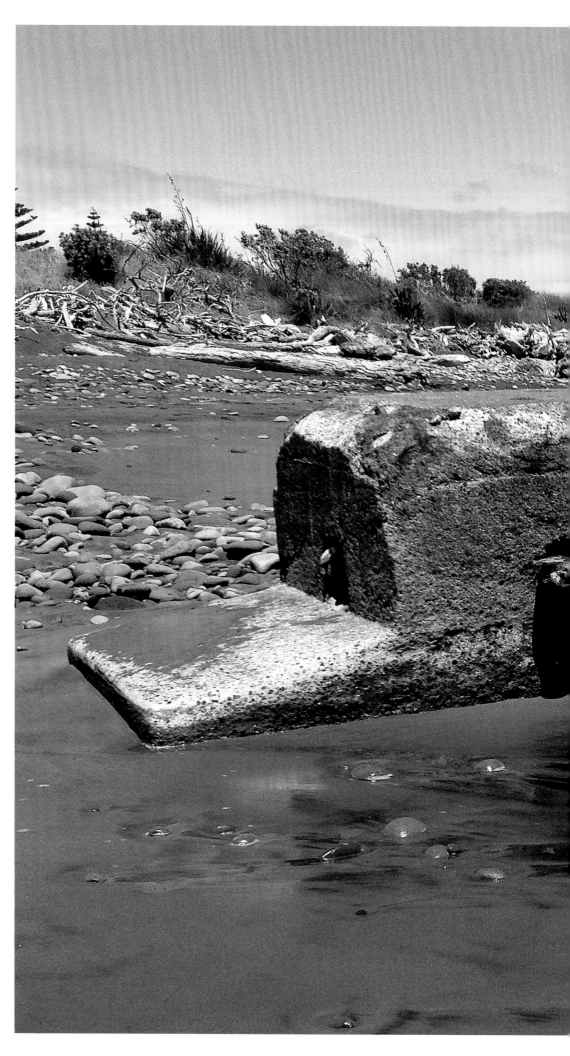

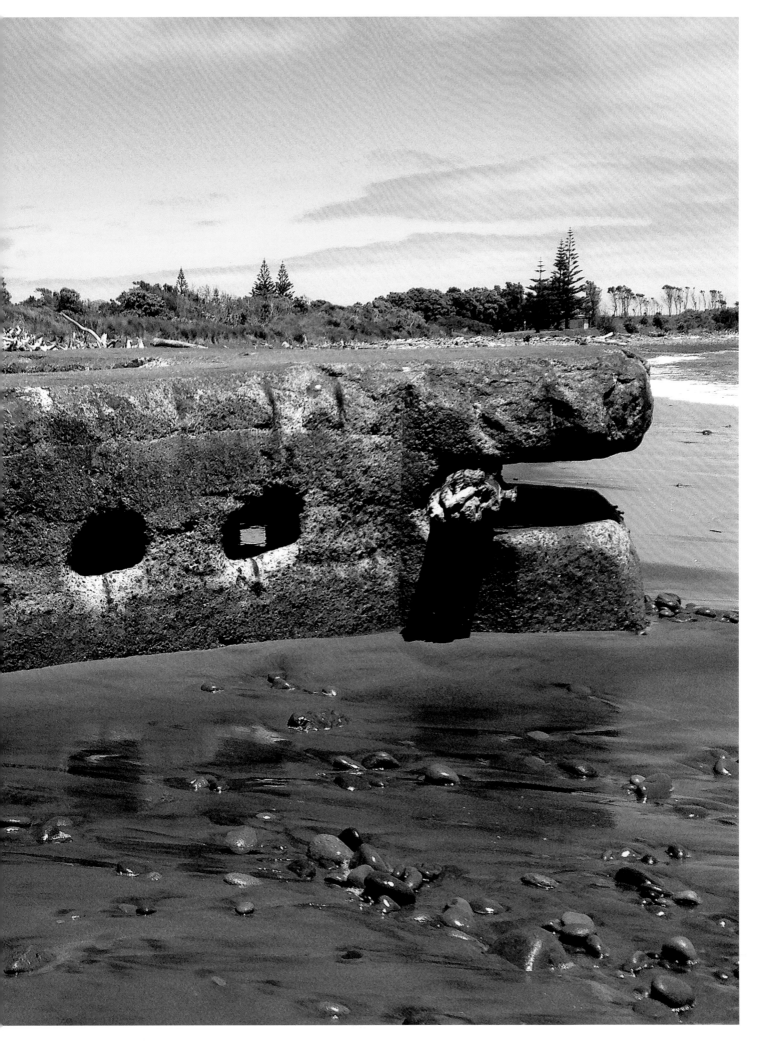

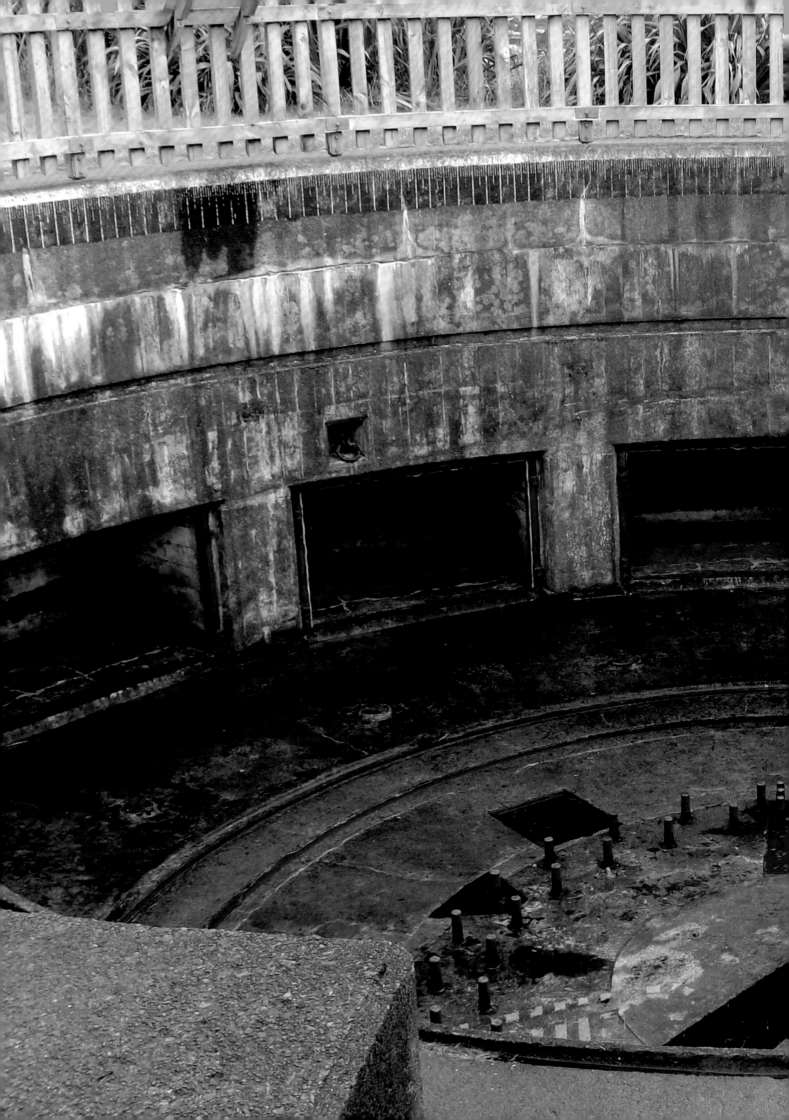

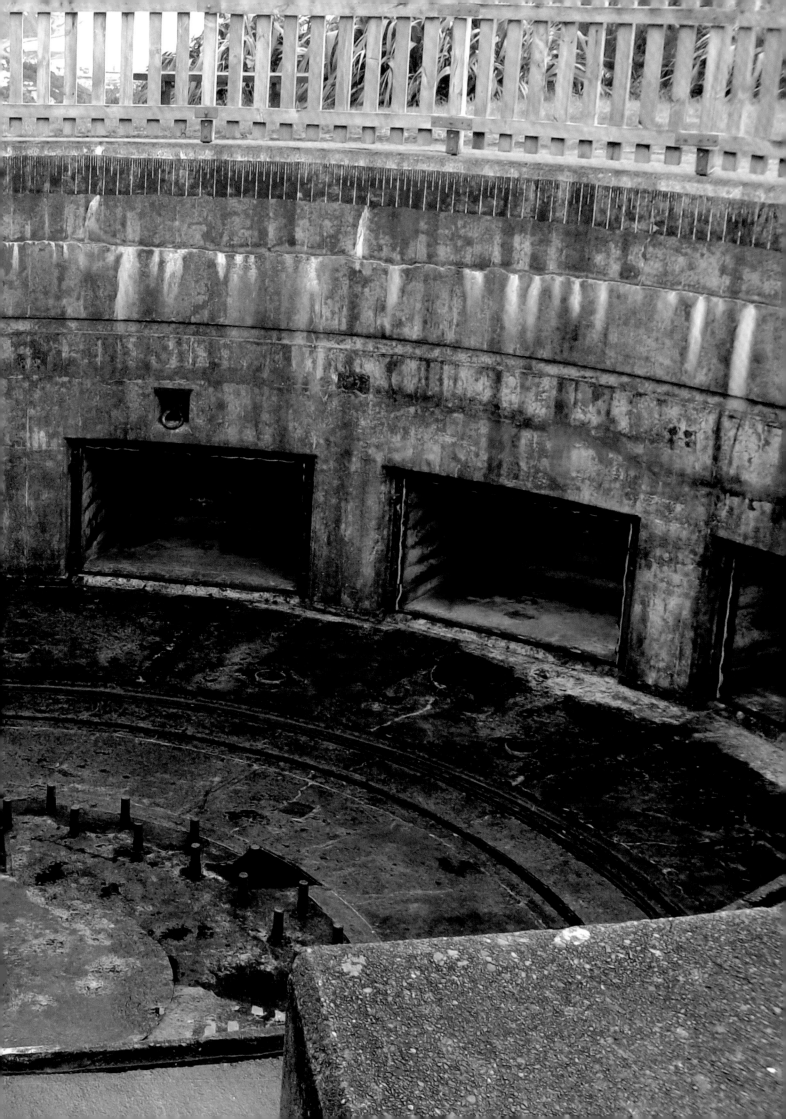

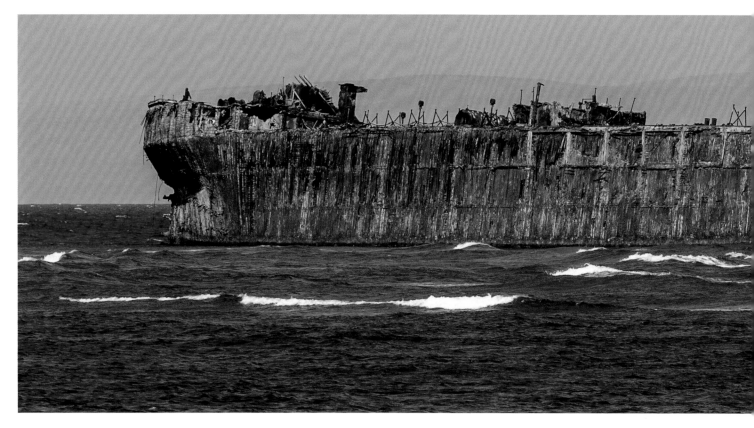

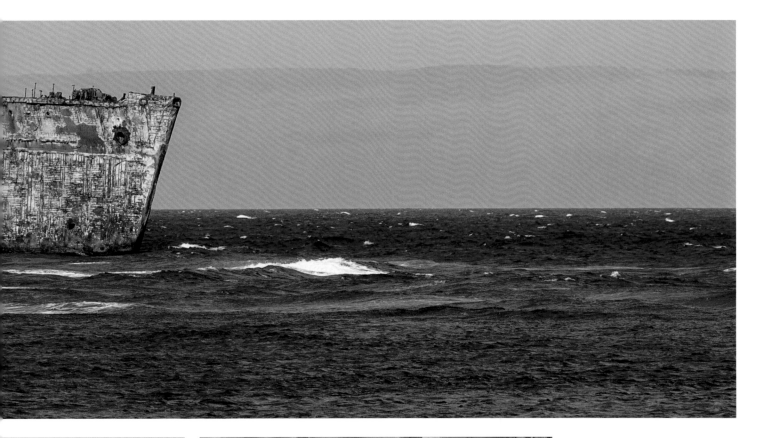

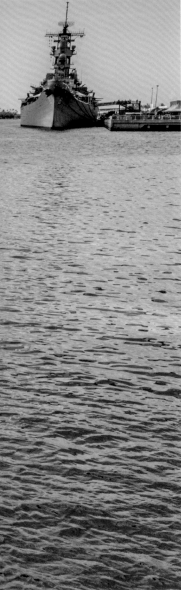

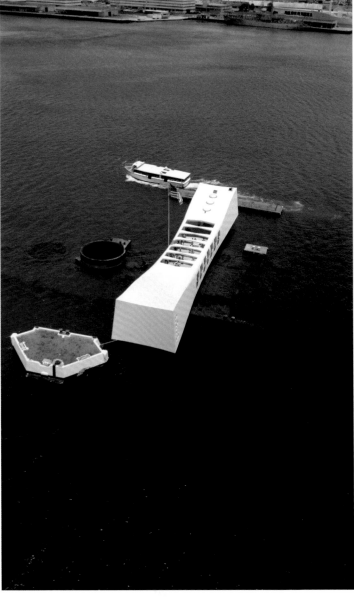

ABOVE:

USS *YOG-42*, Shipwreck Beach, Kalohi Channel, Lanai, Hawaii
The *YOG-42* was a gasoline barge, constructed from ferro-concrete, hence its durability as a wreck. The vessel was in US Navy service between 1943 and 1949, surviving a long combat deployment in the Pacific. The vessel was intentionally beached at the end of her life in 1950.

LEFT AND OPPOSITE:

USS *Arizona*, Pearl Harbor, Hawaii
The Pennsylvania-class battleship USS *Arizona* was commissioned in 1916 and was a visibly mighty addition to the US Navy. Today, however, she is remembered as a spectacularly tragic loss on 7 December 1941, when the Japanese launched their infamous air attack on Pearl Harbor. After being hit by armour-piercing bombs, the ship suffered a catastrophic magazine explosion and sank rapidly, killing 1177 officers and crew. Today, the remains of the ship lie just beneath the surface, and are straddled by a poignant memorial museum.

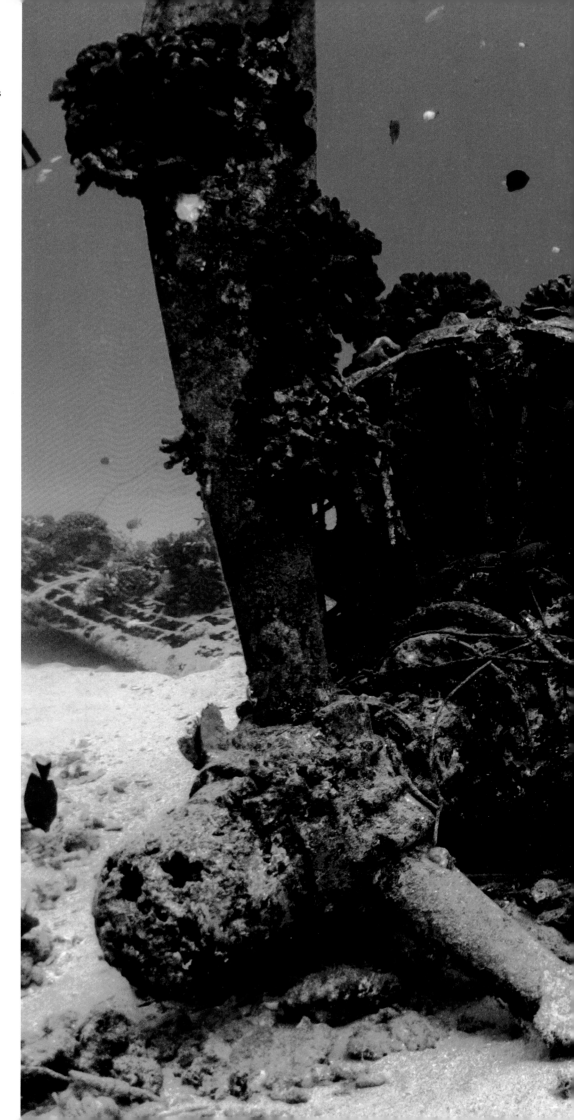

Vought F4U Corsair, Oahu, Hawaii
A diver hovers peacefully over this wreck of a Vought F4U Corsair, the aircraft nestling at the bottom of blue Hawaiian waters. Although this particular aircraft was a veteran of World War II, it actually ended its flying career in 1948, when a routine flight ended in engine failure and ditching. The pilot was unharmed and was later rescued.

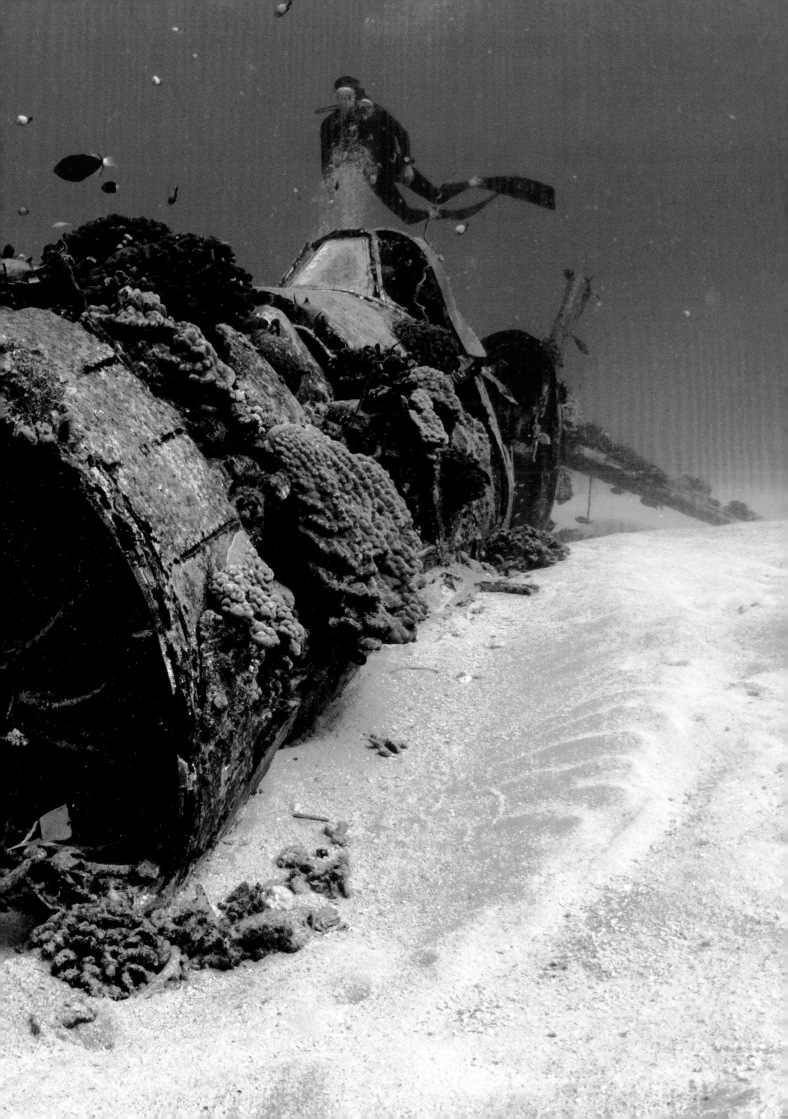

**Type A *Ko-hyoteki*
midget submarine, Kiska,
Aleutian Islands**

The Type A *Ko-hyoteki* midget
submarine came to Allied
attention when five of the vessels
participated in the attack on Pearl
Harbor on 7 December 1941.
This vessel was one of six that the
Japanese anchored at Kiska during
the occupation of the Aleutian
Islands. The submarine was left
behind when the Japanese fled
Kiska in July 1943.

BELOW AND OPPOSITE BELOW:
**Consolidated B-24D Liberator,
Atka, Aleutian Islands**

For many aviators in World War
II, mechanical failure, navigation
errors and adverse weather could
pose as much danger to them as
combat. This aircraft, serial no.
40-2367, was flying on weather
reconnaissance duties over the
Aleutian Islands on 9 December
1942 when terrible weather
conditions prevented the aircraft
from landing at any of the nearby
airfields. The pilot was thus forced
to make an emergency landing,
which he did successfully – only
one person aboard (Brigadier
General William E. Lynd) was
injured, with a broken collar bone.

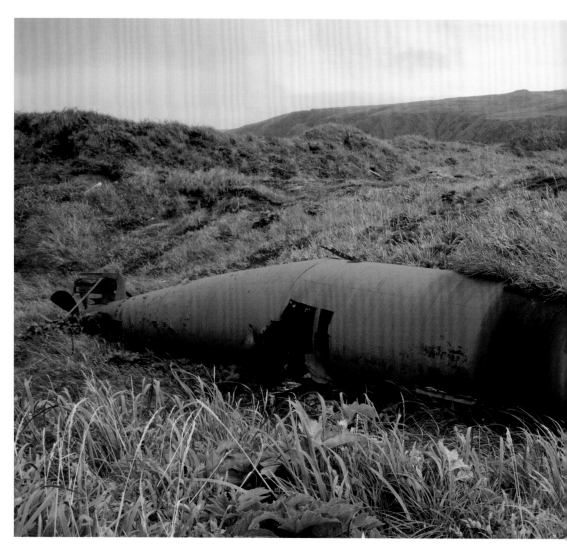

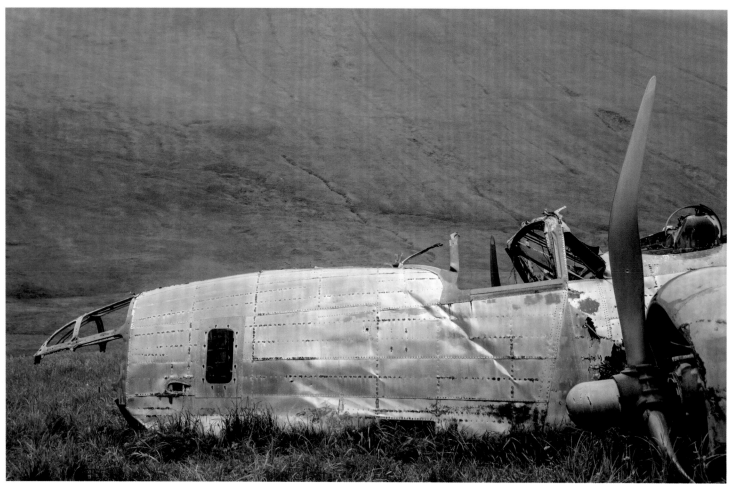

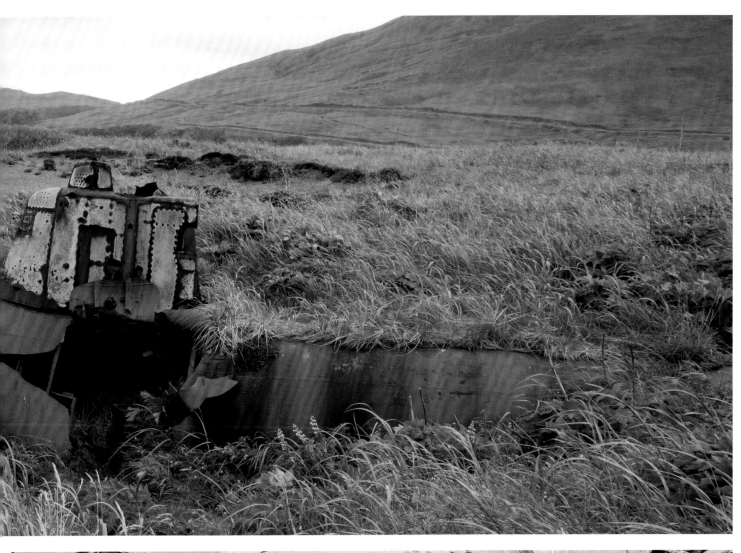

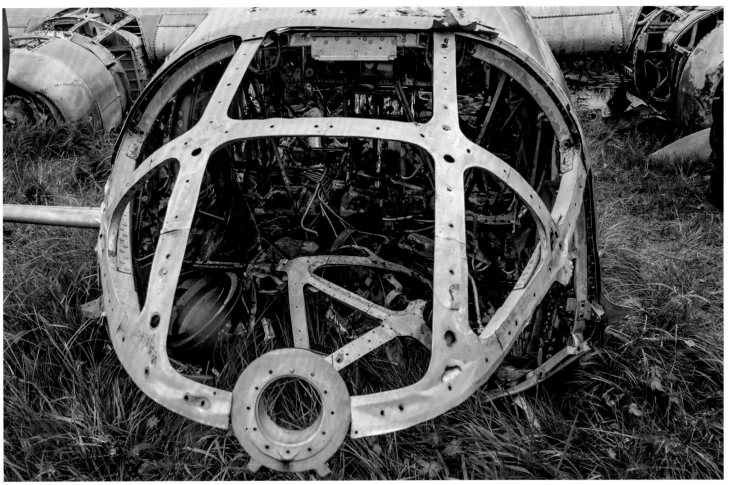

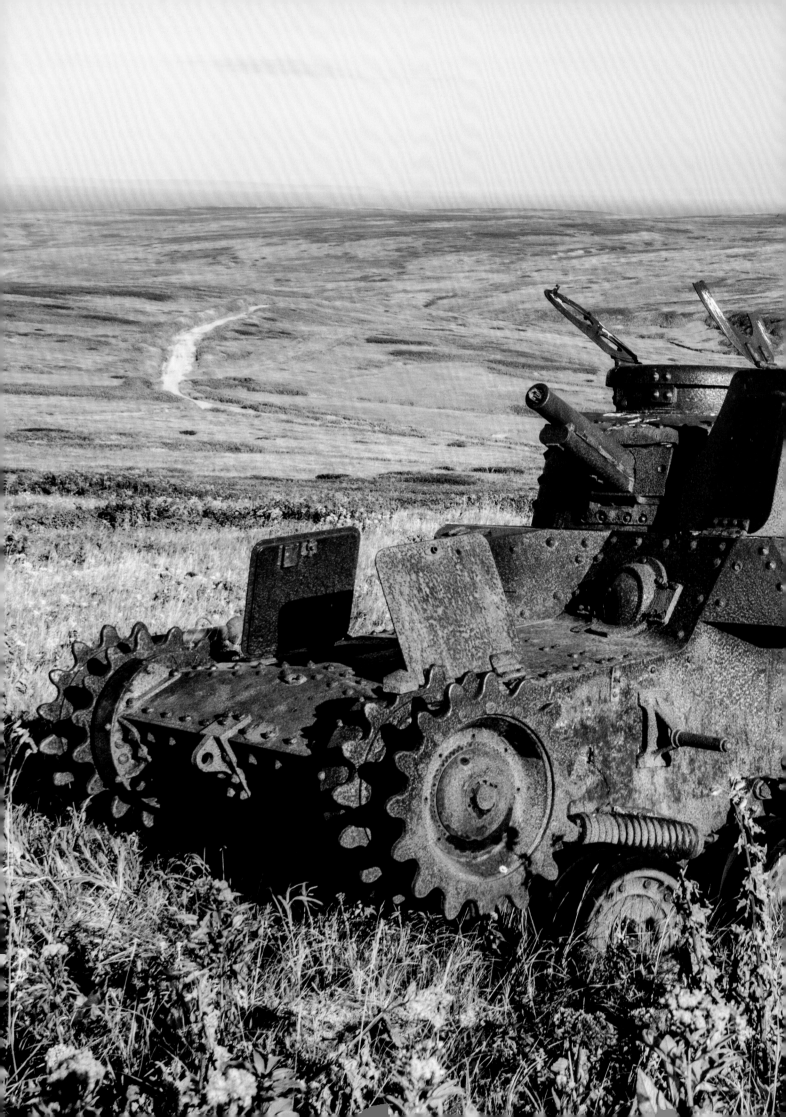

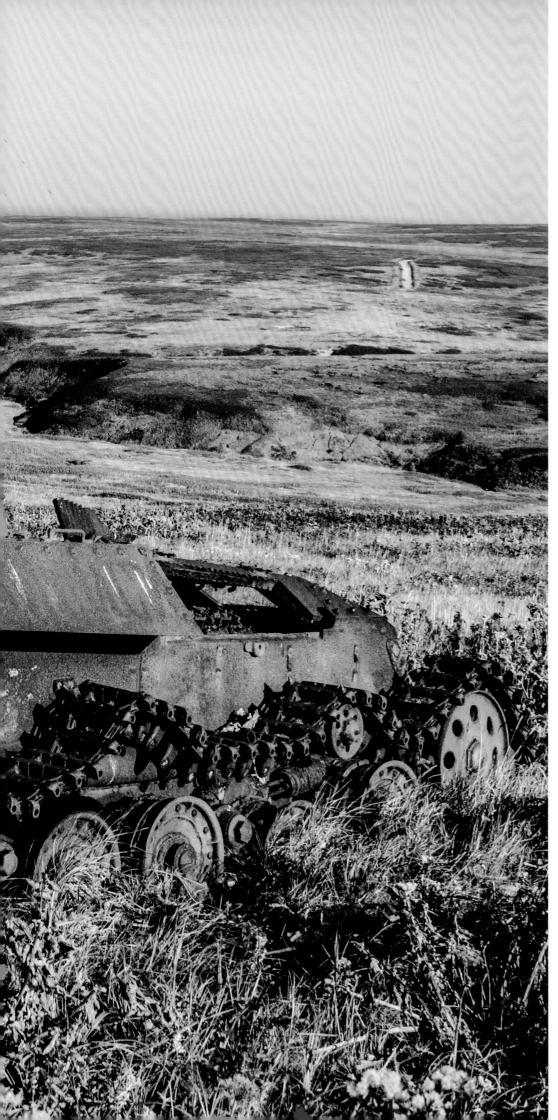

Type 97 Chi-Ha tank, Shumshu, Kuril Islands, Russia
Stretching between northern Japan and Russia's Kamchatka Peninsula, the remote Pacific Kuril Islands were the site of one of the last major military actions of the war, the Soviet invasion of 18 August 1945. The occupying Japanese forces were fully suppressed by 4 September. Their presence, however, is marked by several lonely wrecks, including that of this Type 97 Chi-Ha light tank.

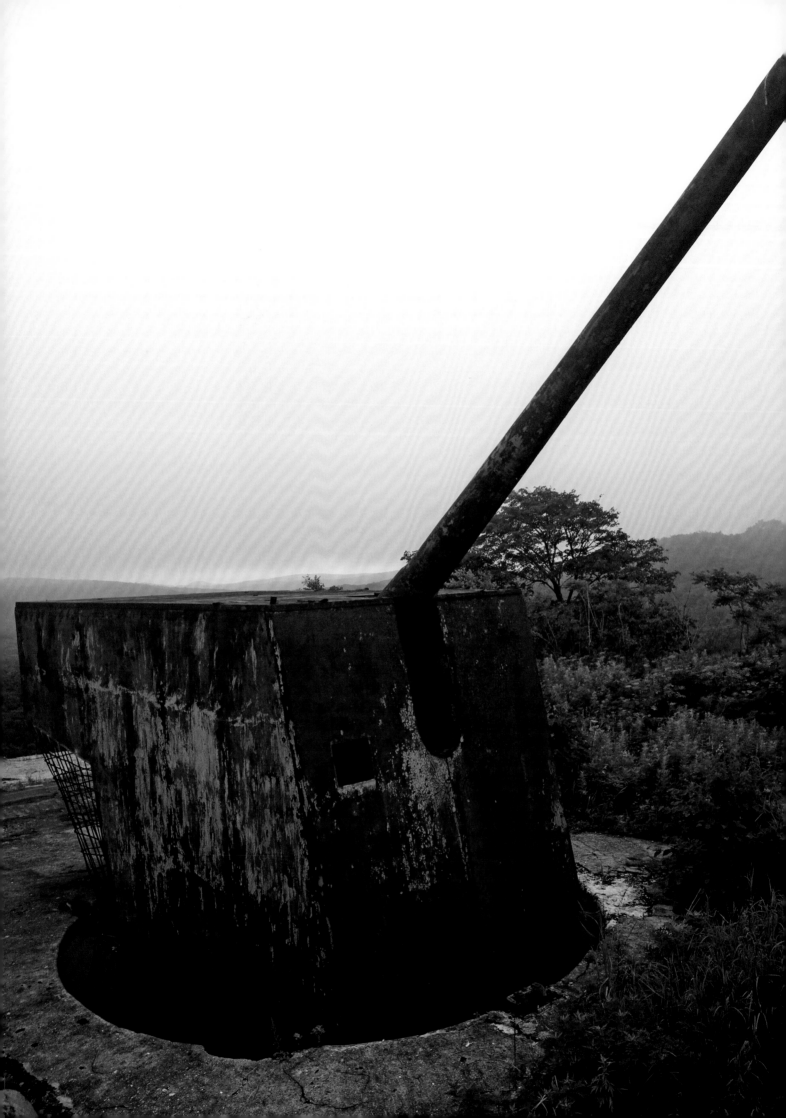

OPPOSITE AND BELOW:

Soviet coastal gun, Vladivostok, Russia
Vladivostok was heavily fortified in the late nineteenth century to defend
against possible incursions by the Japanese, with whom the Russians
fought a major war in 1904–05. By World War II, the gun positions were
mostly abandoned, but they continued to provide a visual threat.

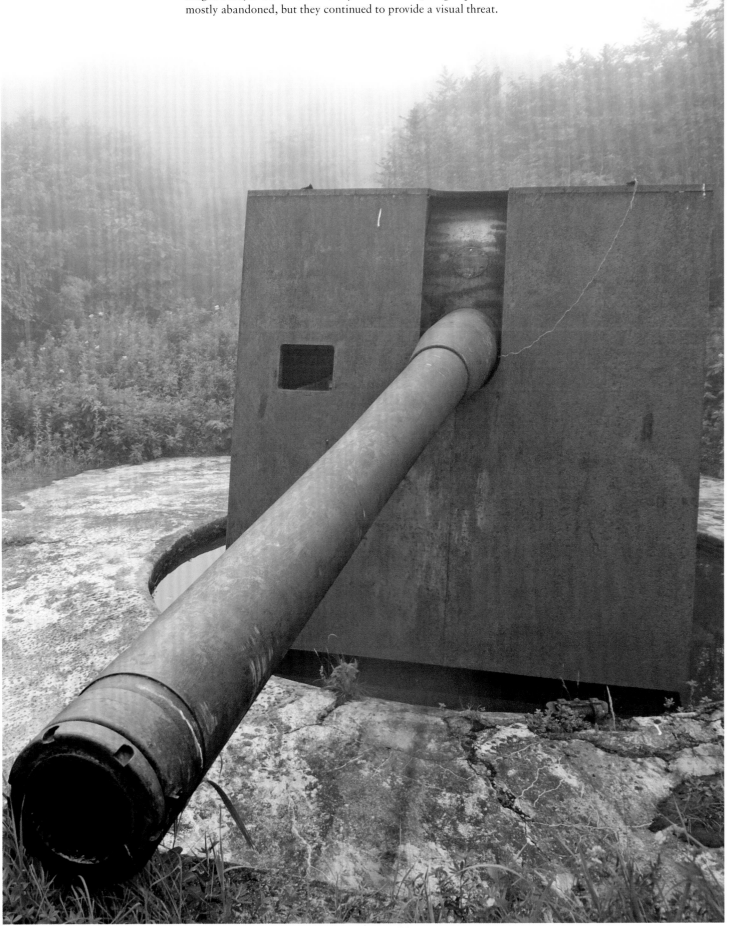

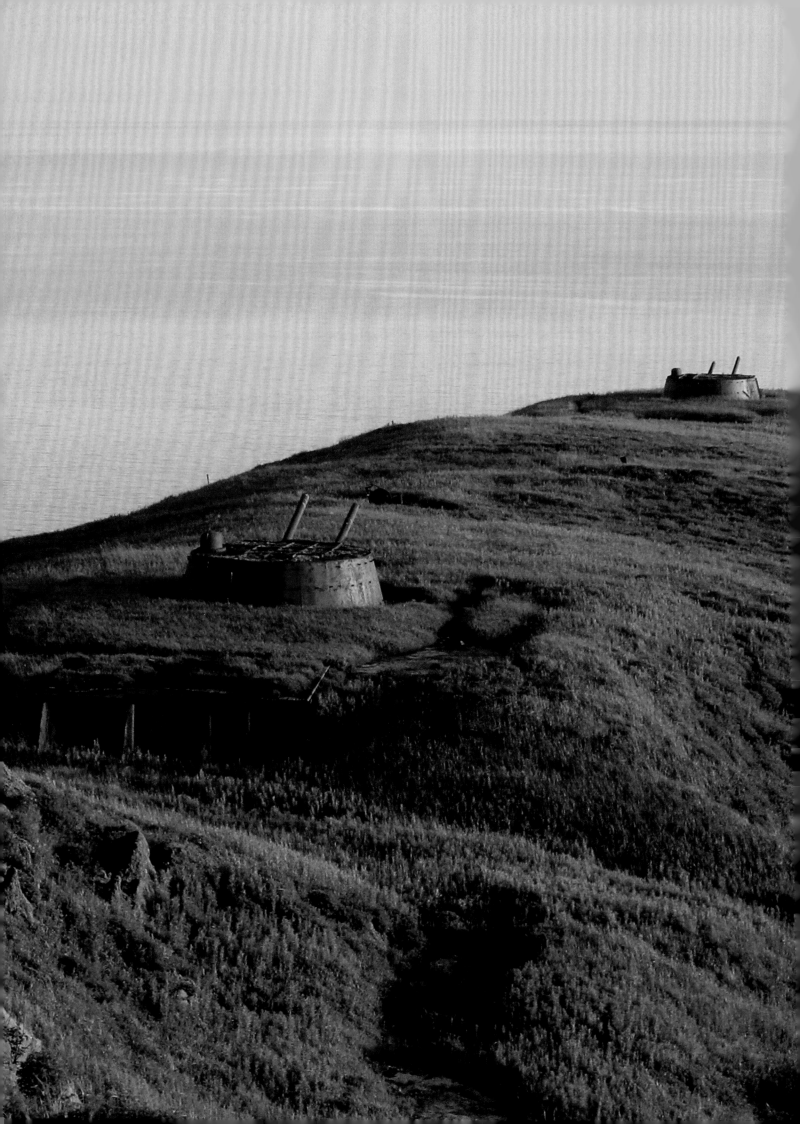

LEFT AND BELOW:

Coastal artillery, Askold, Fokino territory, Russia

Askold is an island in Peter the Great Bay of the Sea of Japan, 50km (31 miles) southeast of Vladivostok city. Between 1936 and 1939, the island was heavily armed with coastal batteries, including these turreted twin 180mm (7.1in) MB-2-180 guns, which were trained over the entrance of Ussuri Bay and approaches to Strelok Bay and Vostok Bay.

The gun positions seen here sit atop underground towers, each containing working compartments, ammunition stores, reloading facilities and crew quarters. Each gun position was connected to its neighbour by underground passageways, totalling nearly 1km (0.6 miles) in length. Today, the isolated location of Askold means that the batteries are reasonably well preserved.

BELOW BOTTOM:

Japanese cannon, Mt Kofuji, Ogasawara Islands, Japan

The Ogasawara Islands (aka Bonin Islands), 1000km (620 miles) south of Tokyo, were intensively prepared to meet a US invasion, and the battle for one of the group – Iwo Jima – was among the bloodiest engagements of the Pacific War. Gun emplacements such as this one, however, were ultimately incapable of repelling US military might.

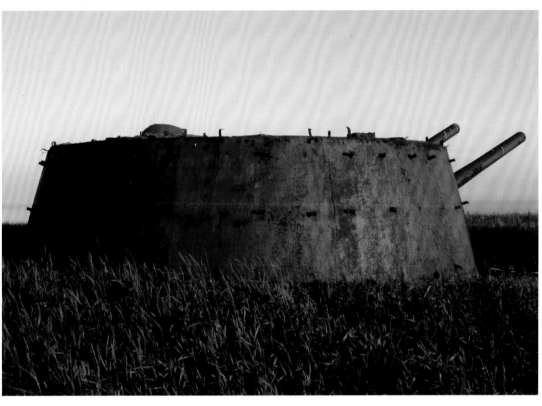

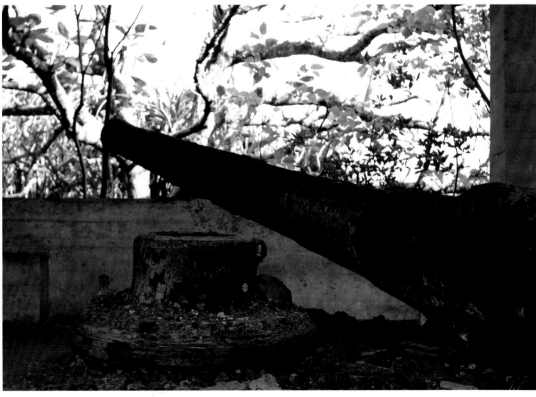

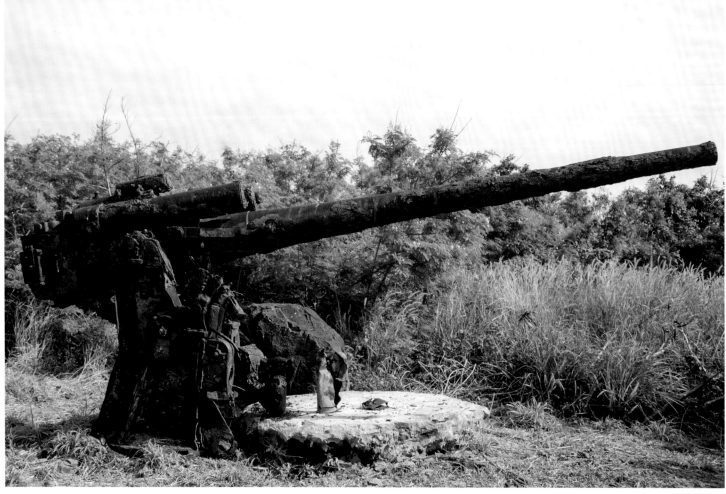

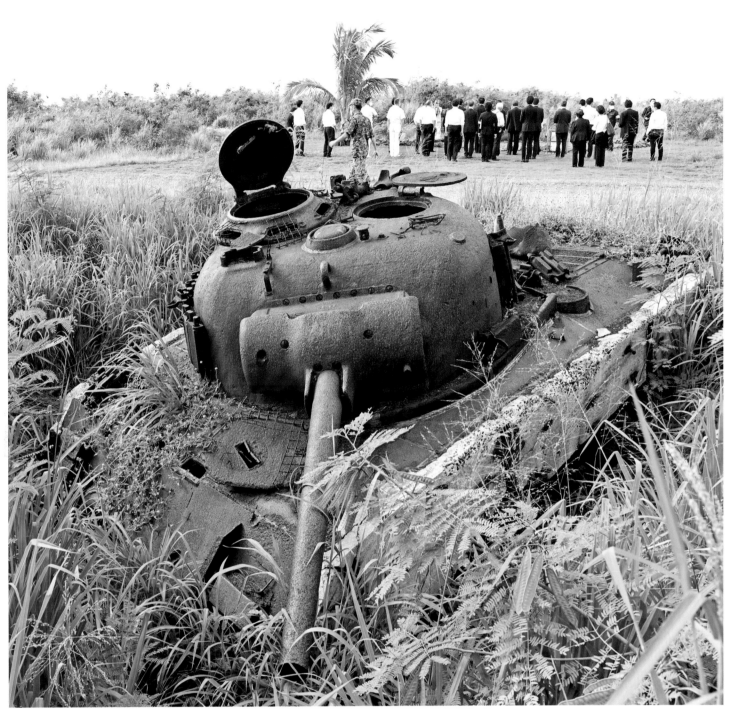

OPPOSITE TOP:

Type 96 gun, Iwo Jima, Japan
The Type 96 was a Japanese 25mm (0.98in) anti-aircraft gun, often set in dual mounts. These weapons were emplaced in their thousands across the Japanese-occupied islands, primarily as air-defence weapons against US carrier-borne ground-attack aircraft, but also as direct-support weapons for ground combat.

OPPOSITE BELOW:

Type 10 gun, Iwo Jima, Japan
At the heavier end of the Japanese artillery spectrum, the Type 10 was a 120mm (4.72in) naval gun, used both for coastal defence and for high-altitude anti-aircraft use. During the US landings on Iwo Jima in February 1945, this gun would have poured shells down onto the beaches and against offshore US shipping and landing craft.

ABOVE:

M4A3 Sherman, Iwo Jima, Japan
An M4A3 Sherman of the 4th Tank Battalion sits where it was knocked-out during the battle of Iwo Jima in 1945. Such tanks were mainly used as armoured mobile flamethrower platforms, equipped with Navy Mark 1 flamethrowers.

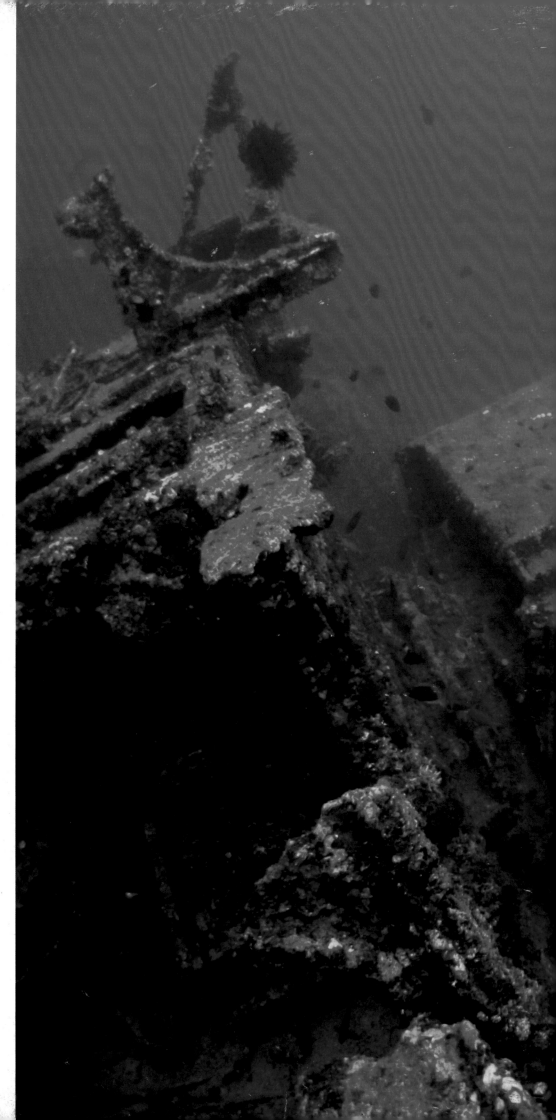

USS *Emmons* (DD-457), off Okinawa, Japan
The USS *Emmons* was a Gleaves-class destroyer commissioned just two days before the Japanese attack on Pearl Harbor brought the United States into a global war. Between 1942 and late 1944, she served in the Atlantic and the Mediterranean, before transferring to the Pacific to support the US landings on Okinawa in April 1945. On 6 April, the ship was hit by five kamikaze aircraft in quick succession. Sixty men died and another 77 were seriously wounded; the surviving crew abandoned a blazing ship, which subsequently sank.

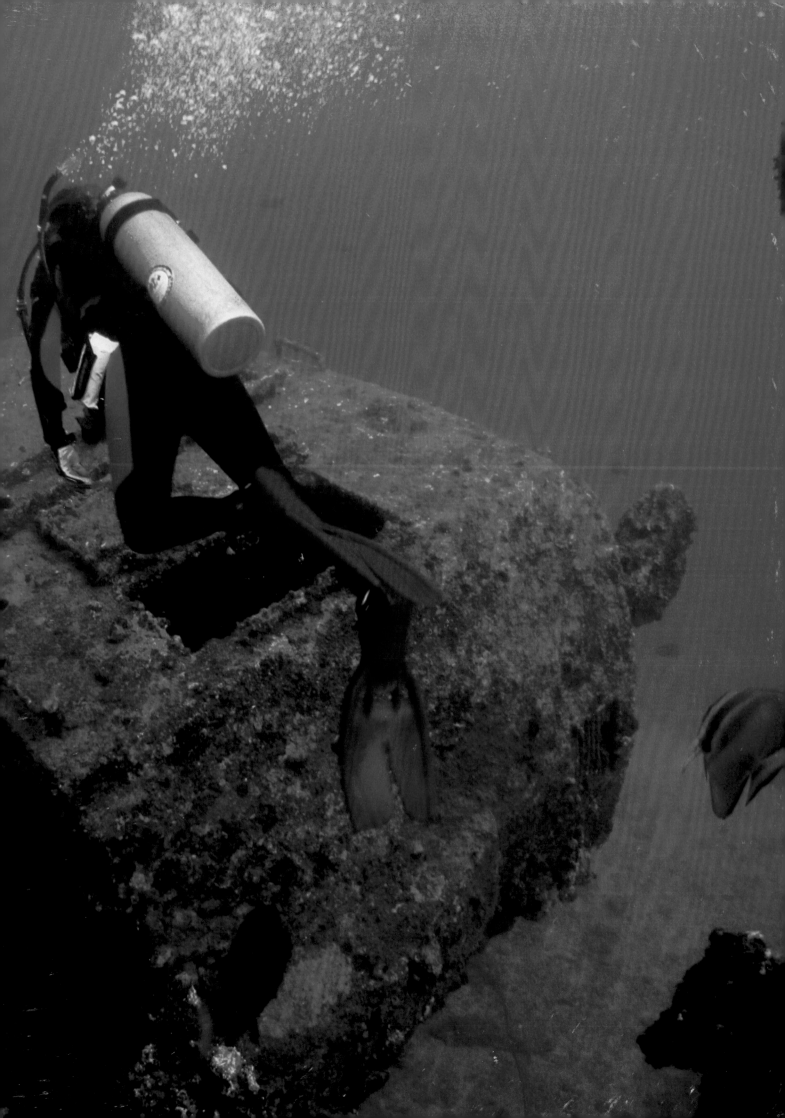

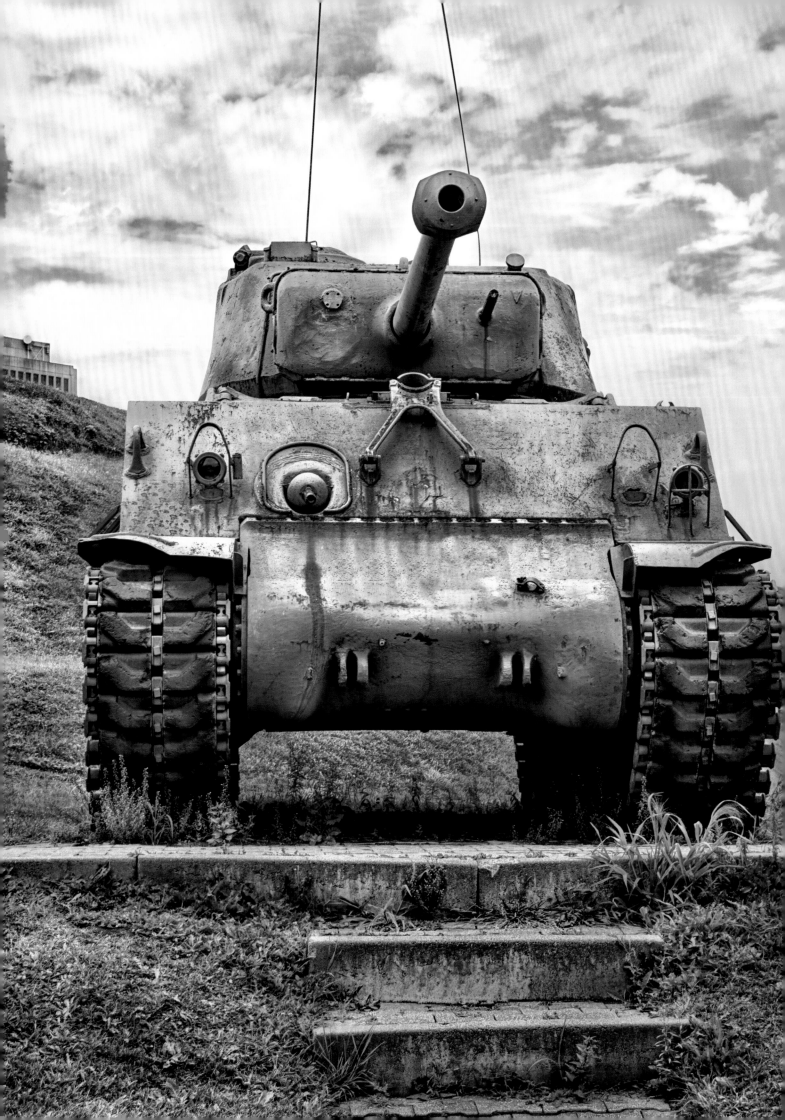

North and South America

The Americas, in many ways, held a blessed geographical position during World War II. Separated from the main theatres of land warfare by the planet's two greatest oceans, North and South America were spared the collosal destruction and unimaginable civilian deaths that engulfed Europe and Asia. The mainland United States, for example, suffered only minor coastal attacks by Axis submarines and Japanese balloon bombs, with few casualties.

This is not to say, however, that the Americas were spared the consequences of a global war – far from it. Both Canada and the United States fully mobilized their military forces, societies and industries for war. Canada suffered 45,000 military deaths; the United States 416,800. Brazil was the only Latin American country to send troops to fight overseas, losing 948 men killed in action, but South America in general suffered heavily economically and politically, with the seeds of many future civil conflicts sown.

Not all of the American casualties were in distant lands, however. The coastal waters off the United States and Canada were periodic battlegrounds between the Allied navies and German U-boats, and further naval engagements occurred around South Atlantic and Pacific waters. Furthermore, the epic industrial transformation of the United States – a country that truly became 'the arsenal of democracy' – brought all the accidents and mishaps that entailed, not least in the world of aviation. The wrecks and abandoned weapons in this chapter represent countries at war, as much as any other nations.

OPPOSITE:
M4A2 Sherman, La Citadelle, Quebec City, Quebec, Canada
More than 49,000 Sherman tanks were built during World War II, giving the Western Allies the required volume of armour to fight on multiple fronts. This specimen is displayed in La Citadelle, a military base and an official residence of the Canadian monarch and the Canadian governor general.

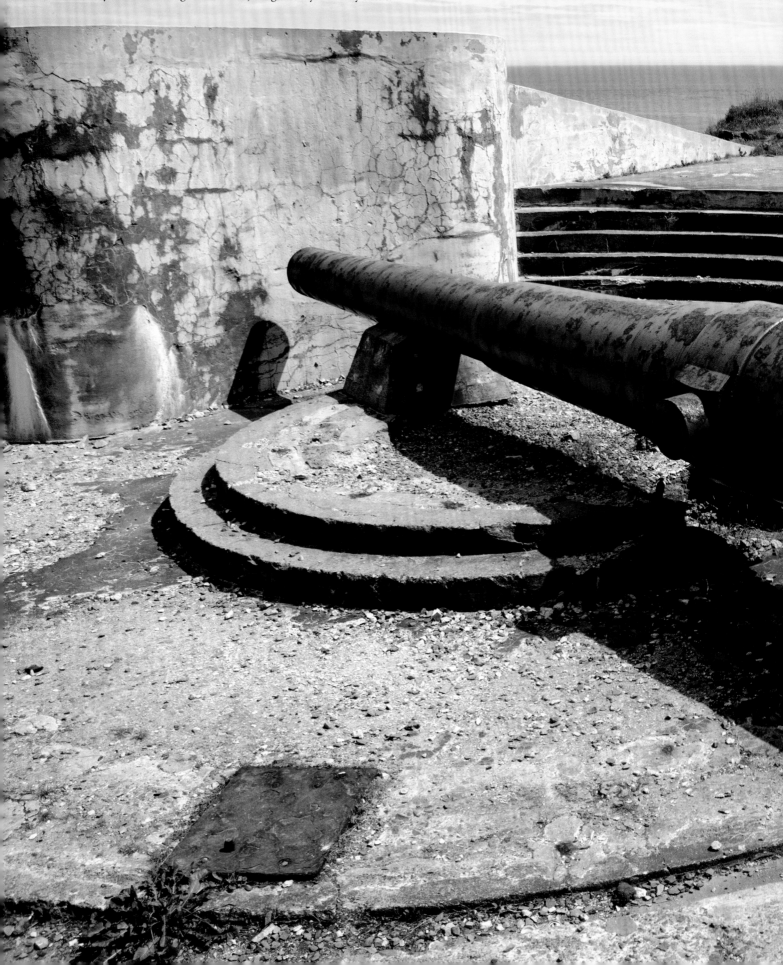

**M1888 gun, Cape Spear, St John's,
Newfoundland and Labrador, Canada**
The Cape Spear Battery sits on the easternmost point of North America.
Its two 10in (254mm) M1888 coastal guns, obsolete at the time, were
provided to Canada by the United States and installed in May 1941, to
face the perceived threat of German surface vessels. Although the battery
was heavily manned throughout the war, the guns stayed mostly silent.

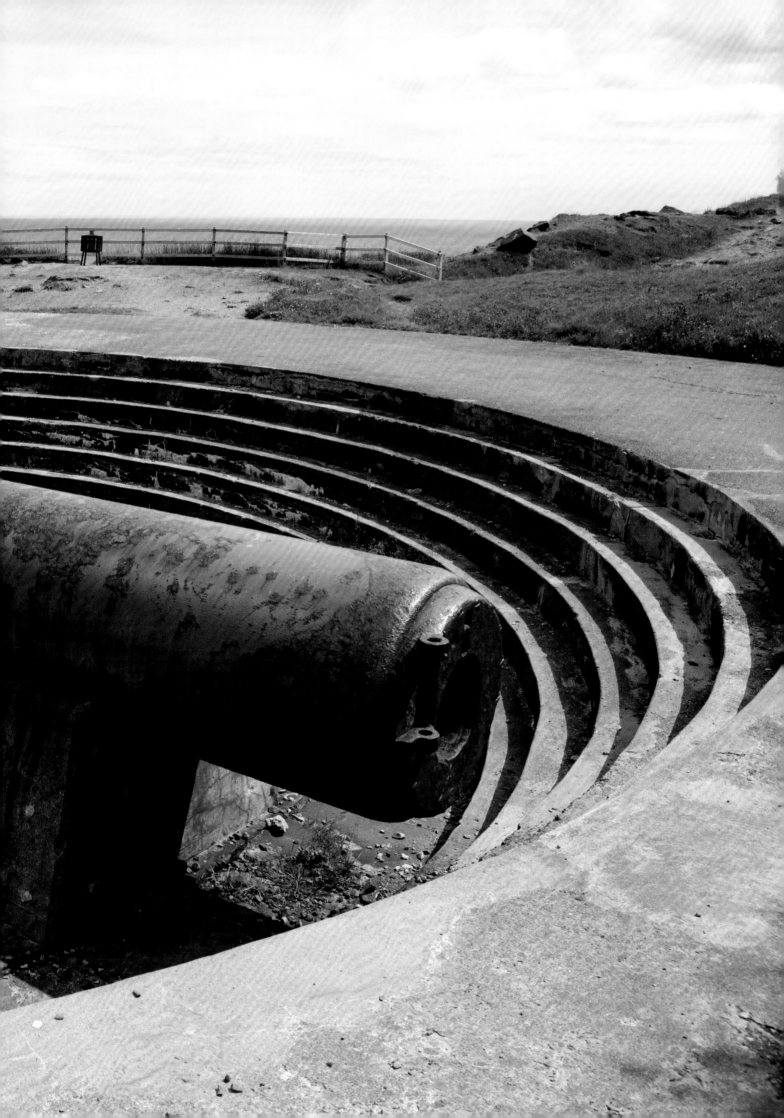

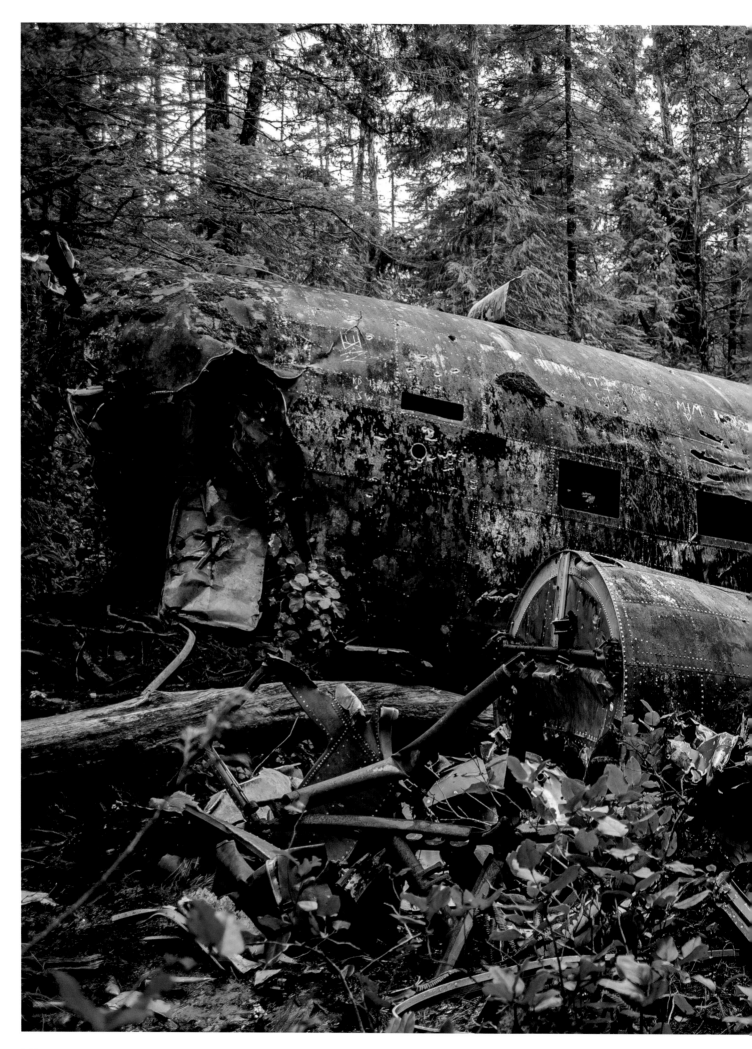

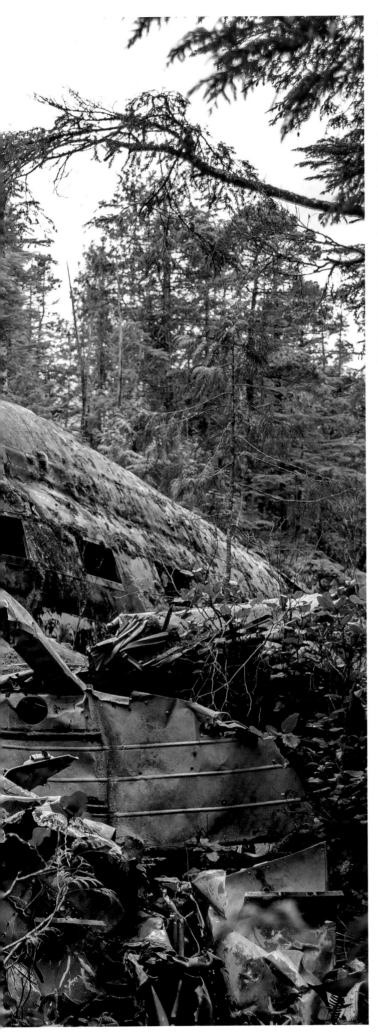

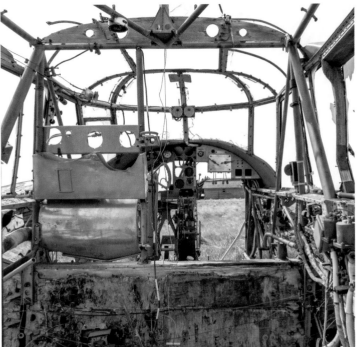

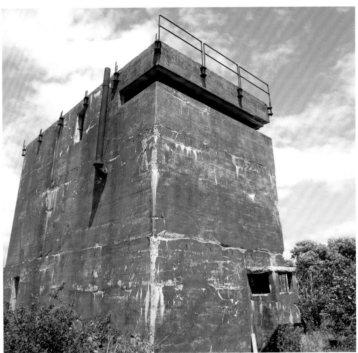

LEFT:

Douglas DC-3 Dakota, Port Hardy, British Columbia, Canada
Flying accidents, rather than combat, were the greatest threat to air
crew over North America. This aircraft, a Dakota 576 belonging to the
RAF No.32 Operational Training Unit, crashed in woodland during bad
weather, killing the pilot and navigator; a third crew member survived.

ABOVE TOP:

Avro Anson, Saskatchewan, Canada
The Avro Anson was a British twin-engine, multi-role aircraft produced
between the mid-1930s and early 1950s. Some 2882 Mk II Ansons were
built by Canadian Federal Aircraft Ltd, used in both military and civil
contexts, some coming to grief in training and operational accidents.

ABOVE BOTTOM:

Blockhouse, Saint John, New Brunswick, Canada
The coastal city of Saint John has military traditions dating back to
the eighteenth century. During World War II, it was heavily fortified
with modern defences, including coastal gun emplacements and anti-
aircraft batteries.

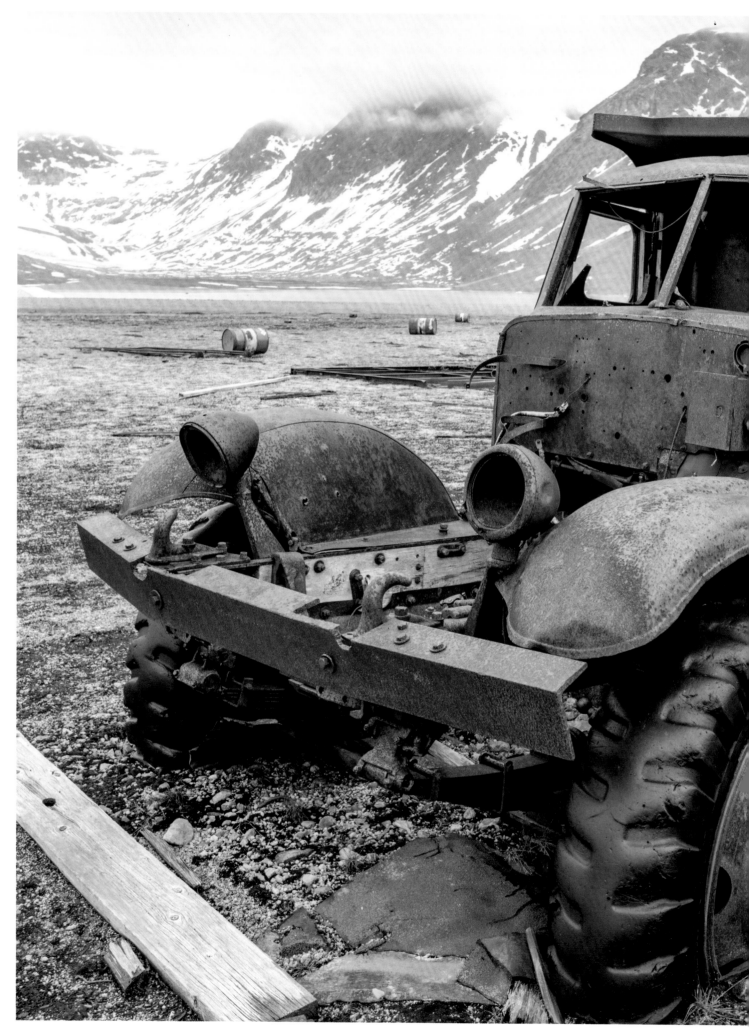

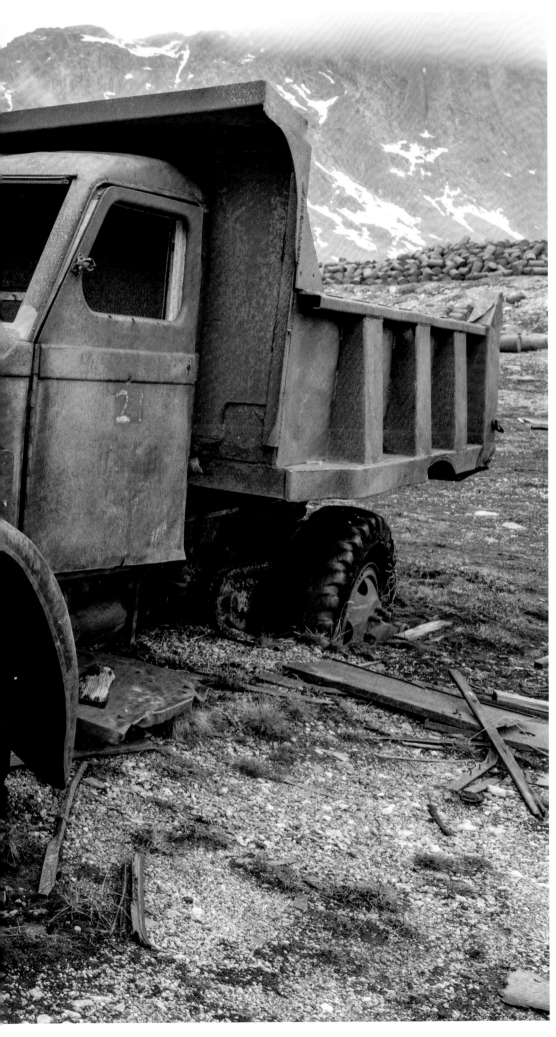

Bluie East Two US Air Force Base, Ikateq, Greenland
From 1941 until 1945, the United States established numerous and extensive facilities for air and sea traffic in Greenland, as well as radio beacons, radio stations, weather stations, ports and depots. Bluie East Two never attained the prominence in trans-Atlantic air traffic originally intended, but it served very well as an alternative airfield, weather station and search-and-rescue support centre. In 1943, Colonel Bernt Balchen used the airfield for a bombing raid against a German weather station at Sabine Island, 950km (600 miles) north.

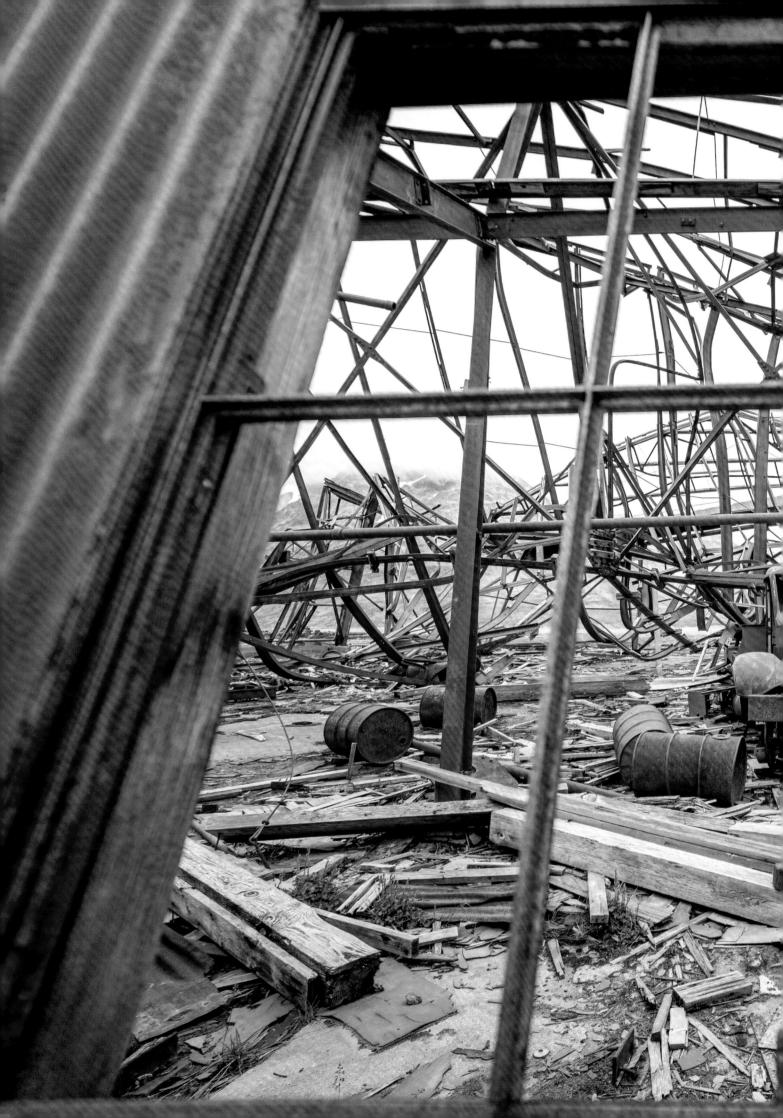

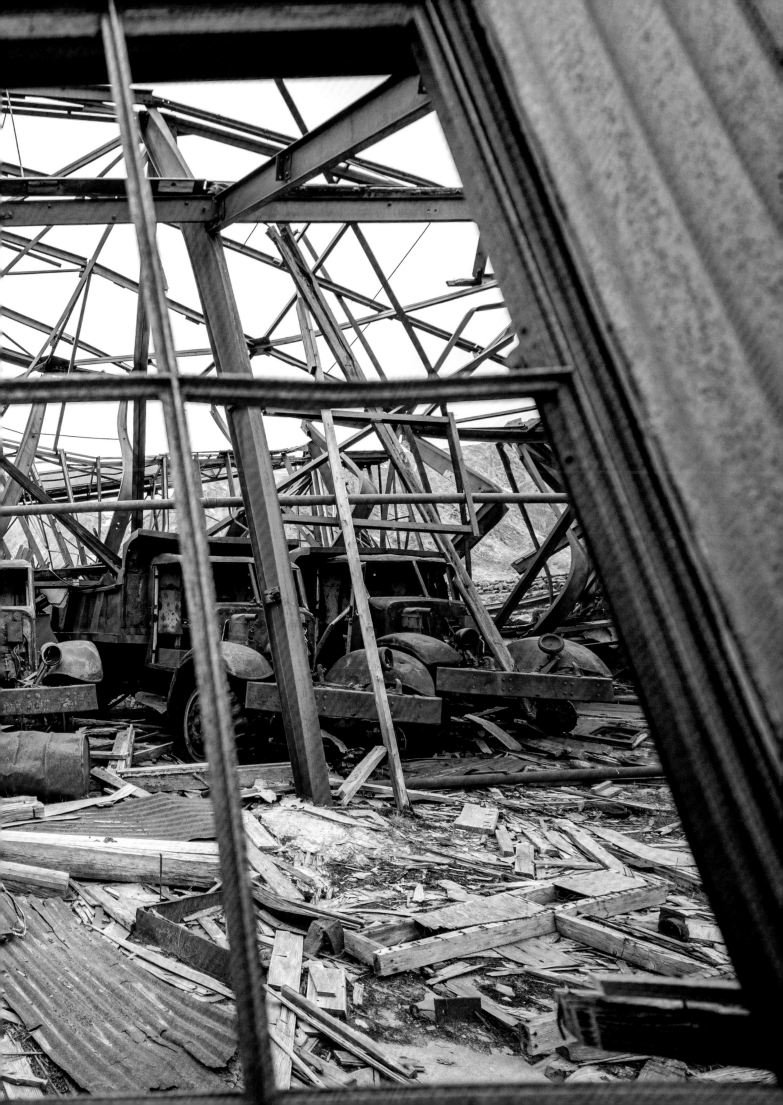

**Douglas C-47B Skytrain,
Gustavus, Alaska, USA**
Many aircraft constructed and
active in World War II went on to
have long service lives after the
conflict, some ending in tragedy.
This 1944-built C-47B met its
end on 23 November 1957 when
it crashed into woods 3.2km (2
miles) north of Gustavus, Alaska,
killing four members of the Air
National Guard.

207

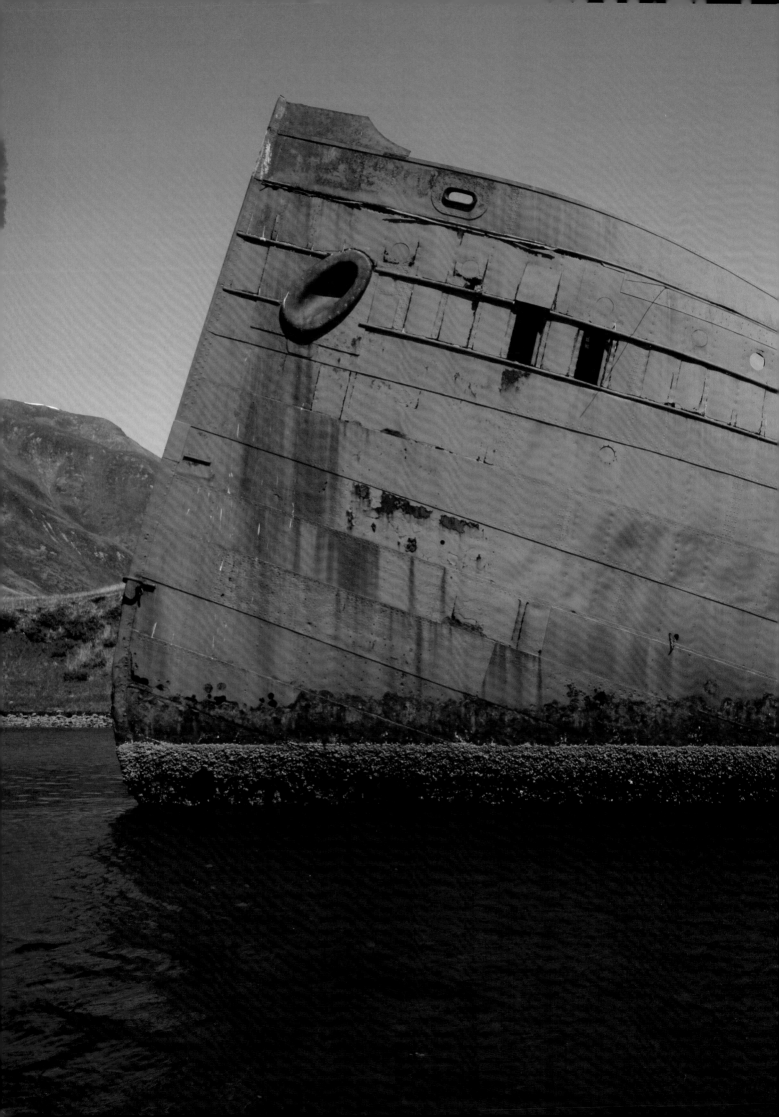

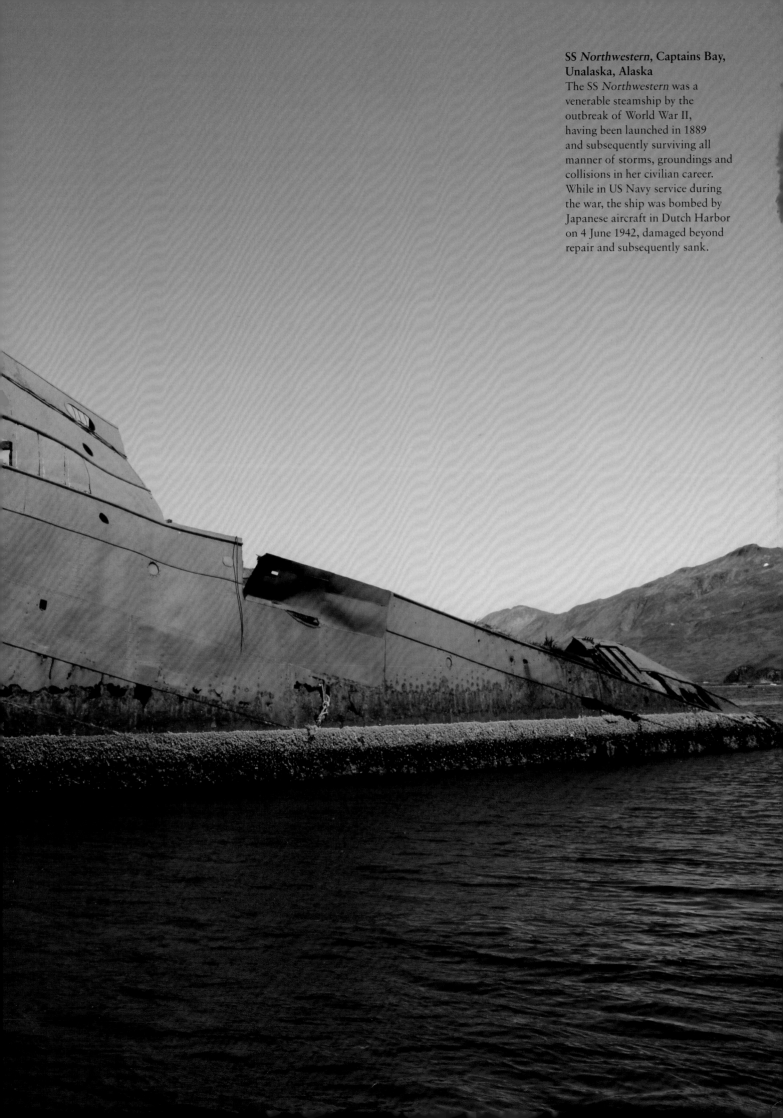

SS *Northwestern*, Captains Bay, Unalaska, Alaska
The SS *Northwestern* was a venerable steamship by the outbreak of World War II, having been launched in 1889 and subsequently surviving all manner of storms, groundings and collisions in her civilian career. While in US Navy service during the war, the ship was bombed by Japanese aircraft in Dutch Harbor on 4 June 1942, damaged beyond repair and subsequently sank.

LEFT:
Consolidated B-24J Liberator, Camel's Hump, Vermont, USA
A wing spar is a stark and strange memorial to the nine crew members of this B-24J who died when the aircraft crashed into the mountain on 16 October 1944. Air gunner James W. Wilson was the only survivor.

BELOW TOP:
Camp Hayden, Tongue Point, Washington, USA
Looking more like a section of Hitler's Atlantic Wall than a US military installation, here is Battery 131 Gun Emplacement No.2 at Camp Hayden, a coastal artillery base established in 1941.

This battery housed two fearsome 406mm (16in) naval guns under a concrete roof 4.9m (16ft) thick.

BELOW BOTTOM:
Battery Spencer, Marin Headlands, California, USA
Construction on Battery Spencer began in 1893, and spawned a major coastal gun position overlooking San Francisco Bay. Heavily armed with 305mm (12in) guns, its heyday was during World War I, as during World War II it was quickly deemed surplus to requirements, and was decommissioned in 1942.

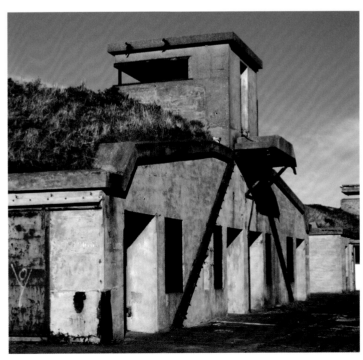

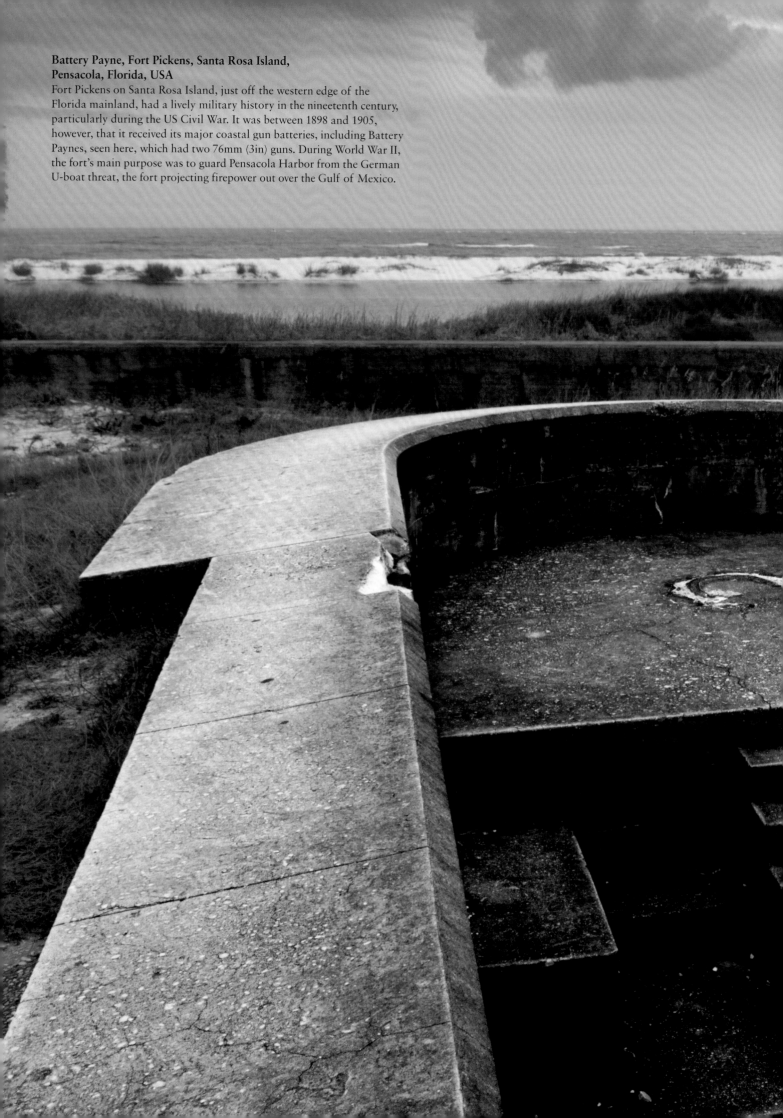

Battery Payne, Fort Pickens, Santa Rosa Island, Pensacola, Florida, USA

Fort Pickens on Santa Rosa Island, just off the western edge of the Florida mainland, had a lively military history in the nineetenth century, particularly during the US Civil War. It was between 1898 and 1905, however, that it received its major coastal gun batteries, including Battery Paynes, seen here, which had two 76mm (3in) guns. During World War II, the fort's main purpose was to guard Pensacola Harbor from the German U-boat threat, the fort projecting firepower out over the Gulf of Mexico.

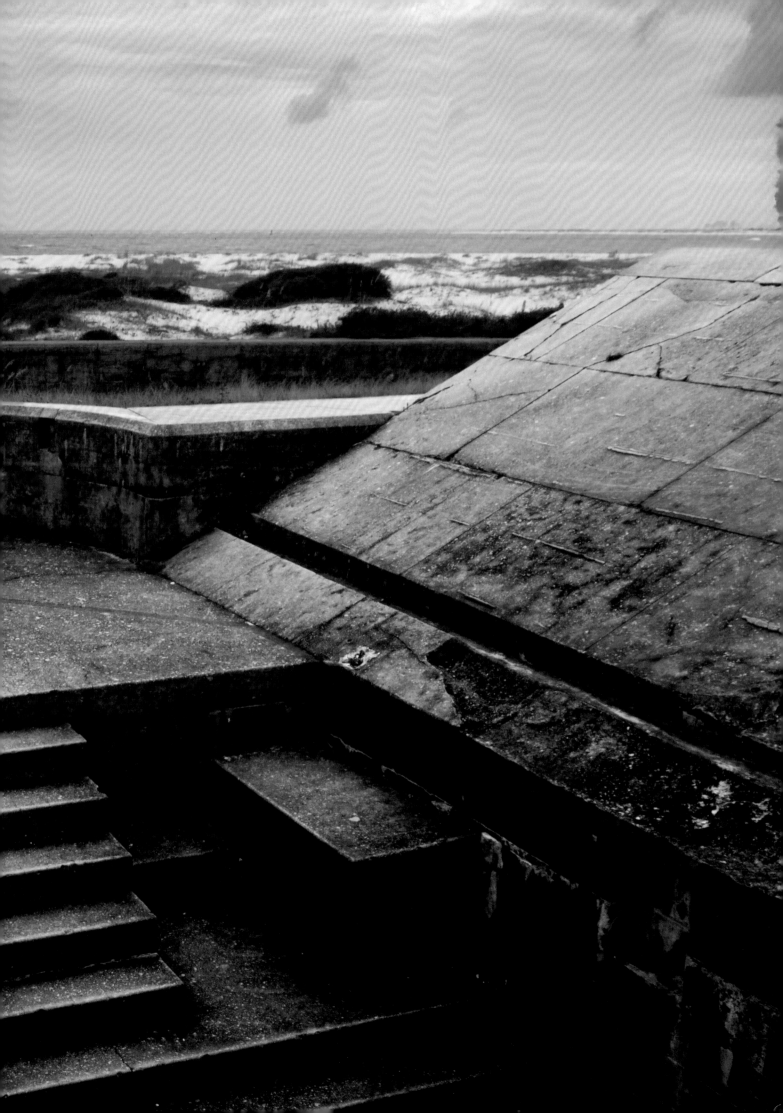

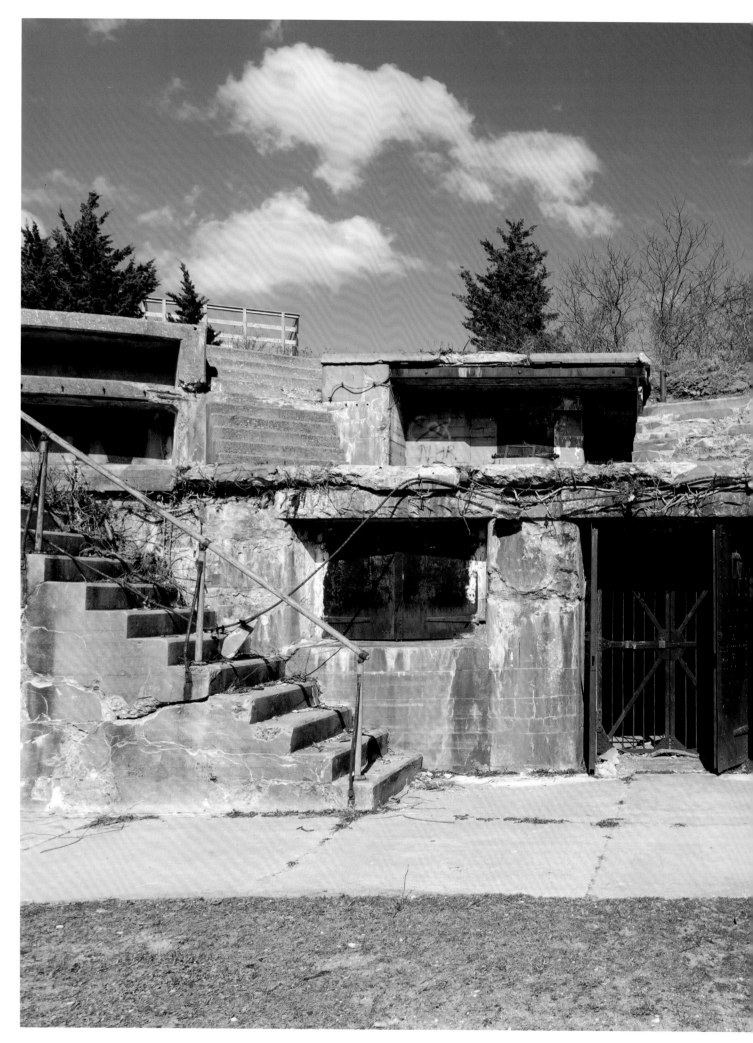

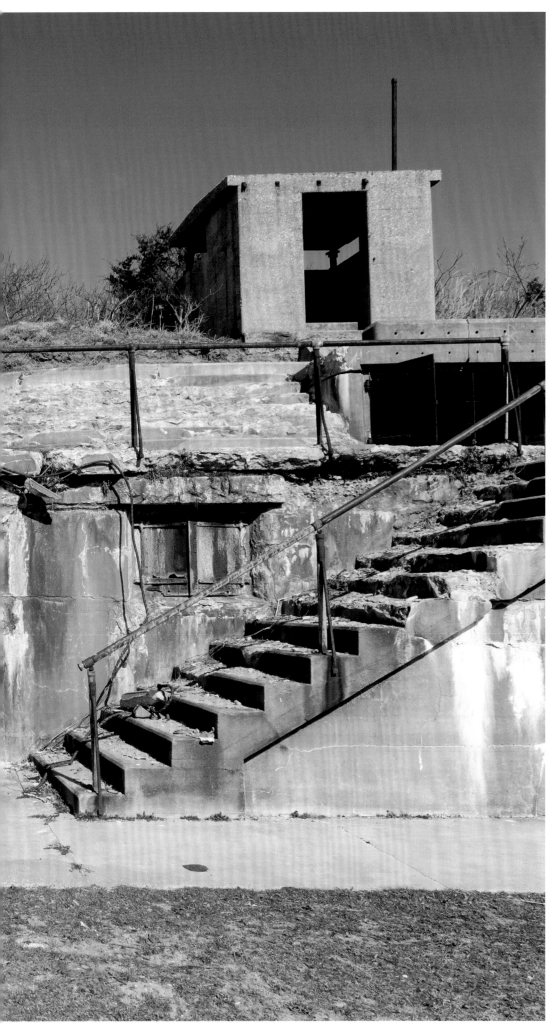

Nine-Gun Battery, Fort Hancock, Sandy Hook, New Jersey, USA
Fort Hancock is another US coastal artillery base with nineteenth-century origins. The Nine-Gun Battery was the term for the extensive gun line that had evolved by 1904, armed with 10in (254mm) and 12in (305mm) naval guns. During World War II the fort also served as a mobilization centre.

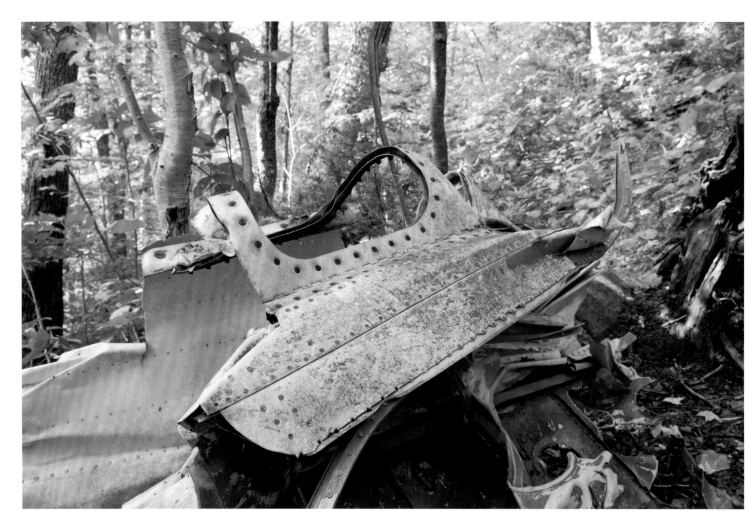

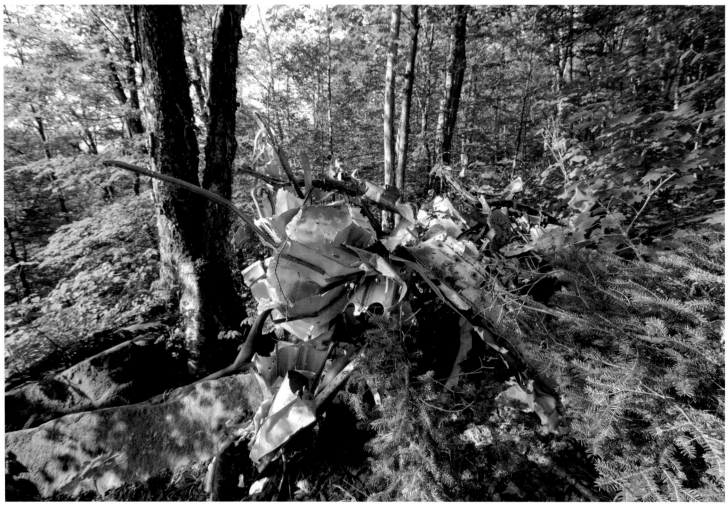

OPPOSITE (BOTH PHOTOGRAPHS):
Douglas B-18 Bolo, Mount Waternomee, Woodstock, New Hampshire, USA
The Bolo has become a rather anonymous aircraft of World War II, being a light twin-engine bomber that was regarded as obsolete even before the United States entered the war in 1941. During the conflict they mostly undertook training, transport and anti-submarine duties. It was performing the latter when this particular aircraft crashed into Mount Waternomee on 14 January 1942, when the crew lost all visibility during a blizzard.

LEFT AND BELOW:
U-352, **off Morehead City, North Carolina, USA**
U-352 met its end on 9 May 1942. Its hull fractured by depth charges from the US Coast Guard cutter *Icarus*, the vessel was forced to the surface and destroyed by naval gunfire. Fifteen of the crew were killed, while the remainder were picked up by US vessels and entered captivity.

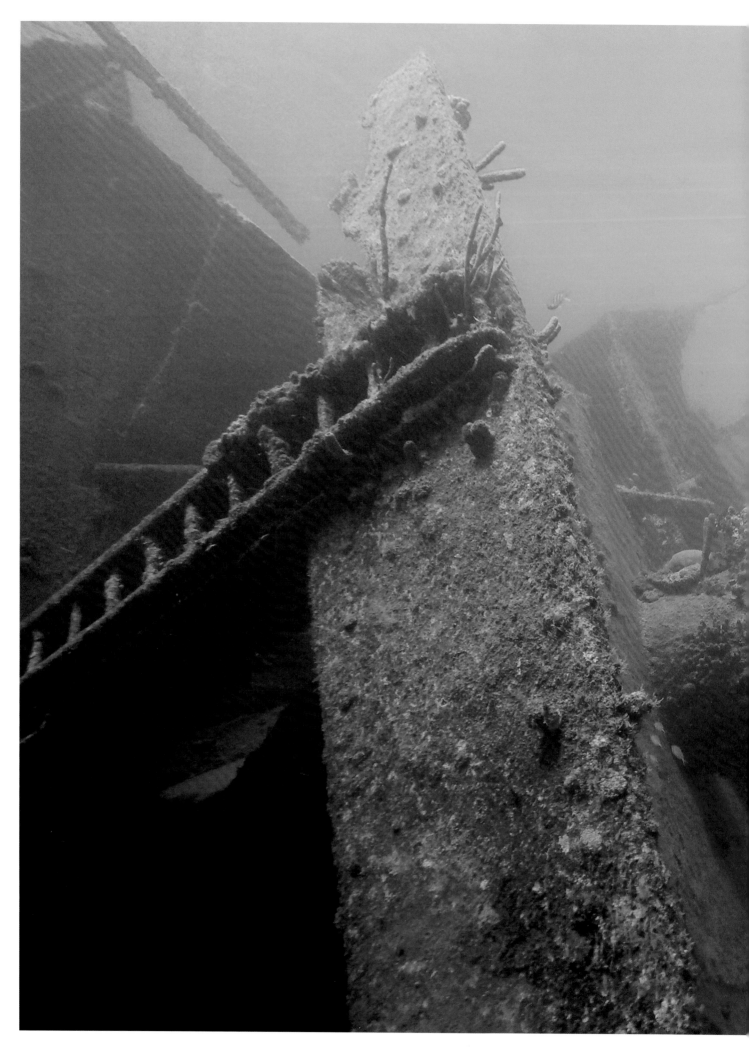

SS *Antilla*, Aruba, Caribbean
One of the Caribbean's biggest shipwrecks, the SS *Antilla* was a 4363 GRT (gross registered tonnage) German cargo vessel launched in March 1939. On 10 May 1940, the ship was anchored in the waters of the Dutch Antilles, just as German forces back in Europe were invading the Netherlands. The captain ordered the ship to be scuttled to prevent it falling into the hands of local Dutch marines.

RIGHT TOP:

St Christopher, Ushuaia, Argentina

St Christopher's humble appearance belies a dynamic history. It was launched in 1943 as a US Navy ATR-1-class rescue tug, but went straight into Royal Navy service under Lend-Lease as HMS *Justice*. As a rescue tug, it served out the war in the European theatre of operations, including supporting the Normandy landings on D-Day in 1944.

After the war, it returned briefly to the US Navy before being sold for salvage work in Argentina. The vessel beached at Ushuaia in 1952 following engine and rudder problems, and it remains there today.

BOTTOM LEFT:

Rangefinder, off the coast of Montevideo, Uruguay

A piece of history emerges from the water off the coast of Uruguay on 25 February 2004. The sea-rusted object is the rangefinder from the legendary German pocket battleship *Admiral Graf Spee*, scuttled in the Battle of the River Plate in December 1939.

OPPOSITE BOTTOM RIGHT:

QF 4in Mark IV naval gun, Gypsy Cove, Port Stanley, Falkland Islands

Despite their extreme distance from the main European battlegrounds, the British Falkland Islands in the South Atlantic were still deemed vulnerable to German, and later Japanese, naval incursions. This Vickers QF 4in (101mm) Mk IV naval gun was one of a pair mounted to watch over Port Stanley.

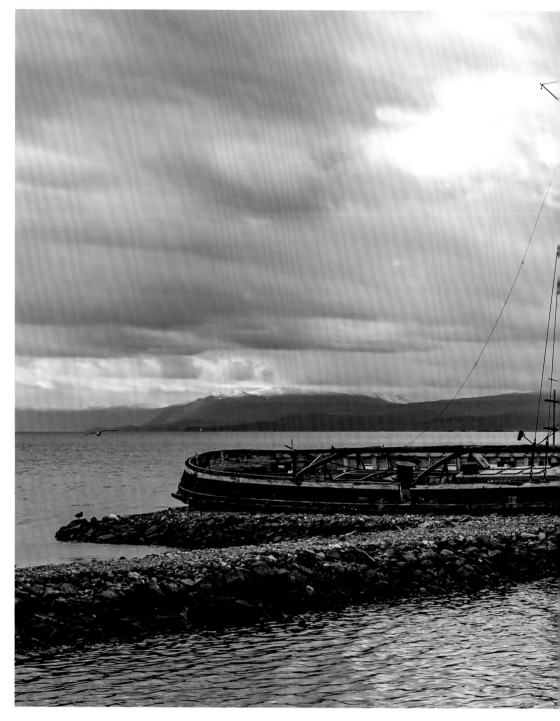

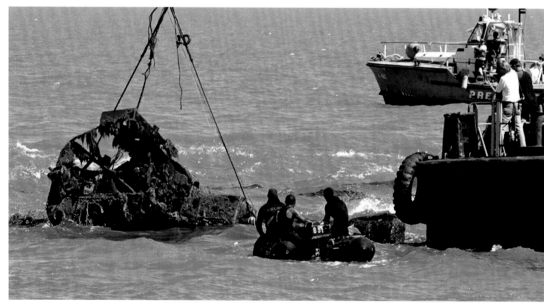

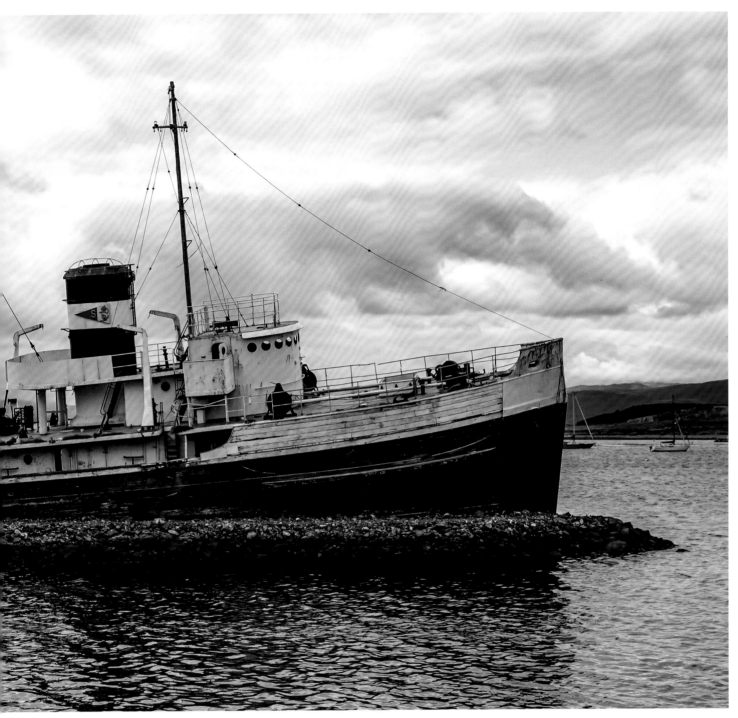

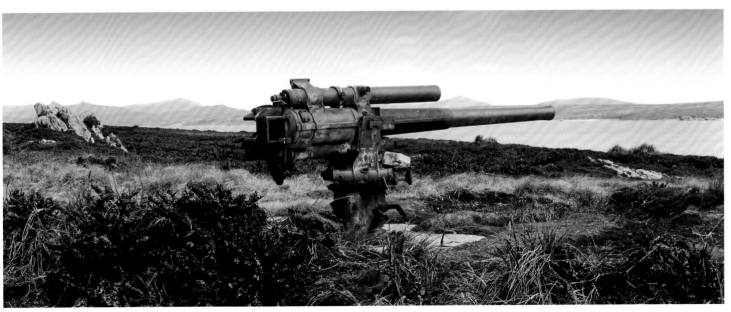

Dodge WC-63 1½ ton truck, Drummond, Montana, USA
The Dodge WC-63 was a powerful 6×6 truck, essentially a WC-52 with an extra axle added to increase capacity. After the war, many were converted to civilian vehicles, one of which sits in this frozen field in Montana.

Picture Credits

Alamy: 8 (Electric Egg), 12/13 top (robertharding), 12 bottom (Beata Moore), 20/21 (Steve Taylor ARPS), 24 & 28/29 (Stocktrek Images, Inc), 32 top (Joanne Moyes), 32 bottom (Arterra Picture Library), 36/37 (Paul McErlane), 43 top (Danita Delimont), 43 bottom (David Murphy), 46/47 (Arterra Picture Library), 48 (Mandoga Media), 49 (dpa picture alliance), 50/51 (Peter Lopeman), 52/53 (Iain Dainty), 54 bottom right (dpa picture alliance), 60 & 61 top (Wojciech Strozyk), 61 bottom (Kamila Koziol), 65 top (CTK), 68/69 (Azoor Photo Collection), 71 top & bottom (DT Darecki), 79 top (National Geographic Image Collection), 87 bottom (DOD Collection), 89 (Eugene Sergeev), 92 top (ITAR-TASJ), 100 bottom (Adam Janes), 106 (Austin Austin), 108 & 109 all (Iain Sharp), 110/111 (Hagai Nativ), 117 bottom (Tiffany Lacey), 127 (Doug Perrine), 132/133 (David Wingate), 138/139 (Matthew Oldfield Travel Photography), 146 bottom (Zoltan Csipke), 150 (Georg Berg), 151 bottom (Roberto Cornacchia), 152/153 (BIOSPHOTO), 154/155 (Stocktrek Images, Inc), 156 & 157 (Chris Willson), 160 top & bottom (Reinhard Dirscherl), 161 top (Andrew Ammenolia), 166 (Minden Pictures), 173 top (KC Hunter), 173 bottom–175 all (Media Drum World), 180/181 top (National Geographic Image Collection), 184/185 top (Galaxiid), 184 & 185 bottom (world-travel), 191 bottom (Silvia Groniewicz), 208/209 (John Zada), 210 (Doug Schneider), 211 top (David Buzzard), 212/213 (Jess Merrill), 216 top & bottom (Erin Paul Donovan), 222/223 (Martin Battilana Photography)

Dreamstime: 16/17 top (Stargatechris), 16 bottom (Lana Hamilton), 22/23 (Jon Anders Wiken), 25 top (Dennis Haga Andreassen), 25 bottom (Eugenesergeev), 26/27 (Oleksandr Korzhenko), 30 top (Johannes Hansen), 31 top (Anthony Mcaulay), 30/31 bottom (Bjorkdahl Per), 38 top (Dennis Van De Water), 56/57 (Sergey Kohl), 58 (Deymos), 64 top (Teine), 67 top (Jan Kacar), 67 bottom (Ondrej Pech), 79 bottom (Tloventures), 82/83 (Ciolca), 85 top & bottom (Nkarol), 88 (Andrea La Corte), 94/95 (Aleksandra Lande), 112/113 (Wasalpan), 114 (Mark Doherty), 115 bottom (Sven Bachstroem), 118/119 (Rowan Patrick), 120/121 (Kobus Peche), 137 (John Anderson), 148/149 (Worldcitywanderlust), 151 top (Eastburgo), 170 top (Philip Stewart), 172 (Pominoz), 178/179 (Kyle Jackson), 182/183 (James Kelley), 190 & 191 top (Silinskaia), 194/195 (Grhugesmedia), 214/215 (Erin Cadigan), 221 bottom (Cherylramalho)

Getty Images: 15 bottom (Paul Mansfield photography), 33 bottom (Dado Daniela), 40/41 (ullstein bild), 42 (Eduardo Fonseca Arraes), 44/45 (Francois Le Diascorn), 54 top (imageBROKER/Volker Lautenbach), 81 (STR), 86 bottom (Vladimir Smirnov), 93 top & 96/97 all (Sergei Malgavko), 101 (Fotosearch), 122 & 126 (Andrew Marriott), 128/129 (Shanenk), 130 top & 131 (Brandi Mueller), 158/159 (John Crux Photography), 161 bottom (Boston Globe), 163–165 & 167 top & 168/169 (The Asahi Shimbun), 170 bottom (Eric Lafforgue/Art in All of US), 193 (Kyodo News), 201 top (GeoStock), 206/207 & 211 bottom (John Elk), 218/219 (Daniel A Leifheit), 220 bottom (Miguel Rojo)

iStock: 33 top (dennisvdw), 39 (JJFarquitectos), 62/63 (ewg3D), 77 (ultramarinfoto), 90 top (Rob Atherton), 91 (Milan Maskovic), 98 (semet), 140/141 (aleks0649), 171 (Ma Felipe), 196 (MikeyGen73), 200 (Prescott Patterson), 201 bottom (bridixon), 202/203 (renelo), 217 top & bottom (Kevin Littlejohn)

Shutterstock: 6 (Kevin Brine), 7 (Rob Atherton), 13 bottom (Andy Wilcock), 14 (coxy58), 15 top (Becky Stares), 17 bottom (Winnietto), 34/35 (R de Bruijn Photography), 38 bottom (Dennis Van De Water), 54 (Iaranik), 54 bottom left (Almgren), 64/65 (Damian Pankowiec), 66 (Kaprik), 70 (Jaroslav Moravcik), 72/73 (Stjepan Tafra), 74/75 (DeymosHR), 76 (burnel1), 78 (Christian Puscasu), 80 (Mikai), 84 (kadetfoto), 86/87 top (Gitanas D), 90 bottom (Photoillustrator), 92/93 bottom (Sergey Kamshylin), 100 top (Raimundo79), 104/105 (Droneworx TS), 107 top (Andronos Haris), 107 bottom (Alxddd000), 115 top & middle (Anna Segeren), 116 & 117 top (Moussar), 125 (Robert Szymanski), 130 bottom (unterwegs), 134/135 & 136 top & bottom (Agrianna76), 142/143 (Janelle Lugge), 144/145 (Destinations Journey), 146/147 top (Man Down Media), 147 bottom (electra), 162 (Kyung Muk Lim), 167 bottom (Bereth Giltoniel), 176/177 (GO Taranaki), 180 bottom (Page Light Studios), 181 bottom (Everett Collection), 186/187 (Andrey Filonov), 188 & 189 (es3n), 198/199 (S. Vincent), 204/205 (Max Forgues), 220/221 top (Leonard Zhukovsky)

Shutterstock Editorial: 10/11 (Fraser Gray), 18/19 (Graham Harries), 102/103 (Andrey Nekrasov/Solent News), 124 (Yirmiyan Arthur/AP)

U.S. Department of Defense: 192 top & bottom

224